HENRY FARNY
PAINTS THE FAR WEST

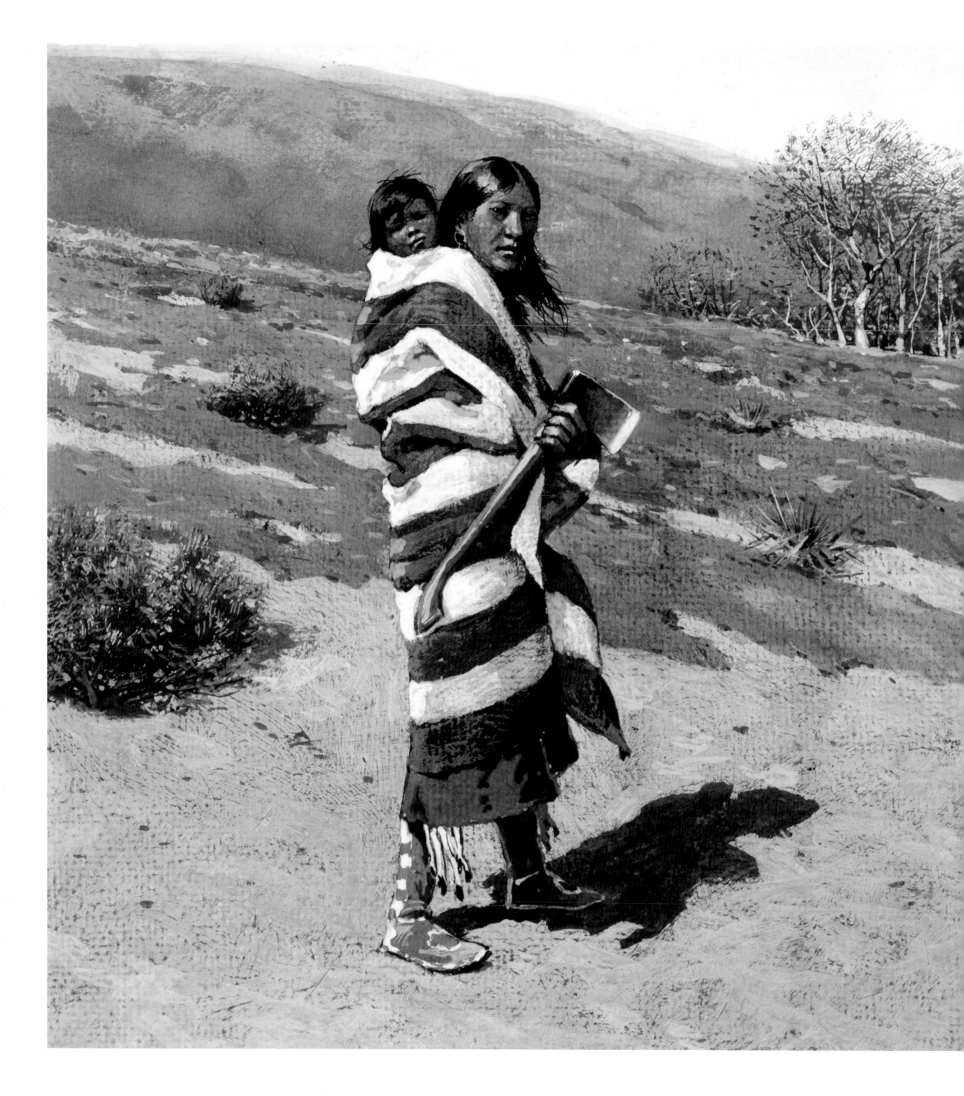

HENRY FARNY
PAINTS THE FAR WEST

Written by
Susan Labry Meyn

Organized and edited by
Kristin L. Spangenberg

With contributions by
Cecile D. Mear
Julie Schimmel

cincinnati @ art museum

2007

OPPOSITE: Henry Farny, *Indian and Child*, 1904 (detail, cat. 30).

Henry Farny Paints the Far West

is published to accompany the exhibition *Vanishing Frontier: Rookwood, Farny, and the American Indian*, held at the Cincinnati Art Museum October 20, 2007 through January 20, 2008.

Cincinnati Art Museum, 953 Eden Park Drive, Cincinnati OH 45202

Author: Susan Labry Meyn

Organizer and editor: Kristin L. Spangenberg

Manuscript editor: Anita Buck

Photography: Cincinnati Art Museum and Tony Walsh

Typography and design: Paul Neff

Printer: The Merten Company

Photo credits: The Cincinnati Art Museum and contributing authors thank institutions, galleries, and collectors for permission to publish comparative photographs of the work in their collections and archives as cited in the figure captions. The Cincinnati Art Museum and Tony Walsh supplied all photographs of the Museum's permanent collection, local loans, and comparative illustrations from the resources in the Mary R. Schiff Library and Archives, and the Public Library of Cincinnati and Hamilton County.

The production of this catalogue was generously underwritten by the Wyeth Endowment for American Art, and Skip Merten and The Merten Company. The Cincinnati Art Museum also wishes to offer sincere gratitude to the Henry Luce Foundation for supporting our ongoing research of Cincinnati's artistic heritage. In addition, the Cincinnati Art Museum gratefully acknowledges project support from the Castellini Foundation, the Farmer Family Foundation, the Farny R. Wurlitzer Foundation, Chase, Cincinnati Art Galleries, Dan and Mim Hillebrand, Betty B. Klinedinst, and an anonymous donor.

Appreciation for operating support goes to the Fine Arts Fund, the Ohio Arts Council, the City of Cincinnati, and our members.

Library of Congress Cataloging-in-Publication Data

Meyn, Susan L., 1942-

 Henry Farny paints the Far West / written by Susan Labry Meyn ; organized and edited by Kristin L. Spangenberg ; with contributions by Cecile D. Mear, Julie Schimmel.
 p. cm.
 "Henry Farny paints the Far West is published to accompany the exhibition Vanishing frontier, held at the Cincinnati Art Museum October 20, 2007, through January 20, 2008."
 Includes index.
 ISBN 0-931537-32-0
 1. Farny, Henry François, 1847-1916--Exhibitions. 2. West (U.S.)--In art--Exhibitions. 3. Indians in art--Exhibitions. I. Farny, Henry François, 1847-1916. II. Cincinnati Art Museum. III. Title.

ND237.F25A4 2007

759.13--dc22

 2007031998

CONTENTS

Director's Foreword / 7

Lenders / 8

Acknowledgments / 8

Images of the Dispossessed by Julie Schimmel / 11

The Artist as Indian Storyteller by Susan Labry Meyn / 37

The Artist's Training and Materials by Cecile D. Mear / 73

Note to Reader / 89

Catalogue Commentaries by Susan Labry Meyn / 90
Assisted by Kristin L. Spangenberg

Chronology / 138

Index / 140

Unidentified photographer, *Henry Farny*, n.d., 15 5/8 x 8 7/8 in. (39.7 x 22.5 cm). Private Collection, North Bend, Ohio.

HENRY FARNY'S VISION

Valiant but lonely, noble but downtrodden, vicious but no longer victorious—the Native American had by the end of the nineteenth century become a contradictory symbol for all that America was losing as it conquered a landscape it felt was its manifest destiny. Few artists captured the myth of the "Indian" with greater elegiac power than the Cincinnati artist Henry Farny. This catalogue is published to accompany the exhibition *Vanishing Frontier: Rookwood, Farny, and the American Indian.*

Henry Farny grew up as an exile from his native France and as a young man had to break off his formal education to support his family. He was thus himself subject to the forces of globalization and modernization that he depicted in his illustrations, gouaches, and paintings. By painting Native Americans, he was able to create the image of a coherent community with its own values and its own place. It became a counter-example to the confused, rapidly changing world of which he was part. That his livelihood depended to a certain degree on the same forces that were destroying the mythic world he so lovingly portrayed, and that he invented much of what he depicted (even clothing men in women's clothing and vice versa, or imagining Plains Indians in Ohio) mattered less than that the world he presented was coherent and convincing.

That romanticized place was one whose landscape had little of the rugged majesty that framed the scenes of later "cowboy painters." It instead shared more qualities with earlier American painters' depiction of an idyllic, but also essentially empty space waiting to be colonized by new inhabitants. The figures in Farny's world of muted colors, soft forms, and extensive horizons seem lost and inward-turned even as they listen for the inaudible sound of telegraph messages or scan the horizon for the white man. They are always on the move, trekking or camping in a terrain that is not bounded or secure in the manner of the settled lands then replacing their native grounds.

Farny was never overtly political in the messages his art conveyed. He was, above all else, an artist who often chafed at the commercial structures within which he worked. He painted beautiful and complete pictures that portrayed an alien world in the manner of an ethnographic report. They served to tell Americans about a world that was disappearing, and fed a culture of nostalgia that, as T. J. Jackson Lears described in his seminal *No Place of Grace: Antimodernism and the Transformation of American Culture, 1880–1920* (1981), shaped a renascent American sense of itself. Yet Farny's carefully posed scenes were also that: scenes with actors and backdrop. In style and subject, these artworks in many ways evoked the traditions of tragic theater in the classical manner, filled with nobility, high principles, and inevitable death. While we can thus not use these images today to tell us anything about how Native Americans "really" lived at the time Farny painted—as contemporary audiences looked at these paintings—we can appreciate Farny's fictionalized American West as a central part of the tale we tell ourselves about the gains and losses that have shaped our country.

This is especially significant because it was this vision, melded with those of both its precursors, ranging from George Catlin to the painters of the Hudson School, and with those of Frederic Remington and the other cowboy painters, that produced the myth of the American West so central to the way this country has defined itself since the middle of the nineteenth century. From Henry Farny to Henry Ford and from there to Ronald Reagan is only a short distance in terms of the use of evocative imagery of the American West. The work of Farny and of the other painters, printers and publishers of Cincinnati, the Queen City of the West, was central in the construction of that myth, and it is this legacy that we celebrate with *Henry Farny Paints the Far West.*

I would like to extend thanks on behalf of the Cincinnati Art Museum to the Wyeth Endowment for American Art, and Skip Merten and The Merten Company, for their generous support of this publication. The Museum also wishes to offer sincere thanks to the Castellini Foundation, the Farmer Family Foundation, the Farny R. Wurlitzer Foundation, and to Chase for their major support of this exhibition, and to the Henry Luce Foundation for supporting our ongoing research of Cincinnati's artistic heritage.

The exhibition would not have been possible without the loans of important gouaches assembled here, and we are extremely grateful to the many lenders for sharing their treasures with the Museum's audience.

Authors Susan Labry Meyn, Julie Schimmel and Cecile D. Mear each illuminate different aspects of Farny's life, career and importance in this catalog. The Cincinnati Art Museum wishes to thank them for their research and insights.

And above all else we would like to thank Kristin L. Spangenberg, the Art Museum's indefatigable Curator of Prints, who initiated, conceived, developed and coordinated this whole project and brought it to such a splendid resolution.

Aaron Betsky
Director

ACKNOWLEDGMENTS

Lenders

Cincinnati Museum Center
at Union Terminal

W. Roger and Patricia K. Fry

Ron and Florence Koetters

Mr. and Mrs. Larry Kyte, Jr.

The Literary Club, Cincinnati

Susanne B. Loeffler

Taft Museum of Art

Mr. and Mrs. Stephen G. Vollmer

Leonard A. Weakley, Jr.

Charles and Patricia Weiner

Williams Family Collection

Three Private Collections

The planning and execution of an exhibition and publication is an extended process involving the cooperation of many individuals who must be acknowledged. The organizer and authors first express their thanks to former Cincinnati Art Museum Director Timothy Rub and former Deputy Director Stephen Bonadies, who endorsed the exhibition, and to Director Aaron Betsky and Deputy Director for Curatorial Affairs Anita J. Ellis for their enthusiasm and support as the project came to fruition. A special tribute is rendered to those early collectors and relations of Henry Farny who possessed the foresight and appreciation of the artist's painting to make the Cincinnati Art Museum a major repository of his work. The organizer extends her appreciation to the dealers and collectors who assisted in locating gouaches by Farny in Greater Cincinnati collections. Special gratitude is due to the lenders, public and private, for generously allowing us to show the works in their collections, thus guaranteeing the successful realization of the exhibition and publication. Our indebtedness to the sponsors whose whole-hearted financial assistance has been crucial to the undertaking is detailed in the Director's Foreword.

This monograph aspires to do more than provide a commentary to accompany the works on display. In 1978 Watson-Guptill Publications in cooperation with the Cincinnati Art Museum published a monograph on Farny by Denny Carter Young. This has been the primary reference on the artist to date. The authors appreciate her sharing her research and photographs. The aim of this project is to take a fresh look at Farny's American Indian subjects. Ethnologist Susan Labry Meyn has made a lasting contribution to our knowledge and appreciation of one of Cincinnati's most important artists. Julie Schimmel has provided an art historical context against which to reappraise Farny's work. Cecile D. Mear, the Cincinnati Art Museum Conservator of Works on Paper, has brought her technical insight to an explication of the artist's materials and working methods.

Local librarians embraced the concept of the publication, generously volunteered their thoughts, and suggested relatively unknown sources about this widely known, widely admired, but rather elusive artist. The organizer appreciates the openness of Farny's relatives in sharing their collections of papers and photographs.

Information about Farny is spread among several repositories in Cincinnati. Mona L. Chapin, Head Librarian; Rebecca Hosta, Archives Technician; and Tim Hennies, Library Assistant, provided access to the Museum's artist files and archives for the authors.

Susan Meyn is deeply indebted to Sylvia V. Metzinger, former manager of Rare Books and Special Collections at the Public Library of Cincinnati and Hamilton County, for providing access to the library's old card catalogue, thereby locating references not in the online catalogue system; her staff Sherry Lytle, Diane Mallstrom, and Claire Smittle performed yeoman's duty tracking down sources. Research librarian Rick Kesterman and assistant librarian M'Lissa Kesterman, both of the Cincinnati Historical Society Library, also suggested ideas for research and diligently reviewed *Harper's Weekly* for Farny illustrations. Reference librarian Anne B. Shepherd, also at the Cincinnati Museum Center, answered questions about Farny's genealogy. Gene Hinckley, artist and Cincinnati Art Club Librarian, made the club's files on Farny available; and Kevin Grace, Head and University Archivist, Archives and Rare Books at the University of Cincinnati Blegen Library,

provided access to Ohio's WPA sources. All these resources, combined with outside sources such as the Henry F. Farny papers located at the Archives of American Art, provided an understanding of Henry Farny and his knowledge of American Indians. Michelle Ann Gray, office manager at the Warren County Historical Society in Pennsylvania, provided insight into the institution's biographical paper on Farny. Debbie Vaughan of the Research Center at the Chicago History Museum helped pinpoint information on Farny's participation in the World's Columbian Exposition held in Chicago in 1893. Dr. Ted J. Brasser assisted with information related to Farny's images of Canadian Indian peoples. Peter Strong, Director, and Mary Bordeaux, Curator of The Heritage Center, Pine Ridge Indian Reservation, looked at Farny's paintings from a Native American perspective. Jack Lewis provided detailed information on the firearms depicted by Farny.

Cecile Mear appreciates the efforts of Linda Bailey, Librarian/Photograph Curator at the Cincinnati Historical Society Library at the Cincinnati Museum Center, for locating a needed poster.

The authors extend their deep appreciation to the following individuals who reviewed their essays. Julie Aronson, Curator of American Painting at the Cincinnati Art Museum, made suggestions on early drafts of the essays. William H. Truettner, Curator at the Smithsonian American Art Museum, commented on Julie Schimmel's essay "Images of the Dispossessed." Sue Conrad; George P. Horsecapture, Sr.; and John Painter offered insightful suggestions on Susan Meyn's essay "The Artist as Indian Storyteller."

Numerous members of the Cincinnati Art Museum staff whose critically important efforts behind the scenes generally pass unnoticed include, in the Development Division, Director of Development Susan Laffoon, Grants and Foundation Manager Genevieve Richardson, Corporate Relations Manager Roxanne Christophe, and their excellent staff, whose work supports every Museum undertaking. In the Marketing Division, Director of External Relations and Marketing Cindy Fink, Assistant Director for Communications Preeti Thakar, and Assistant Director for Advertising and Promotion Jutta Lafley ensured that the exhibition would get the public attention it deserves. In the Education Division, Curator of Education Ted Lind and his accomplished Assistant Curators Katie Johnson, Emily Holtrop, and Marion Cosgrove-Rauch, former Associate Curator Amber Lucero-Criswell, and Manager of Docent Programs Megan McCarthy assisted with the interpretation of the exhibition. In the Curatorial Division, former Chief Registrar Kathryn Haigh; Registrar, Permanent Collection Jay Pattison; and the efficient Registration staff coordinated the loans. Head of Photographic Services Scott Hisey and his staff photographed and prepared the digital files for publication. Cecile Mear, Conservator of Works on Paper, and Megan Emery, Assistant Conservator of Objects, oversaw the preparation of the Museum's collection for exhibition and the loans for photography. Exhibition Designer Matt Wizinsky and Chief Preparator Christopher P. Williams and crew displayed Farny's gouaches to stunning effect. Lastly, special appreciation to Curatorial Administrative Assistant Jade Sams for her efficient acquisition of comparative images.

The publication would not have been realized without the editorial skills of Anita Buck and elegant design of Paul Neff. Judith Daniels turned the index around with blazing speed.

Lastly, the organizer and authors express their appreciation to their spouses John E. Gilmore III, Malcolm Anthony Meyn, and John Mear for their unequivocal support on the home front.

Kristin L. Spangenberg
Curator of Prints

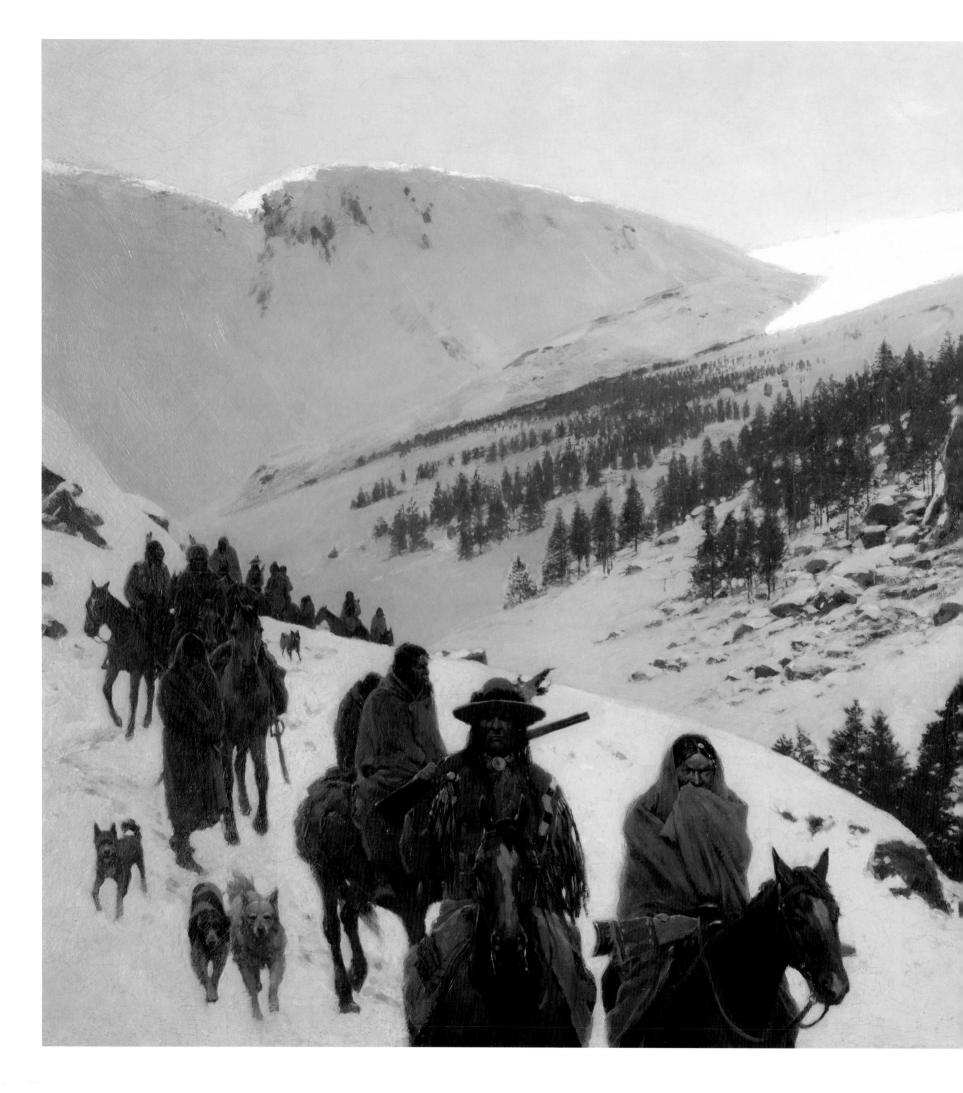

JULIE SCHIMMEL

IMAGES OF THE DISPOSSESSED

The golden West isn't what it used to be.
HENRY F. FARNY, 1882

The Indian that Henry Farny painted beginning in the 1880s was not the same Indian that earlier western American artists George Catlin, Karl Bodmer, Alfred Jacob Miller, and John Mix Stanley had traveled among in the 1830s and 1840s. These painters created celebratory paintings of tribes found in their traditional lands, living—at least in the eyes of the artists—more or less as they had for centuries. Farny did not. By the time he observed Native Americans, the majority of them were living on reservations, that is, public lands set aside by the federal government for enforced Indian occupation. It is this historical context that trumps all previous discussions of Farny's work as simply realistic. Much more routinely and obviously, a significant portion of Farny's work evokes a sense of isolation and stasis, qualities that indirectly suggest, but do not literally portray, the dislocation of Plains Indians to lands they had not chosen for themselves.

This essay, part art history, part history, provides explanation of the disassociated elements and disjuncture between what is expected and what is actually seen in many, but not all, of Farny's imaginings of Indians. Initially, this will be done by comparing Farny to other artists of the American West in order to identify what is unique about his view of the Indian. A biography is also given, not for its own sake but in order to identify the political context in which Farny was raised, a significant factor in the construction of his particular vision of Native Americans. It will be argued that Farny's paintings—made during the last two decades of the nineteenth and the first decade of the twentieth centuries—could not

have been created at any other time in American or Native American history. This part of Farny's story includes an interweaving of federal Indian policy and the reservation system, in relationship to the tribes that Farny is known to have visited. Finally, the artist's work will be placed in the context of a particular iconographic tradition, that of the "doomed" or "vanishing" Indian that first appeared in the visual arts in the 1840s.

Catlin and Early Western Art

Western American art traditions were established early in the nineteenth century, particularly by George Catlin (1796–1872). As almost all western artists would do in the future, Catlin argued foremost that his paintings were true and faithful records of Indian culture and that his paintings served to record native customs before they disappeared from the face of the earth. These claims were inextricably tied to the fact that he had traveled the West for years and that his paintings were based on first-hand observation. By the time Farny visited Indian reservations, it was no longer possible for any western artist to heroize his work by claiming extensive time and travel spent among Indians in their native settings, because most of those who had survived disease and battle no longer remained in their homelands. In truth, Farny's paintings were much more likely to be based on photographs taken when he visited reservations than on extensive first-hand observation.

In the 1840s, Catlin had written passionately about the state of Indian affairs, arguing, as eighteenth-century philosophers and authors had, that civilization often represented the decline of humankind, not its ascent. From this point of view, it was the primitive state and natural man that was to be venerated and the excesses of civilization to be reviled, as Catlin wrote:

> Their country was entered by white men, but a few hundred years since; and thirty millions of these are scuffling for the goods and luxuries of life, over the bones and ashes of twelve millions of red men; six millions of whom have fallen victims to the small-pox, and the remainder to the sword, the bayonet, and the whiskey.[1]

Writing decades later, Farny describes Indians in the dispassionate scientific language of the 1870s emergence of American anthropology:

> The forest Indian, such as the Seneca, is a different Indian from the Plains Indian. The former is sedentary, the latter is nomadic, and everything they do shows the difference. The Sioux Indian, who is a plainsman, for instance, has a peculiar sagging or swaying motion of his body as he dances. The Seneca dances are quite different, although probably no one who is not familiar with Indian life would know the points.[2]

In contrast to earlier western artists, who treated Indians with dead seriousness, Farny exercised his sense of irony and wit when speaking of Native Americans, as when he comments on an Indian sitter, "He sat and eyed me with all the legitimate suspicion which would naturally arise on the mind of a man to whom a paper bag of prunes had been offered for the mere pleasure of sketching him."[3] Or even more slyly, "The Indians do not like to repeat their legends to the whites. When urged they repeat the stories told them by white people, and in this way the old European tales are retold innocently as pure Indian lore."[4]

Also unlike Catlin and other painters, Farny rarely identified individual Indians, and even more rarely wrote about the subjects he painted. If he found them unique beyond their visual attraction or general state of being, he never made it self-evident. All of the early artists, and Farny's contemporaries Elbridge Ayer Burbank and Joseph Henry Sharp, painted Indian portraits that laid claim to historical and ethnographic truth. Catlin routinely depicted noted tribal members, as illustrated in his 1838 painting *Osceola, Black Drink, Seminole* (fig. 1). Catlin's identification of individuals did not rest simply on the titles of paintings, but also on texts that he wrote to describe his sitters. Catlin wrote that he painted Osceola five days before he died at Fort Moultrie, South Carolina, where he had been imprisoned because of his role in the Seminole Indian wars. Catlin's admiration of Osceola is apparent when he describes him as a distinguished and extraordinary individual.[5]

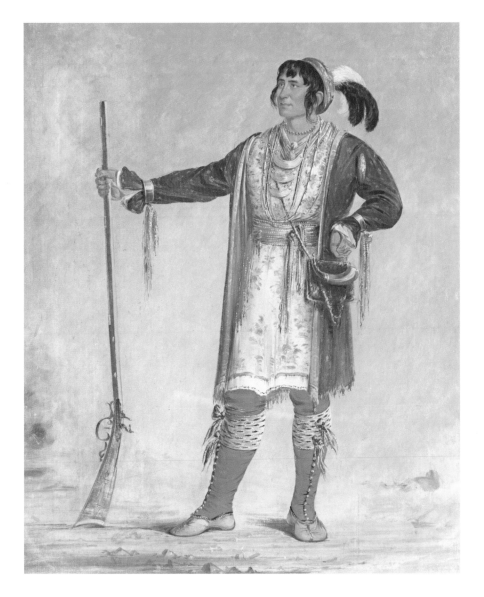

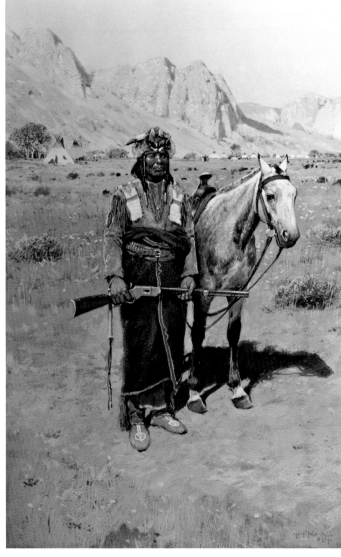

In contrast, Farny portrayed single figures but only rarely identified them as individuals. He locates the lone Indian in *On the Alert* (fig. 2) in an unprotected space, even though he presumably is a sentinel on watch for an enemy. Despite the title, the figure appears only vaguely alert, his gun held parallel to the ground and his horse dozing beside him. The final impression on the viewer is one of puzzlement, particularly because the implied narrative is completely confounded by the tension between the title and the image itself.

These same qualities are pervasive in other paintings by Farny, including *In Luck* (fig. 3), a scene of the aftermath of a hunt. Alfred Jacob Miller (1810–1874) in *The Yell of Triumph* (fig. 4) provides the theatrics more commonly associated with a successful hunt: an Indian standing on the back of a downed buffalo, whooping his success. Here we see the frenzy of the hunt and the possibility of danger, as a horse and rider gallop away from the charge of a maddened buffalo. In contrast, Farny's painting takes place after the climax of the scene, after the prey has been killed. There is no movement, no drama. The hunter simply regards his prey while a woman and horse remain in the background, no hint of future activity indicated. With or without intent, Farny has painted these figures, as he does others, in stasis, as if the hunt is only a means to avoid starvation, not a vital way of life that includes the adventure of the hunt.

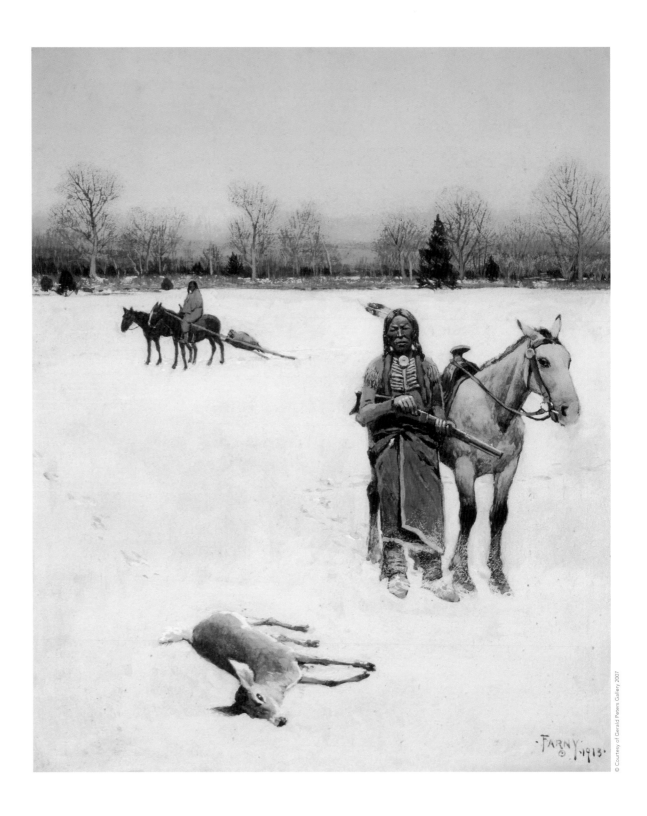

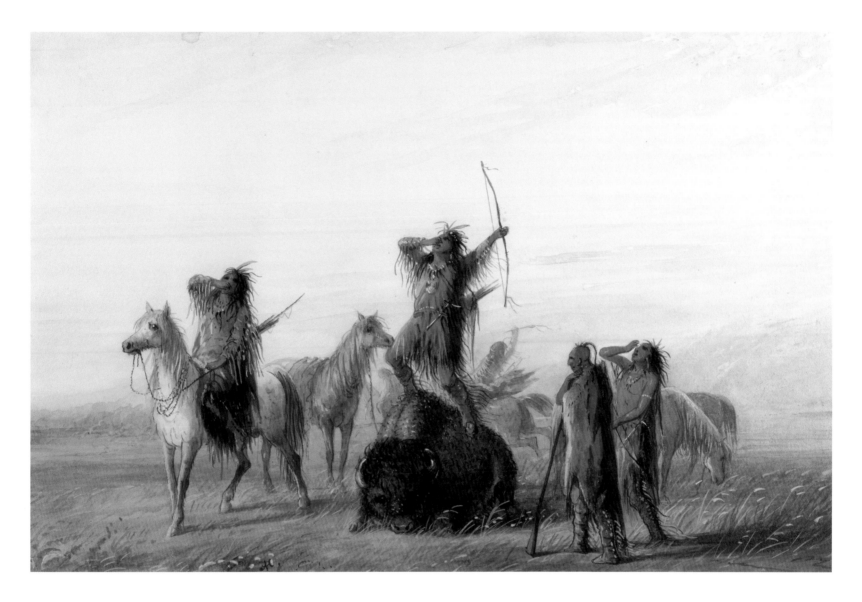

Political and Social Influences

The almost airless scenes of inaction that are part of Farny's oeuvre can be partially understood through a review of the political context in which he was raised. He entered the world as François Henri Farny on July 15, 1847, the third child of Charles and Jeannette Farny. He was born in Ribeauvillé, located in northeast France along the Rhine River in the region of Alsace. Alsace had experienced a complex history of foreign invasion that created a heterogeneous population of divided loyalties, of German and French speakers, of Protestants and Catholics.

More recently, France had undergone the most tumultuous period in its history: the first revolution, the first republic, the first empire, the entire series of Napoleonic wars and the restoration of the monarchy. By the time Farny was born, the emerging French middle class, which would have included the Farnys, was divided in its loyalty to republican or monarchical forms of government. Both the urban and rural poor lived in extreme poverty, suffering near-famine whenever crops failed.

Just months after Farny's birth, the French people once again protested the rule of kings and social inequity in the revolution of 1848.[6] The uprising lasted only three days, but the results were dramatic:

FIGURE 4
Alfred Jacob Miller, *The Yell of Triumph*, 1837, watercolor, 8 1/16 x 12 3/8 in. (20.5 x 31.4 cm). The Walters Art Museum, Baltimore, Maryland.

King Louis-Philippe abdicated the throne, while freedom of the press and freedom of assembly were instituted. Most remarkably, elections were held. Prince Louis-Napoleon Bonaparte, the nephew of Emperor Napoleon I, seized the occasion to return to France from exile. He was a dark horse candidate, but the middle class and provinces elected him president of the constitutional government of the Second Empire. If Napoleon's election was unexpected, the coup he staged in 1851, which ultimately established him as Emperor of France, was stunning. Subsequently, he pledged France to the old Bonapartist ethos of authoritarian order, ending a brief period of republican rule.[7]

Charles Farny had long been politically opposed to autocratic rule, whether by a king or, now, an emperor. According to an 1880 article in the *American Art Review*, Charles was "one of the Republican leaders of Alsace, and had taken so prominent a part in opposing the Napoleonic party that, after the *coup d'état*, he only escaped transportation to Cayenne by flight."[8] (Cayenne, in French Guiana, was the site of France's most wretched penal colonies, from which few prisoners returned.) To escape imprisonment, Farny left France with his family in September 1853 and sailed to New York City, arriving by October 25, when the death of their young son is noted.

The family soon moved to northwestern Pennsylvania, arriving in Warren in early January. Farny's sister traveled with them, apparently to join her husband, who already owned land near Warren. Charles declared his intention to become a United States citizen on January 5, 1854, and, because he had the means to purchase land, a deed was drawn the following day for a parcel of 165 acres, adjacent to an equal parcel of land owned by his brother-in-law.[9] Charles then opened a sawmill on Tionesta Creek, close to the headwaters of the Allegheny River.

By this point, the Farny clan would have experienced both the worst and best of political systems, moving from a monarchy to a frontier democracy. In America, the family lived what Farny senior had fought for in France: a democratic society in which his pursuit of happiness did not depend on the dictates or whims of authoritarian rule. The young Farny was raised by a father who had put himself and his family at enormous risk because of strongly held political beliefs. Charles Farny's commitment to social justice very likely prepared Henry Farny to recognize the suffering of marginalized groups, an awareness that would explain his later political sensitivity and impatience with government policy in regard to Native Americans.

Farny's experience as an immigrant is crucial to an understanding of his paintings. Immigration is not simply the process of moving from one place to another: it is a dramatic upheaval that designates a person as a "foreigner" or an "outsider." The ability to speak English was paramount to acceptance in the larger culture. It appears that Farny's parents quickly arranged for their children to learn English while they lived in rural Pennsylvania, hiring a tutor to live with them for three months each year.

Farny's political education did not end with what he learned from his family; the social turmoil the Farnys experienced in Europe was replaced by the ideological, economic, and racial tensions that led to the American Civil War. In 1859, after five years in Pennsylvania, the Farnys moved to Cincinnati, a major transportation center through which riverboats continually passed to and from the South.

Farny attended high school and grew to manhood in Cincinnati. He was fourteen when the Civil War broke out in 1861. After his father died, two years into the war, Farny left school to work, eventually serving an apprenticeship as a lithographer for Gibson & Company, where he drew scenes of Civil War battles.[10] While Cincinnati lay at some distance from the battlefields, it is reasonable to assume that Farny understood that the Union's stated goal of ending slavery—that is, of ending one group's absolute power over another group without power—rose from the same beliefs that had forced his family to emigrate from France.

Farny's political sympathies became evident the year the conflict ended, when he drew a satirical cartoon of Jefferson Davis, the defeated Confederate president, climbing through a fence in a woman's dress to escape capture and imprisonment by northern soldiers.[11] The cartoon was reportedly first published in a Cincinnati newspaper, but it also captured the attention of the popular magazine *Harper's Weekly*, where Farny was offered a contract as an illustrator. He would publish work in *Harper's* until the early 1890s.[12]

European Studies and Politics

Farny once again found himself in the midst of political unrest when he went to Europe in 1867, a decision vividly described in 1893 by Ed Flynn, a writer for the *Cincinnati Commercial Gazette*. "His health becoming precarious, his friend, Buchanan Reid [*sic*], then Minister to Rome, urged him to take a sea voyage and visit him in Rome. Not having the 'scads,' this was a difficult thing to do, but he finally secured passage on a schooner laden with tobacco, to Civita Vecchia, on the coast of Italy. He paid $50, all the money he had, for his 'passage.' Not being able to procure a passport, he was listed as a supercargo."[13]

Farny went to Europe to study art, which he did for a year in Italy before traveling to Germany, stopping for short periods in towns close to one another near the Rhine River. He was in the small town of Grafenberg, near Düsseldorf, by July 1868, when he briefly studied with Herman Herzog. Farny then returned to Alsace, visiting relatives in Colmar, before moving to Strasbourg for several months.

Farny's periods of study for the next several years are only intermittently documented, but his travels throughout Germany and France undoubtedly immersed him in yet another highly charged political environment. The political battles were in many ways the same ones Charles Farny had dealt with twenty-five years earlier, over what form of government should be instituted.[14]

The arguments played out, too, even in art circles. The Düsseldorf Art Academy was a magnet for American art students, many of them German Americans whose families had fled various Germanic cities because of political oppression, just as Farny's family had fled France. In the fall of 1868, Farny met Albert Bierstadt in Düsseldorf, where Bierstadt himself had studied a decade earlier, and the artist encouraged Farny to continue painting.[15]

Farny returned to the United States sometime around the outbreak of the Franco-Prussian War in July 1870—a war that must have particularly concerned Farny, for his native Alsace was ceded to Germany upon France's defeat in 1871. Whatever his opinion of Alsace's new allegiance, Farny returned to Munich for further study in 1873 and again in 1875.

Ye Giglampz

In the summer of 1874, having returned to Cincinnati, Farny teamed with Lafcadio Hearn, a young journalist who would later be known for his writings on Japanese culture, and for a brief time published *Ye Giglampz*. The self-described nature of the newspaper-sized publication appeared on the cover page: "A Weekly Illustrated Journal Devoted to Art, Literature and Satire." The irreverent heart of the journal is clear in the title itself, "Giglampz," apparently derived from schoolboy slang for "spectacles of huge and owlish description."[16] In other words, the journal reported on those of little vision and perhaps of foolish appearance, including members of the temperance movement, British society, organized religion, missionaries, spiritualism, physicians, and politicians.[17] Farny's cover illustration for the fifth issue of *Ye Giglampz* (fig. 5) reflects his lifelong sympathy for the downtrodden. This drawing, captioned "The Chicago Fire—'Only the Plebs,'" depicts a working-class family burned out of their tenement. The father sits despondently on scorched timbers. The mother stands with a baby in her arms, a young child standing to her left. The family's few possessions other than the clothes on their backs are in a bag on the ground. Poverty and desperation stare us in the face, making evident Farny's sensitivity to those who were without.

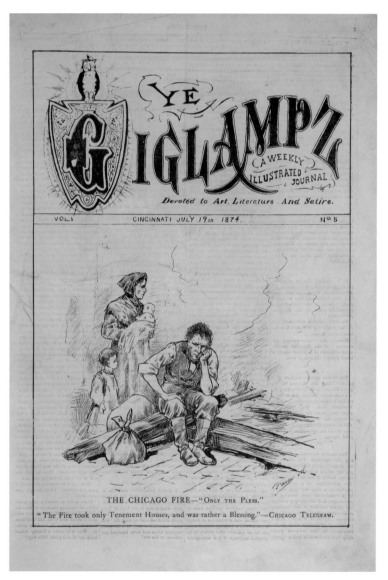

FIGURE 5
Henry Farny, title page from *Ye Giglampz*, July 19, 1874. From the collection of the Public Library of Cincinnati and Hamilton County.

Farny's Childhood Encounters with Indians

Farny did not visit the trans-Mississippi West until he was in his thirties, but he had been aware of the plight of Indian tribes and the consequences of reservation life since childhood. Once in America, the young boy transformed himself into a western hero, as can be seen in this thinly veiled self-portrait from his childhood sketchbook, *Daniel Boone at Age Fourteen* (fig. 6).[18] According to a later reminiscence, Farny's initial exposure to Indians was through tall tales, a significant oral tradition on the frontier.

> When I was a small boy my father ran a sawmill in the backwoods of the Upper Allegheny River, and our lumbermen used to tell weird stories of the Indians around the fire at night in the logging camps, to which I listened open-mouthed and awe stricken. . . . My idea of an Indian was that he was a bloodthirsty human ferret, noiseless and insatiable for gore, and the chief ambition of my life was to learn to swing an ax and become a dead shot with a rifle.[19]

However, the far more lasting impression of Indians came from his meeting with a former Indian hunter called Old Jacob:

> When I was chopping kindling in the woodshed one bitter cold day I heard a voice at my elbow suddenly say, "Little boy! Little boy!" and on looking up I beheld an Indian who had come in noiselessly For a moment I was paralyzed with fear, for I devoutly believed I was about to be made into a meat salad and then I let out a series of such blood-curdling yells that even the men in the sawmill heard me, and came running over to see what was up.[20]

The young boy responded as if he were seeing one of the bloodthirsty Indians out of the many fireside stories he had heard, but the truth was quite different. While the elderly Indian carried a rifle and a hatchet, he had actually come from a nearby Seneca reservation to beg for food. "Jacob was half starved, and my father took him in and made him sit down to dinner with us, and kept him over night."[21]

Farny describes a friendship between Jacob and himself, although when Farny describes the "beady eyes" of Seneca children his language recalls his earlier characterization of Indians as "human ferrets":

FIGURE 6
Henry Farny, *Daniel Boone at Age Fourteen*, n.d., pencil, 7 1/4 x 9 1/2 in. (18.4 x 24.1 cm). Current location unknown. Photograph courtesy of the Smithsonian American Art Museum.

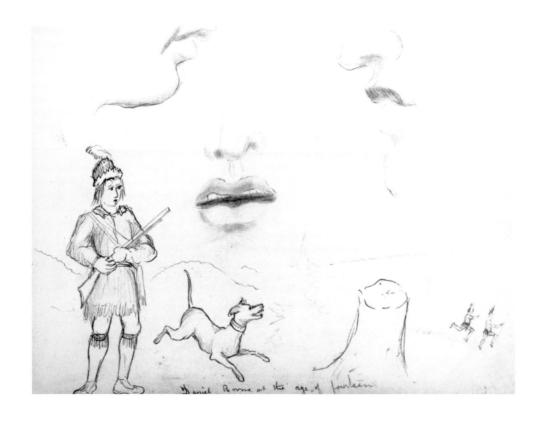

Of course, he and I became great chums. He would take me to his camp, show me how to make moccasins and bows and arrows, and later, when hunting parties of his tribe came near us he would take me to see the shy, unkempt children with beady eyes and though we could not speak together, we soon learned not to be afraid of each other.[22]

It is impossible to know whether Farny or his father knew the circumstances that led to the decline of the Seneca Indians and the poverty Old Jacob endured, but the history of the Seneca provides a classic example of the degradation Indian tribes suffered. The Seneca were one of the five tribes of the Iroquois Confederacy, a group that originally occupied much of New York State and adjacent territory in Canada. During the American Revolution, four tribes of the Iroquois Confederacy, including the Seneca, sided with the British, hoping to prevent American settlement in their lands. When the British lost, the Iroquois never recovered from the Americans' punitive destruction of their villages, fields, and orchards.[23] Contributing to the tribe's increasingly grim circumstances, a Seneca leader named Cornplanter signed a deed in 1788 ceding the extensive eastern half of Seneca lands to land developers Phelps and Gorham.[24] Cornplanter and his followers left New York, settling in nearby northwestern Pennsylvania, where Old Jacob lived in poverty many years later. By 1804, New York State had seized most of the remaining Iroquois lands, establishing the Buffalo, Tonawanda, and Cattaraugus reservations. Just over twenty years later, these reservations were dramatically reduced by approximately 75,000 acres by another land developer, the Ogden Company.[25]

Farny's First Trip West

Farny's awareness of the impoverishment of reservation Indians first becomes evident, in word and image, in 1881, following his first trip westward to Fort Yates. The fort was located on the Missouri River in what would become North Dakota. Farny also visited nearby Standing Rock Agency on the Great Sioux Reservation, established in 1868. Standing Rock was one of the federal agencies established on reservations to distribute food and goods to Indian groups in exchange for their agreement to remain on the land designated for their use. Farny painted *Crossing the Continent* following his trip, a work that gives hint to the often unsatisfactory transactions of ration day.[26] It was not uncommon for Indians to receive inadequate, bad, or unneeded goods. In the right foreground of *Crossing the Continent*, Farny includes a mounted Indian whose clothing refers to this circumstance. Instead of wearing the customary blanket, the man has improvised with a flour sack on which the letters "USID," i.e., property of the United States Indian Department, have been stenciled.

In 1884, Farny traveled westward in company with journalist Eugene V. Smalley. The men had been commissioned by *Century Magazine* to illustrate and write an article describing their trip down the Missouri River from Helena, Montana, to the Great Falls of the Missouri. Smalley's long article is an inviting travelogue spiced with a few adventures, until the passage in which he and Farny reach Fort Benton, near Bismarck, when his light tone abruptly changes:

> Near the town [Bismarck], we visited the camp of a dozen lodges of Piegan Indians, who had come to stay all winter for the sake of such subsistence as they could get from the garbage-barrels of the citizens. A race of valorous hunters and warriors has fallen so low as to be forced to beg at the back doors for kitchen refuse.[27]

Farny, too, commented on what he had witnessed at Fort Benton, sharply observing in the *Cincinnati Enquirer* that federal Indian policy was nothing more than "a mixture of sentimentality and cupidity, and between the two we are making them tramps and dead men."[28] As had that of other tribes, Piegan survival had become centered on the government ration house.[29] An observation made by Farny more than thirty years later contained the same ire, although changes on the Plains over that time now included the intrusion of the cowboy as well. "It breaks my heart to see the prairies cut up with barbed wire, and to see the once noble Red Man debauching himself with fire water on the reservations. The golden West isn't what it used to be."[30]

Western Expansion and Indian/White Conflict

The rapid pace of western exploration and white settlement provides additional context for Farny's unique construction of Indian life. Although Indian trails had long been established, the Lewis and Clark expedition of 1804–05 yielded maps that whites would need to traverse the northern Plains and Northwest. Other expeditions followed Lewis and Clark, each identifying natural resources that invited future settlement and development, from farming to mining. By the mid-1840s, four to seven thousand people a year were traveling in caravans on the long and difficult Oregon Trail. In 1847, Brigham Young inaugurated the Mormon Trail, leading 148 pioneers to what would become Salt Lake City; 2,500 emigrants followed the next year. The Santa Fe Trail, initially a commercial route, soon was swelled by settlers, the experience well publicized by Josiah Gregg's classic 1844 account of the trail, *Commerce of the Prairies*.[31]

Between 1846, when President James K. Polk, a vigorous expansionist, negotiated the acquisition of the Oregon Territory, and 1848, when Polk's successful prosecution of the Mexican War resulted in the cession of New Mexico and California, the United States added to its territory vast new lands extending west from Texas to California and north to Oregon. The trans-Mississippi West now appeared to Americans to be free land, ripe for possession.

The original inhabitants of the continent, the Indians, thought otherwise. As a Seminole warrior is reported to have said in 1839, during the Second Seminole War: "Let us alone and we will not molest you—remain at your posts or your homes, and we will not attack you—but if you make war on us, we will fight as long as our ammunition lasts, and when this is gone, we will take to the bow and arrow."[32]

FIGURE 7
Carl Wimar, *The Attack on the Emigrant Train*, 1856, oil on canvas, 55 1/16 x 79 1/16 in. (139.9 x 200.8 cm). Bequest of Henry C. Lewis, 1895.80. © The University of Michigan Museum of Art, Ann Arbor, Michigan.

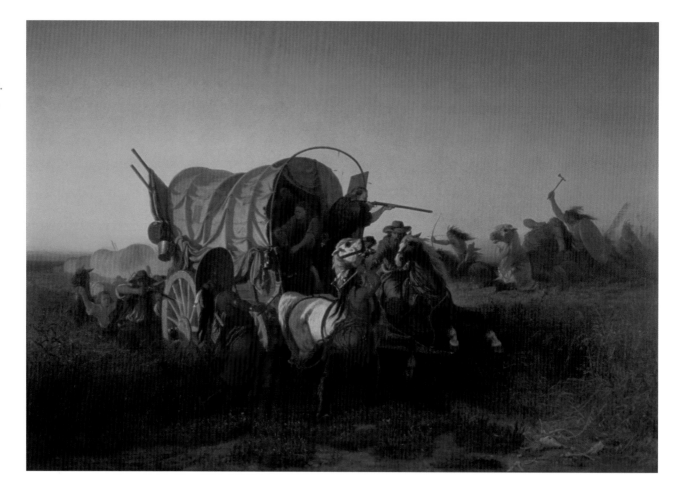

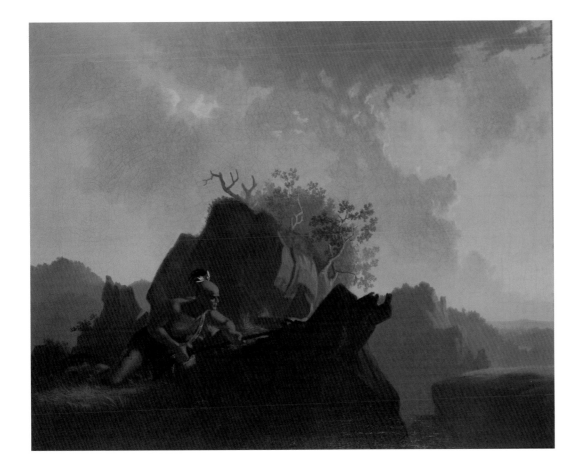

FIGURE 8
George Caleb Bingham, *The Concealed Enemy*, 1845, oil on canvas, 29 1/4 x 36 1/2 in. (74.3 x 92.7 cm). Stark Museum of Art, Orange, Texas, 31.221/1.

Not surprisingly, Indians resisted encroachment on what they held to be their lands, now crossed by thousands of emigrants. By the 1850s, war developed with the Plains Indians; later, Northwest and Southwest tribes resisted white settlement, and U.S. army actions, fighting into the 1890s. With these conflicts, Indians were no longer seen as children of the forests but as dangerous savages who willfully, and supposedly without provocation, obstructed white settlement. At this point, paintings of Indian and white conflict replaced earlier images of Native Americans as "noble savages" living in idyllic settings as if the white man had not yet arrived on the continent.

Carl Wimar (1828–1862), whose family had emigrated to St. Louis from Germany when he was sixteen, returned to his native country to study in Düsseldorf in the mid-1850s. Wimar's dark skin and hair led Germans to believe he was an Indian himself, and his costumed performances of Indian dances before his fellow artists only enhanced his supposedly native identity. While in Düsseldorf in 1856, Wimar painted *The Attack on the Emigrant Train* (fig. 7), a subject inspired by current Indian and white conflict in the West. In this scene of a caravan attacked by Indians—now portrayed as bare-chested savages—the battle clearly will be won by the pioneers, whose guns outmatch the tomahawks and bows and arrows of their enemies. Another image typical of this period was painted by George Caleb Bingham (1811–1879), whose studies in Düsseldorf briefly coincided with Wimar's. Barbara Groseclose describes *The Concealed Enemy* (fig. 8) as it would have initially been understood. "An Osage warrior crouches behind a boulder, menace in his scowling face and tightly grasped weapon. His intended victim, doubtless imagined to be a white settler by most of Bingham's contemporaries, is more vividly imperiled because unseen. Long shadows of sunset heighten the sense of dramatic anticipation, as do the nervous outlines of the rocks and scrubby vegetation. Deceitfulness in his concealment, violence in his intentions, and wildness in his lair sum up the Indian's savage traits and, by way of association, the dangers of the uncleared forest."[33]

The Concept of the Doomed Indian

It is in the context of Indian and white conflict and the belief that Indians now deserved their fate that images of the vanishing race developed. Horace Greeley, for example, used the power of his own newspaper, the *New York Tribune*, to espouse his ardent support of western expansion. Like many, though not all expansionists, Greeley's vision allowed for extermination of Indians, and he articulated, with evident hatred, the beliefs of many Americans: "These people must die out—there is no help for them. God has given this to those who will subdue and cultivate it; and it is vain to struggle against his Righteous decree."[34]

While Greeley's viewpoint was based in religious belief and shaped by political opinion, other causes were given for the Indian's ill fate. It was common in the nineteenth century and even earlier to believe that the Indian would inevitably disappear in the face of westward expansion and settlement. The cause might be identified as differing racial constitutions, an idea fostered by the scientific community in an ethnocentric belief in the superiority of the Caucasian race. Others believed that the displacement of the Indian was the result of historical inevitability that necessarily led humankind to ever more advanced forms of civilization—those that valued agrarian lifestyles, fostered progress, and practiced Christianity. In other words, Native Americans, who were hunter-gatherers, who valued the continuity of long-standing traditions rather than progressive change, and who practiced religions that the dominant culture identified as superstitions, simply would perish as civilization advanced.

The idea of the "doomed" or "vanishing" Indian appeared in literature, particularly in poetry, before it did in the visual arts. A favored metaphor described the Indians melting in the face of the sun's heat, as in the 1824 poem by William Cullen Bryant, "An Indian at the Burial-place of his Fathers":

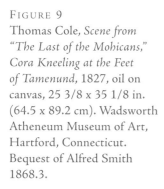

FIGURE 9
Thomas Cole, *Scene from "The Last of the Mohicans," Cora Kneeling at the Feet of Tamenund*, 1827, oil on canvas, 25 3/8 x 35 1/8 in. (64.5 x 89.2 cm). Wadsworth Atheneum Museum of Art, Hartford, Connecticut. Bequest of Alfred Smith 1868.3.

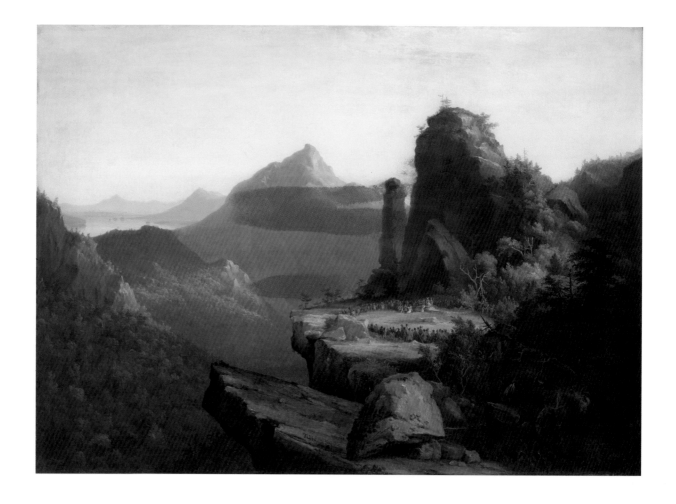

They waste us—ay—like April snow

 In the warm noon, we shrink away;

And fast they follow, as we go

 Towards the setting day,—

Till they shall fill the land, and we

Are driven into the western sea.[35]

Frank Mayer, who studied with Alfred Jacob Miller in Baltimore and made one trip west in 1851, addressed the same issue with less sentimentality. "The aboriginal inhabitants of this great continent are fast yielding to the more powerful race now peopling their ancient domain. The time indeed is not distant when few will remain to instruct us in their customs, arts and polity."[36]

Visual images did not long lag the written word. Thomas Cole (1801–1848) painted *Scene from "The Last of the Mohicans," Cora Kneeling at the Feet of Tamenund* (fig. 9) in 1827, a year after James Fenimore Cooper published his classic novel of the same title. The central scene within the larger painting depicts the heroine, Cora, pleading with the Delaware sachem, Tamenund, to spare her sister from the threatening Magua. However, the painting, like other elegiac subjects of the Indian in the early nineteenth century, was primarily viewed as a magnificent landscape. Cole's patron Daniel Wadsworth (founder of the Wadsworth Atheneum) wrote Cole in admiration of the "deep Gulfs, into which you look from *real* precipices,—the deep heavenly serenity of the firmament, contrasted with the savage grandure, & wild Dark Masses of the Lower World,—whose higher pinnacles only, catch a portion of the soft lights where all seems Peace, . . ."[37]

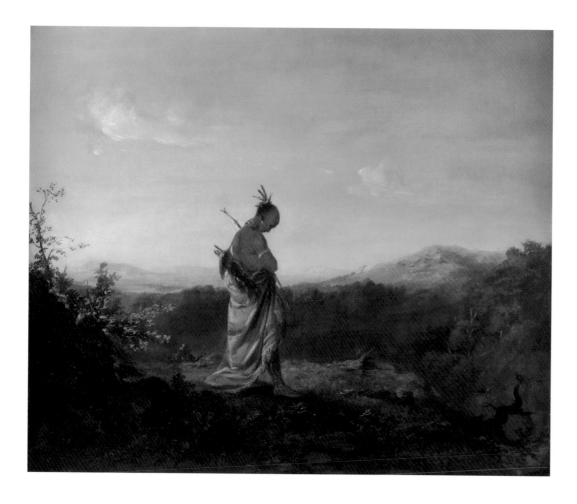

FIGURE 10
John Adams Elder, *The Last of His Tribe*, 1860–75, oil on canvas, 25 x 30 in. (63.5 x 76.2 cm). O-M4. Valentine Richmond History Center, Richmond, Virginia.

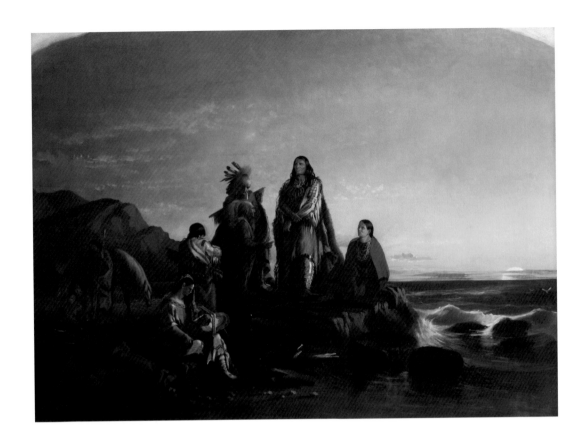

In 1846, John Adams Elder (1833–1895), another Düsseldorf student, painted *The Last of His Tribe* (fig. 10), in which a lone figure stands motionless at the end of a cliff, overlooking an abyss. His bowed head and stooped shoulders express utter dejection. Even the blanket wrapped around him is sliding downward. The sun has set and night approaches—not just the end of the day, but the end of a people. The elements of this painting are much the same as in other depictions of this theme. John Mix Stanley (1814–1872), who traveled the West for ten years beginning in 1841, painted *Last of Their Race* (fig. 11) in 1857. The extended family of multiple generations stands for the race itself. A mother holds a baby swaddled in a cradleboard. To the left of her, a young boy stands to assist an elder of the group, who kneels before the current chief. The chief directs his gaze inland, toward the locus of the past, and not to the distant horizon, symbolically the future. Again, it is the end of the day. These paintings look almost as if they could be illustrations for either the William Cullen Bryant poem or "Indian Warrior," by P. M. Wetmore, published in 1839:

> A stranger race had sprung
> Like Phantoms on his sight—the white men came,
> His lands were gone—he quaffed the liquid flame,
> Till madness round him clung.
>
> The twilight found him there,
> The moon went down upon the desolate one,
> And morning came—the wandering chief was gone
> To die in his despair![38]

Indian Images and Reservation Life

For a time following the Civil War, monumental landscapes of the West's natural wonders dominated western American art. The Indian appeared once again as a full-fledged painting subject in the 1880s, when Indian policy, and popular attitudes toward Indians, had become yet more complex. Two separate federal policies that had derived from religious charity, political necessity, and popular belief together served to engender the reservation system.

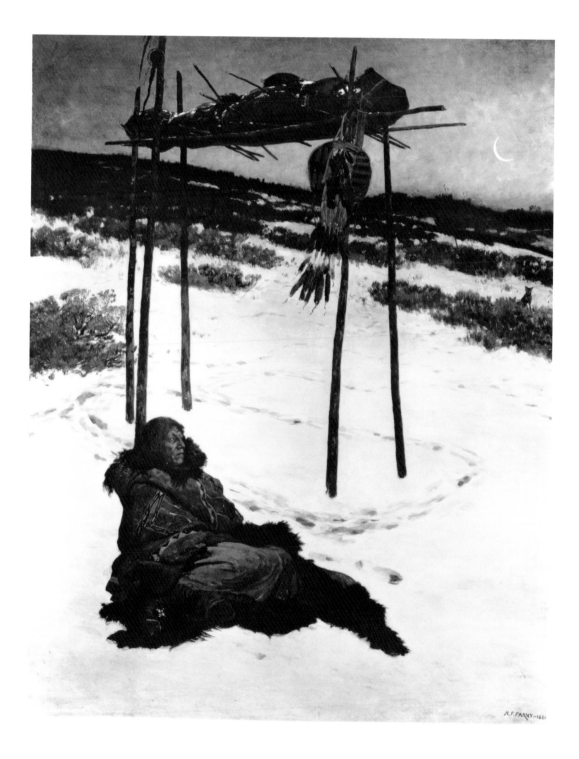

FIGURE 12
Henry Farny, *End of the Race*, 1881,
oil on canvas, 49 x 39 in. (124.5 x 99.1 cm).
George A. Rentschler Collection.
Photograph courtesy of Denny Carter Young.

Early in the nineteenth century, President Andrew Jackson had argued for the separation of the races, an idea that became federal policy after passage of the Indian Removal Act in 1830. The act sanctioned forcible relocation of sixty thousand Indians from their traditional lands to a newly designated Indian Territory located on the Plains in present-day Oklahoma, causing the death of thousands of Indians en route and untold misery for the survivors. The development of the reservation system in the late 1860s was a re-statement of this policy of removal, but with a significant difference. President Ulysses S. Grant proposed a "peace policy," arguing for humane treatment of the Indians.

The policy was largely carried out on newly formed reservations through missionary agencies that ran boarding schools, sometimes on the reservation, sometimes distant. Tribes agreed to move to reservations with the understanding that the government would provide them with food and supplies, particularly since traditional means of subsistence had disappeared.

The reservation system, however, proved to be no more humane than any other Indian policy, and corruption, indifference, and ignorance severely undermined supplies. Moreover, the Indian schools, in which English was mandatory and children who spoke their own language were punished, were a final attempt to strip Indian children of their traditions. Significantly, it was the refusal of Native Americans to learn English (and become Christian farmers) that led to the establishment of these boarding schools.

The Indian that Farny met in his travels was living the consequences of reservation life. In response, Farny created paintings that were as mournful as earlier versions of the doomed Indian. After his 1881 visit to Fort Yates, he created *End of the Race* (fig. 12). The subject is a death watch or vigil. A number of tribes did not bury their dead in the earth, but placed them on high scaffolds out of reach of animals, like the wolf seen to the right in the distance. In this scene, a woman sits next to the scaffold in the cold snow, wrapped in thick winter buffalo skins. Earlier artists too had been fascinated by the custom of scaffold burial, but their images are colored by scientific inquiry or exotic appeal without dramatically signaling the end of an entire race, as seen in Stanley's *Chinook Burial Grounds* (fig. 13).

The theme of extinction is explicit in Farny's *End of the Race*, but he also developed other images that implicitly communicate the same message of deterioration and decline. *Winter Encampment of the Crow Indians* (fig. 14) is an anecdotal painting that depicts a small group of tipis. To the right, a young woman is bent over by a heavy load of wood she carries. Behind her to the left, strips of meat hang from

FIGURE 13
John Mix Stanley, *Chinook Burial Grounds*, ca. 1870, oil on canvas, 9 1/8 x 14 1/8 in. (23.2 x 35.9 cm). Gift of Mrs. Blanche Ferry Hooker. Photograph © Detroit Institute of Arts.

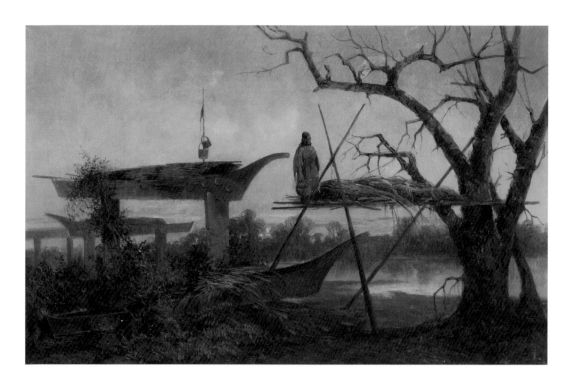

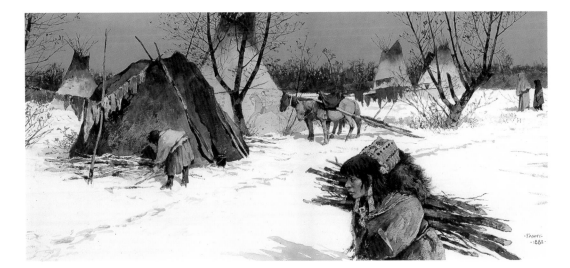

Figure 14
Henry Farny, *Winter Encampment of the
Crow Indians*, 1882, watercolor and gouache
on paper, 13 x 27 1/2 in. (33 x 69.9 cm).
Private Collection, Montana. Photograph
courtesy of the Thomas Nygard Gallery,
Bozeman, Montana.

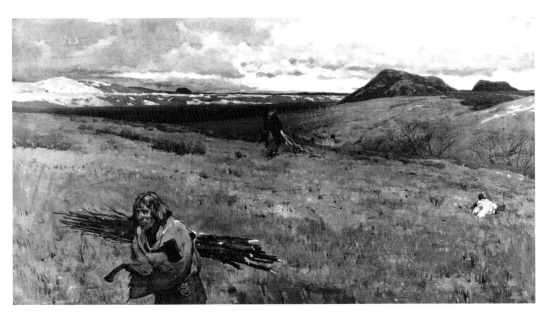

Figure 15
Henry Farny, *Toilers of the Plains*, 1882,
oil on canvas, 22 3/16 x 40 in. (56.4 x 101.6 cm).
Current location unknown. Photograph,
Cincinnati Art Museum Archives,
Mary R. Schiff Library.

a pole in front of an open cooking tent, where another woman bends over what appear to be iron pots. Another version of the subject, *Toilers of the Plains* (fig. 15), is a distillation of the significance of *Winter Encampment* minus anecdotal detail. The colors in *Winter Encampment* are naturalistic, a blue sky and brown earth. In contrast, the muted colors of *Toilers* are used to create a dark mood, a kind of editorial comment. In the foreground, an older woman hauls a heavy load of firewood on her back, her figure cut off by the lower edge of the painting. While this painting might initially appear to be a scene of everyday life, illustrating the kind of realism often attributed to Farny, it is much more than that. The advanced years of the foreground figure emphasize the drudgery of the work; her cropped hair might even indicate that she is in mourning. The women who trudge behind her are evidence of the endless, repetitive nature of the task. A buffalo skull is seen to the right, a symbol often used by artists to signify not only the end of the buffalo, but the end of the Indian as well.

Although painted in 1893, the subdued colors and mood of *New Territory* (fig. 16) are much the same as in the Fort Yates paintings. The territory certainly is an unpromising expanse of land where the buffalo no longer roam. An Indian family is shown at a standstill in front of a barely visible wagon road parallel to them in the foreground. The mounted father looks to his left; the mother on foot looks to her right.

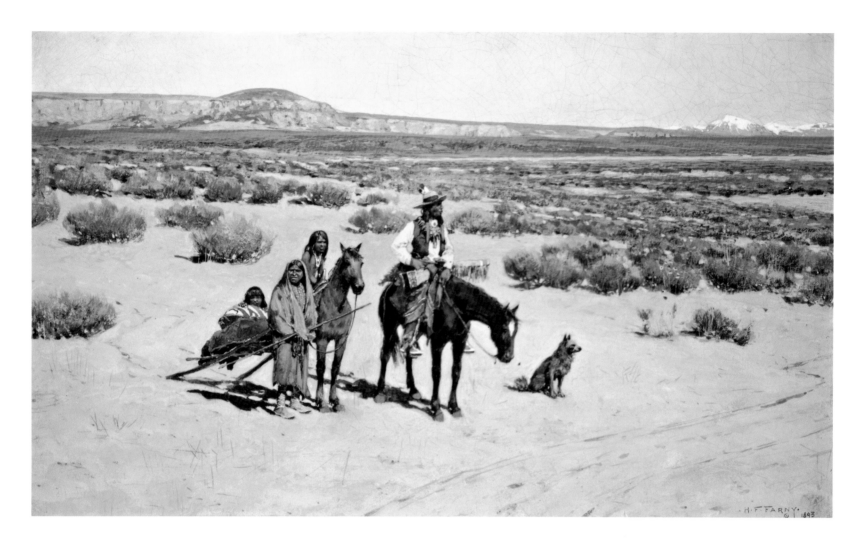

The two children look nowhere in particular. In fact, Native Americans often found themselves in new territory, when they were relocated to Indian Territory in the 1830s and 1840s and later to reservations. Traditionally Indians knew the land they occupied or traveled in great detail. The idea that a family would travel alone and not know which way to turn is as shocking as it is poignant, but relocated Indians typically were unfamiliar with their new locations in every way, from geography to subsistence to water to game. They also were likely to meet with hostility from tribes who had traditionally inhabited the land.

The Indian and the Railroad

Following his second trip to the West in 1883, Farny developed a subject he was to paint repeatedly, one that makes clear the cause of the Indian's demise. On this trip he traveled in luxury as part of an entourage of 350 dignitaries from the United States and abroad invited by Henry Villard, president of the Northern Pacific Railroad, to witness the driving of the last spike joining the eastern and western divisions of the Northern Pacific's transcontinental railroad line. En route to the ceremony site outside Missoula, Montana, the excursionists disembarked in Grey Cliff, Montana, near the Crow Reservation. While there Farny witnessed a nighttime scene that he painted in shades of black, white, and gray, *A Dance of Crow Indians* (cat. 1), for reproduction as a wood engraving in *Harper's Weekly* (fig. 36, p. 54).

He vividly contrasted the gas lights from Villard's excursion train seen in the background to the Indians dancing around a fire, a symbolic comparison of modern and primitive life accentuated by the sleek, rectangular form of the train and the irregular shapes of the dancers lit by fire. The magazine added a vivid accompanying text, which notes the contrast: "Never had the extremes and highest types of savage and civilized life been brought together as on the unique occasion, when the dandified habitués of Pall Mall and spectacled German 'Philistine' elbowed the painted warriors of the plains. The lurid light of the camp fires, deafening drum-beat, jingling bells of the dancers, and the weird monotonous chant of the singers were echoed by the whistle of the locomotive."[39]

Farny went on to create a number of paintings that contrasted rail travel and horse-mounted Indians, participating in the belief that inventions of the future would inevitably displace the Indian. Diverging moods characterize three of Farny's images on this theme. The Indians in *The White Man's Trail* (fig. 17) could be a small war party, given the feather warbonnets, guns, and the gesticulating fists raised at the passing train. But it is evident the group has stopped suddenly—the heads of two of the horses are still jerked back, as their riders have turned to look at the passing train. The train travels in one direction, the Indians in another, literally and symbolically. It appears that the war party has been defeated before it has even begun. In contrast, *The Coming of the "Fire Horse"* (cat. 36) is a wild and carefree race with the approaching train, which runs beside additional signs of oncoming civilization— telegraph poles and lines. In the front of the riders, one Indian turns to his riding companion with a smile, the reins of his horse loose, while other riders lean forward to speed their mounts.

But the quintessential image of this theme, the ironically titled *Morning of a New Day* (fig. 18), was also painted later in Farny's career, in 1907. In the foreground, an Indian party travels a narrow mountain trail in winter, not a customary time of travel among the Indians. The men ride, the women walk. All ages are represented, from young babies carried on their mothers' backs to an elderly figure with a

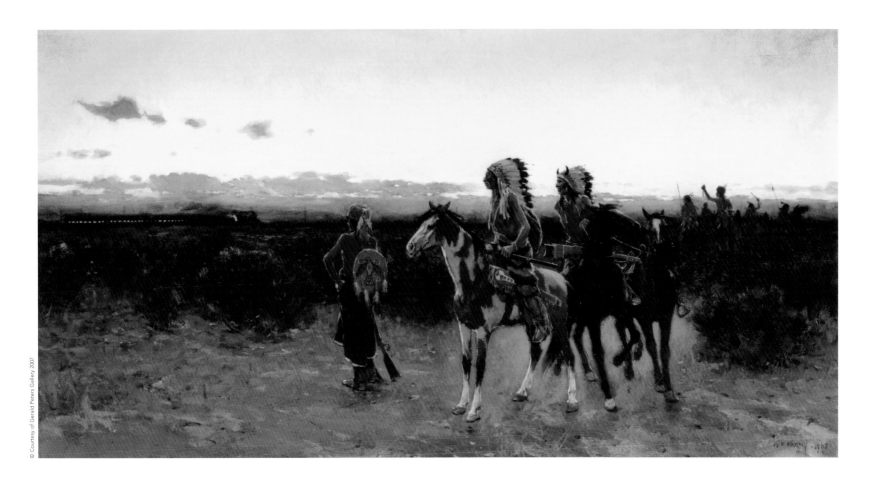

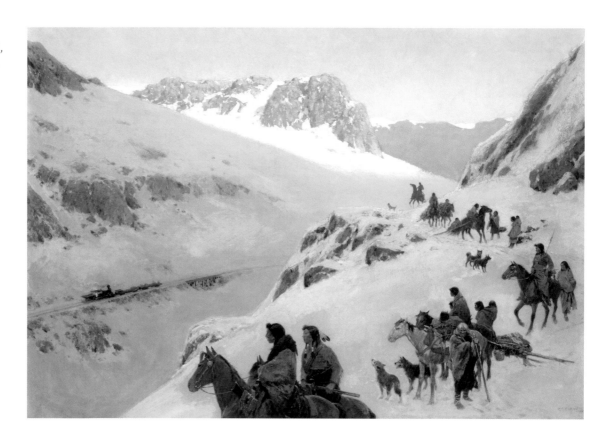

walking stick to the right. Many heads are turned to look at the train below. William H. Truettner identifies the implicit message in an analysis of this painting. "At first glance, the painting seems easy enough to understand: It says, in effect, that the West . . . is changing. A New West, symbolized by the railroad train cutting across the landscape, is replacing an Old West, spelling hardship and eventual doom for the Indian tribes that inhabit the region."[40] Truettner deepens the interpretation of the painting by identifying the engine and the four flatcars it pushes as ones used in the 1860s by the Union and the Central Pacific Railroads to lay and test new track. He goes on to argue that the Plains Indians depicted by Farny are not those warrior Indians who would have deliberately torn up track in the period the train suggests, but are "their weary descendants, trudging through deep snow toward an uncertain destination."[41] By the time Farny created this image, there was little belief that the Indian would embrace the inventions of progress.

In 1894, General Nelson Miles, a master of Indian warfare who had captured the great Apache warrior Geronimo just eight years earlier, invited Farny to accompany him on an inspection tour of a Kiowa and Comanche reservation on which Apache lived as well. By the time Farny visited General Miles at Fort Sill, the Comanche and Plains Apache had been persuaded under the 1887 General Allotment Act, or Dawes Act, to break up their reservations and accept 160 acres per family, while the remaining land would inevitably be sold by the government to white settlers and developers. Philanthropic groups had promoted the Dawes Act in a deliberate effort to overthrow tribalism and communal organization by fostering the growth of individualism and privately owned land. No greater proof of the resulting disintegration of tribal integrity could have been evident to Farny than at Fort Sill, where the legendary Geronimo now sold pictures of himself, and small bows and arrows with his name on them, as souvenirs.[42] Farny's drawing of Geronimo includes an autograph, one that the artist presumably paid for (fig. 19). But after all, in 1885 Sitting Bull had joined the Buffalo Bill Wild West Show to play himself.

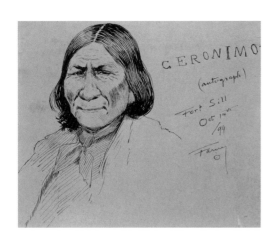

Indians in Winter

Farny often portrayed Native Americans in winter. Although these are not explicitly paintings of the ill-fated Indian, Indians are not often depicted in winter by other western American artists, with the exception of Peter Rindisbacher (1806–1834), whose immigrant family had lived through frigid winters in Canada. Winter is symbolically the season of absence and death, the season when animals hibernate and nature disappears. Many Plains Indian tribes settled in one place in the winter, with the exception of necessary hunting trips undertaken by the men and an occasional move if their horses' grass ran out.

In Farny's winter paintings, the cold sits heavily, almost palpably, on his subjects, as in the work *In the Valley of the Shadow* (fig. 20). The severe cold is emphasized further, as a rider to the right pulls a blanket across his face for protection against the frigid temperatures. It is clear that the Indians are on the move, yet each appears immobile. The discomfort of the scene is intensified by the imminent disappearance of the group that will soon ride out of the scene at the bottom on the picture. One cannot help but admire their ability to endure, but the overall mood is deeply somber and devoid of energy.

One painting encapsulates all the visual language Farny developed to communicate the fate of the Indian: *The Song of the Talking Wire* (cat. 32), in which a single Indian stands in winter snows, his ear pressed against a telegraph pole. With the exception of his rifle, the subject's appearance establishes his close ties to traditional Indian life: he wears a single feather in his hair and is wrapped in a decorated buffalo robe, with beaded moccasins on his feet. The telegraph lines and pole represent American progress, led by the inventions of the industrial age. Living by the hunt and not through agriculture as whites advocated, the cold, gray weather and deer slung over his nearby horse underscore the message of the "doomed Indian."

Farny's career unfolded at the same time that American Indians were literally driven to the end of their endurance, and reservation life neared its lowest point. But no one else painted what Farny painted. Artists trained in Düsseldorf portrayed the Indian as a savage, picturesque figure, or as a foil to indicate

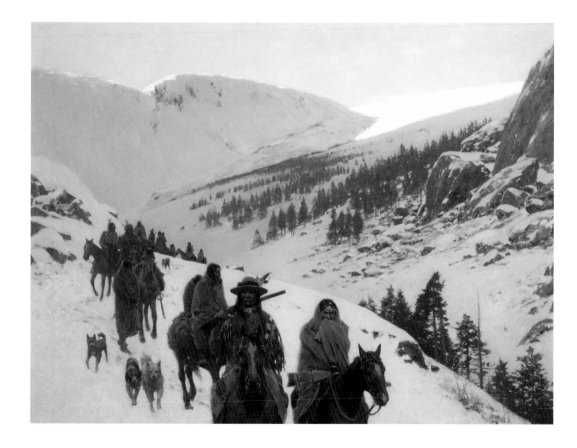

FIGURE 20
Henry Farny, *In the Valley of the Shadow*, 1895, oil on canvas, 21 x 30 in. (53.3 x 76.2 cm). Queen City Club, Cincinnati, Ohio.

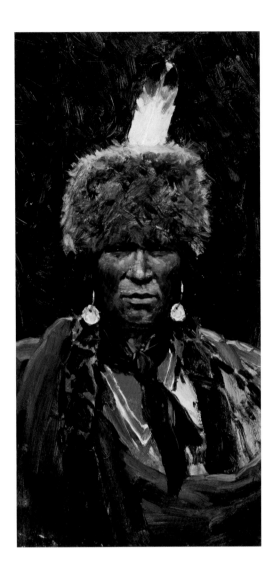

the progress that white America had made. These artists included George Caleb Bingham, William Hahn, Emanuel Leutze, Henry Lewis, Worthington Whittredge, Carl Wimar, and Albert Bierstadt. More generally, Frederic Remington, Charles Schreyvogel, and Charles Remington illustrated dramatic scenes of Indian and white conflict that were in direct contrast to Farny's work. There also were the aforementioned portrait painters, Burbank and Sharp, whose Indian portraits would end up in anthropological collections.

In 1898, an artists' community began to form in Taos, New Mexico, where the artists would paint the peaceful lifestyle of the Pueblo Indians. Farny's artistic practices, though not his paintings, were most like those of the Taos Society of Artists, particularly Bert Phillips, Eanger I. Couse, and Joseph Sharp. Some of the Taos artists employed models who served as handymen as well as muses. Phillips's favorite model, Michael Mondragon, was also known as Tudl-Tur or "Sunshine on the Mountains." Farny had a favorite model, "Joe," painted here in 1902 as *Chief Ogallala Fire* (fig. 21), who worked as Farny's part-time servant and as a janitor for the Cincinnati Art Club.[43] In 1898 and 1899, Joe also modeled for Sharp, who wintered in Cincinnati with his school-aged children but was better known for his paintings of Pueblo Indians in Taos, where he summered. Sharp and Couse also had favorite models who worked for them at various odd jobs.

Like Couse and Phillips in particular, Farny relied on photographs he took during his western travels, rather than on consistent first-hand observation. On these trips, he also acquired numerous Indian artifacts, just as other artists had done before him, including the Taos artists who hung an array of Pueblo Indian and Hispanic objects on their walls. A Cincinnati newspaper writer noted Farny's Indian collection with some glee. "[Farny] gazes on his photographs of Indians; he draws Indians, he paints Indians, he sleeps with an Indian tomahawk near him, he lays greatest store by his Indian necklaces and Indian pipe, he talks Indian and he dreams of Indian warfare."[44]

FIGURE 21
Henry Farny, *Chief Ogallala Fire*, 1902,
oil on wood panel, 12 x 6 in. (30.5 x 15.2 cm).
Photograph courtesy of the
Gerald Peters Gallery.

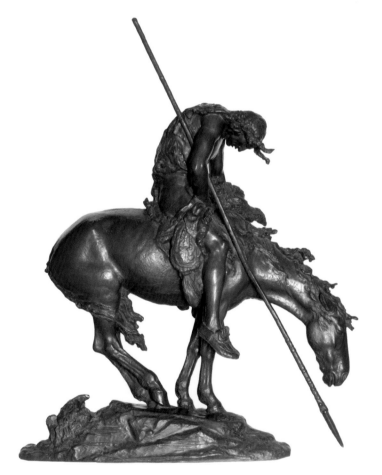

FIGURE 22
James Earl Fraser, *The End of the Trail*,
ca. 1894, bronze, 44 x 37 1/4 x 11 1/2 in.
(111.8 x 94.6 x 29.2 cm). © Gilcrease Museum,
Tulsa, Oklahoma.

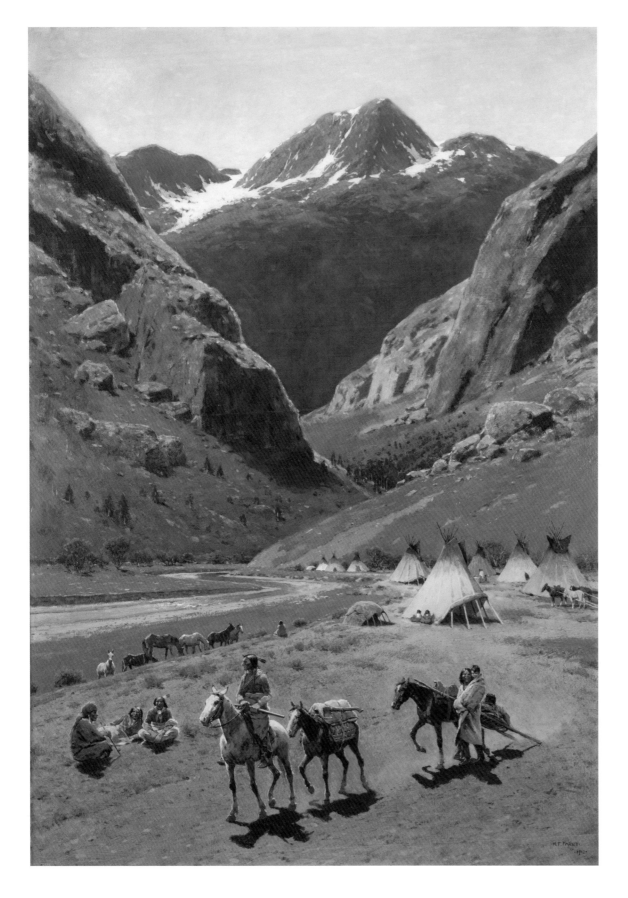

Figure 23
Henry Farny, *Happy Days of Long Ago*,
1912, oil on canvas, 33 1/16 x 22 3/4 in.
(84 x 57.8 cm). Current location
unknown. Photograph, Cincinnati Art
Museum Archives, Mary R. Schiff
Library.

Like some of the Taos painters, Farny sometimes spoke of Indians and the West as great painting subjects, but not as individuals, tribes, or places. Describing eastern South Dakota, he wrote, "The plains, the buttes, the whole country and its [Indian] people are fuller of material for the artist than any country in Europe."[45]

But finally, it was the sculptors in the latter part of the nineteenth century that Farny shared the most with, at least in terms of a common theme, if not in the conceptualization of that theme. Farny painted in the same age in which American sculptors created monumental, multi-figural works in bronze and marble of the vanishing Indian, variations on the image appearing in the work of Henry Kirke Brown, Alexander Stirling Calder, Horatio Greenough, Augustus Saint-Gaudens, Randolph Rogers, Adolph Weinmann, and others, who created works with such titles as *The Dying Tecumseh*, *The Fallen Warrior*, *The Last Arrow*, and *The Dying Indian*. Sculptures such as these, and the stereotype that remains with us today—*The End of the Trail* (fig. 22), by James Earle Fraser—were apparent everywhere. What is perhaps most striking about these images is their display in public parks and buildings, the image a commonplace means of communicating the necessary submission of the supposed primitive past to give rise to American civilization.

Farny lived a comfortable and satisfying life in Cincinnati. The distinguished Kansas historian Robert Taft, Farny's first biographer, described him as a charming, outgoing man of presence: "A huge man, over six feet in height, broad shouldered, bulky in the waistline, an inveterate storyteller, renowned as an after-dinner speaker, a man with innumerable friends, alike with interests in life; such is an epitome of Farny in his prime."[46]

Farny loved good times, especially when acting in the comic plays he wrote for presentation at the Cincinnati Art Club, where he twice served as president, and the German pubs. And he certainly was not shy about donning a variety of costumes, whether as a troubadour, Robin Hood, a Japanese warrior, or Samson about to destroy the infidel's temple built from shoeboxes he painted.[47] The paintings that Farny is best known for arose from this part of his personality, those paintings that imagine the halcyon days of an Indian past, as witnessed in the sunlit painting, *Happy Days of Long Ago* (fig. 23).

But alongside paintings like *Happy Days of Long Ago*, Farny's upbringing in a politically aware family, and his familiarity with the conditions of Indian life on the reservations, shaped a number of the images he created like none painted by any other western American artist. If Farny's Indian figures appear immobilized, so were the reservation Indians whose lives he witnessed. Federal rations had replaced wild game and plants. Increasingly, log cabins replaced wigwams, clothing was store-bought, and English and Christianity taught in boarding schools eroded spiritual traditions and language. While tribal governance and customs certainly would not disappear, the past could never be revisited—except in art.

* *

Epigraph: Henry Farny, quoted in "Henry F. Farny, Noted Painter of Indians, At Work in His Studio," *Cincinnati Commercial Tribune*, January 23, 1910, 8.

1. George Catlin, *Letters and Notes on the Manners, Customs, and Conditions of the North American Indians; Written during Eight Years' Travel (1832–1839) amongst the Wildest Tribes of Indians in North America* (London: D. Bogue, 1844; reprint, with an introduction by Marjorie Halpin and photographic reproductions of paintings in the Catlin collection of the United States National Museum, New York: Dover Publications, 1973), 6.

2. Quoted in Marlou J. Quintana, *The Realistic Expressions of Henry Farny* (South Bend, IN: University of Notre Dame, 1981), 11.

3. *Illustrated Catalogue of the Art Department, Tenth Cincinnati Industrial Exposition, 1882* (Cincinnati: Robert Clarke & Co., 1882), 25.

4. Ibid.

5. Thomas Donaldson, *The George Catlin Indian Gallery in the U. S. National Museum (Smithsonian Institution) with memoir and statistics* (Washington, D.C.: Government Printing Office, 1887), 217.

6. Violent political uprisings to abolish rule by hereditary dynasties and establish more democratic forms of government had been fundamental to the French or Great Revolution of 1789 and then the July Days of 1830.

7. See "Empire and Siege" in Alistair Horne, *La Belle France: A Short History* (New York: Alfred A. Knopf, 2005), 258–88.

8. George McLaughlin, "Cincinnati Artists of the Munich School," *American Art Review* 2, no. 13 (November 1880): 1. Also, the searchable online database for Castle Garden, the main U.S. immigration center prior to the establishment of Ellis Island, shows the Farny family's arrival on October 19, 1853. http://www.castlegarden.org

9. Denny Carter, *Henry Farny* (New York: Watson-Guptill Publications in association with the Cincinnati Art Museum, 1978), 15, 203 notes 3–8.

10. Charles Baltzer, *Henry F. Farny* (Cincinnati: Indian Hill Historical Museum Association, 1975), not paged.

11. McLaughlin, "Cincinnati Artists of the Munich School," 1.

12. Carter, *Henry Farny*, 16.

13. "Something about the Career of the Eminent Cincinnati Artist," *Cincinnati Commercial Gazette*, March 14, 1893. Thomas Buchanan Read, not "Buchanan Reid," was a Cincinnati painter and artist who offered Farny lessons in Rome for about a year. I can find no evidence of his having been "Minister to Rome."

14. See "Nationalism in Search of a Mass Audience, 1819–1871," in Stefan Berger, *Germany, Inventing the Nation*, vol. 5 (London: Arnold, 2004), 47–75.

15. Nancy K. Anderson and Linder S. Ferber, *Albert Bierstadt: Art and Enterprise* (New York: Hudson Hills Press in association with the Brooklyn Museum of Art, 1991), 186; Carter, *Henry Farny*, 16–17.

16. Ewell L. Newman, "The Graphic Art of Henry F. Farny," *Imprint* 8, no. 1 (spring 1983): 15.

17. Ibid.

18. Alex Nemerov, in William H. Truettner, ed., *The West as America: Reinterpreting Images of the Frontier, 1820–1920*, (Washington, D.C.: Published for the National Museum of American Art by the Smithsonian Institution Press, 1991), 296. Nemerov argues that artists such as Remington drew in part on long-standing European art traditions. In this context, he identifies the profile drawings faintly visible in *Daniel Boone at Age Fourteen* as drawings after Greek or Roman casts of antique sculpture that would have been available in Cincinnati.

19. "Artist Farny," *Cincinnati Enquirer*, June 24, 1900, 17.

20. Ibid.

21. Ibid.

22. Ibid.

23. Timothy Dwight, *Travels in New England and New York* (1821–22), ed. Barbara Miller Solomon with Patricia M. King, vol. 1 (Cambridge: Belknap Press of Harvard University Press, 1969), 146.

24. Anthony F. C. Wallace, *The Death and Rebirth of the Seneca* (New York: Vintage Books, 1972), 163.

25. H. Perry Smith, *History of the City of Buffalo and Erie County*, vol. 1 (Syracuse, NY: D. Mason & Co., 1884), 200.

26. Illustrated in Carter, *Henry Farny*, 48.

27. Eugene V. Smalley, "The Upper Missouri and the Great Falls," *The Century Magazine* 35, no. 3 (January 1888): 417.

28. "Lo! The Poor Indian," *Cincinnati Enquirer*, November 8, 1881, quoted by Susan Labry Meyn, "Western Romanticism Versus Indian Reality," from *The Vanishing Frontier: Henry F. Farny, 1847–1916* (Cincinnati: Taft Museum, 1997), not paged.

29. Hugh A. Dempsey, "Blackfoot," in William C. Sturtevant, ed., *Handbook of North American Indians*, vol. 13, part 1 (Washington D.C.: Smithsonian Institution, 2001), 619.

30. "Henry F. Farny, Noted Painter of Indians, At Work in His Studio," *Cincinnati Commercial Tribune*, January 23, 1910, 8.

31. See "Mormon Trail," "Oregon Trail," and "Santa Fe Trail," in Howard Lamar, ed., *The Reader's Encyclopedia of the American West* (New York: Thomas Y. Crowell Co., 1977).

32. "The Seminole War," *Wisconsin (Madison) Enquirer*, June 15, 1839, 1:1.

33. Barbara Groseclose, "The 'Missouri Artist' as Historian," in *George Caleb Bingham* (New York: Harry N. Abrams in association with The Saint Louis Art Museum, 1990), 57–58.

34. Quoted in William H. Truettner, *The Natural Man Observed: A Study of Catlin's Indian Gallery* (Washington, D.C.: Smithsonian Institution Press, 1979), 80.

35. Brian W. Dippie, *The Vanishing American: White Attitudes and U.S. Indian Policy* (Lawrence: University of Kansas Press, 1982), 13.

36. Frank B. Mayer, "Annual Report of the President of the Maryland Historical Society and Its Committee on the Gallery of the Fine Arts," in *Maryland Historical Society Publications*, vol. 2, 1850, 4–5.

37. Ellwood C. Parry III, *The Art of Thomas Cole: Ambition and Imagination* (Newark: University of Delaware Press, 1988), 60.

38. Quoted in Rembrandt Peale, *Portfolio of an Artist* (Philadelphia: Perkins and Marvin, 1839), 215.

39. Robert Taft, *Artists and Illustrators of the Old West, 1850–1900* (New York: Charles Scribner's Sons, 1953), 221.

40. William H. Truettner, "For Museum Audiences: The Morning of a New Day?" in Amy Henderson and Adrienne L. Kaeppler, eds., *Exhibiting Dilemmas: Issues of Representation at the Smithsonian* (Washington D.C.: Smithsonian Institution Press, 1997), 31.

41. Ibid.

42. See "Comanche Indians" and "Geronimo" in *The Reader's Encyclopedia of the American West*.

43. "Ogallala" is a variant spelling of a Lakota Sioux band of people more properly known as the Oglala Sioux.

44. "Studio Studies," *Cincinnati Commercial*, December 1, 1881, 8.

45. Peter H. Hassrick, "Henry Farny: The Frenchman Who Went West," *Connoisseur*, February 1981, 123.

46. Taft, *Artists and Illustrators of the Old West*, 217.

47. Baltzer, *Henry F. Farny*, not paged.

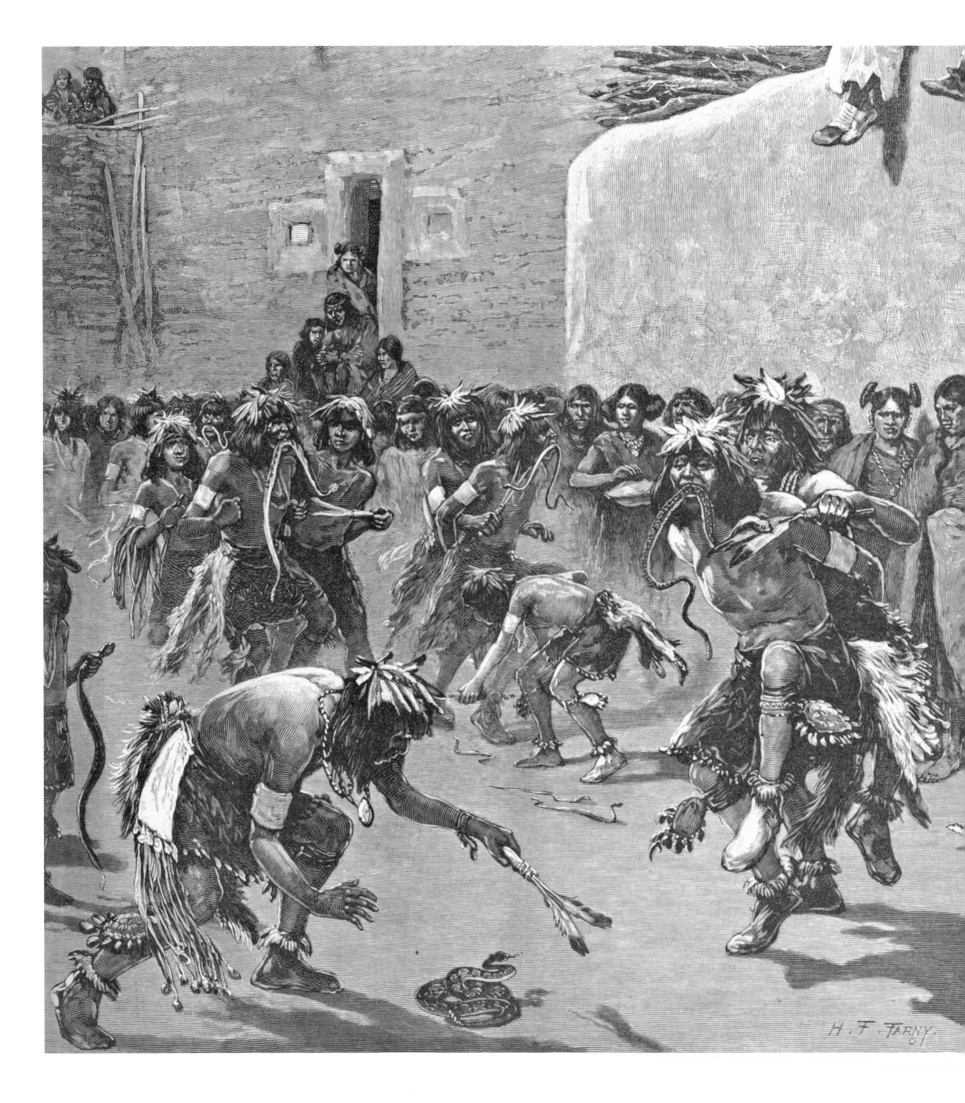

SUSAN LABRY MEYN

THE ARTIST AS INDIAN STORYTELLER

His illustrations as well as his paintings always succeed in both telling a story and in depicting character. Imagination and realism are successfully blended.
CARL VITZ, 1954

By the time Henry Farny made his first trip west in 1881, the Indian peoples of the entire Great Plains region, from Texas into Canada, were already greatly impoverished, culturally as well as economically. These Native Americans had endured nearly a century of pernicious federal policy and more than forty years of punishing war with the U.S. military. The government's objective was to either civilize or exterminate these proud and brave warriors.

The Indian story that Farny usually chose to tell reflected the lifeways of these Indians during the glorious earlier days of traditional Plains life, when they had charged across the grasslands hunting buffalo prior to their confinement on remote reservations. When he visited isolated western reservations Farny witnessed the Indians' grievous suffering—the diseases brought on by semi-starvation and the psychological pain of a defeated people. Throughout his life Farny knew about and was sympathetic to the Indians' cause, yet his art rarely reflected their tragic situation. Because of the discrepancy between what he knew and what he chose to portray, Farny's paintings and drawings of Indians are fascinating from an ethnological viewpoint.

Prior to his first trip west, Farny earned much of his living as an illustrator rather than as a painter. He illustrated a wide variety of works: children's books, volumes of poetry, magazine articles, travelogues, catalogues, and programs. Most often Farny did not travel to the place he was illustrating or even have

OPPOSITE: Henry Farny, *The Snake Dance of the Moqui Indians*, 1889 (detail, fig. 43).

direct participant experience with the subject of his artwork. And yet, during his lifetime, Farny was wildly famous in Cincinnati. Whether intentionally or not, Farny seemed to know how to promote himself through the Cincinnati media as an expert on Indians and the Indian situation. Consequently his fans repeatedly praised his realism and ability to accurately portray Indian life, even though we can document only four short trips west. One enthusiastic critic, after Farny had been painting Indians for approximately fourteen years, claimed, "The name of Farny is inseparably associated with Indians and portrayals of the disappearing race as they are. He paints not the idealized red man, but the Indian as he exists—as he is to be seen in the West today."[1] Farny understood that Americans had become nostalgic for and yearned to see again the wild, uncivilized frontier. The appeal of the mythic West steadily grew in direct proportion to how quickly its vast empty expanses were becoming populated.

This manuscript will evaluate Farny's work ethnologically and historically. It will deal primarily with Farny's black-and-white illustrations reproduced for *Harper's Weekly* and *Century Magazine*, rather than with the oils, gouaches, and watercolors for which the artist is best known. While Farny's black-and-white gouaches are not well known, his paintings, which in many instances are nearly identical to the drawings, are instantly recognizable.

For a basis in how to think about Farny's artwork I am indebted to the late John C. Ewers, a renowned ethnologist who once lived and worked among the Blackfeet in Montana and served for several decades as the curator of ethnology at the Smithsonian Institution. Ewers's knowledge of Plains life and of photographs made of Indians around 1890 enabled him to make an ethnological evaluation of this highly popular art form that supposedly documented Indian life on the Great Plains. Ewers maintained, "We must try to separate the wheat from the chaff—the fact from the fiction in western art." He stressed the importance of not generalizing about an artist's creative output, but instead examining each separate painting or illustration on its own merit. Artistic realism, he contended, was no substitute for participant observation.[2]

My purpose therefore is not to evaluate Farny's artistic merit; those discussions are best left to art historians. Examining an artwork ethnologically means that the details of the work—for example, the inclusion of the ubiquitous short Plains gramma grass, the gender of a weaver, the traditional hairstyles of a people—must be considered before a work can be called authentic. Sadly, neither a specific work's nor an artist's popularity has any bearing on a painting's value as a historical document.[3] Hence, as we examine Farny's work we will discover that while Farny knew a great deal about Indians, he rarely chose to represent the devastating reality of contemporary Indian life, even in his illustrations, perhaps because the romantic past was what his public wanted and what they bought.

As far as we can tell, Farny made four brief trips west—in 1881, 1883, 1884, and 1894—always as someone's guest. (It is possible that Farny made additional trips, but these remain undocumented.) Unfortunately, relatively little primary material dealing with Farny's art is known and accessible to scholars. Only one small sketchbook of Farny's survives and that is in private hands. Only a few of his photographs of Indians have been found; those are in the Rare Books and Special Collections Department of the Public Library of Cincinnati and Hamilton County.

Fortunately, Henry Farny welcomed newspapermen with "Bohemian *bonhomie*" and enjoyed speaking with them; they, in turn, relished visits to his studio for a cigar and a fireside chat.[4] Through the work of these reporters, Farny left a legacy of insightful quotes in Cincinnati newspapers. Farny even wrote a few stories about Indians—at least one for publication and a few for Cincinnati's Literary Club—occasionally illustrating the stories as well. Thus, in addition to his artwork depicting Indians, Farny left a record of his thoughts and opinions about the government's quandary of how to treat indigenous peoples. Through his travels west and conversations with military men, Indian agents, and Indians he met, Farny formed his own ideas about government policy and expressed these in the Cincinnati dailies. Some additional information about Farny's experience and attitude toward Indians is buried in archives. These materials enable those interested in Farny's Indian art to examine Farny through the lens of his own statements, as well as that of the popular opinion of the time.

Henry Farny Meets Old Jacob, a Seneca Indian

François Henri Farny, the third child of Charles and Jeannette Farny, was born on July 15, 1847, in Ribeauvillé in Alsace, present-day France. His father opposed the Napoleonic party and, forced to flee his country, emigrated with his family to the United States. By 1854 the Farnys had settled in the pine forests of western Pennsylvania, outside Warren, a town on the Allegheny River.[5] Warren was at one time the home of the Seneca Indians, one of the original five tribes of the Iroquois Confederacy.[6]

Later in his life Farny recollected his early childhood impressions about Indians, saying, "My idea of an Indian was that he was a sort of bloodthirsty human ferret, noiseless and insatiate for gore." His first encounter with "one of these terrible red men" occurred when he and his father were on a rare visit to Warren town. Farny's second Indian encounter was with Old Jacob, a once-famous Seneca hunter who was starving, now that he was old and his people had been dispossessed. Jacob startled the young Farny, who was alone chopping kindling in the woodshed (fig. 24); however, Farny's father invited Jacob to eat and spend the night with the family. Gradually the boy and Jacob became "great chums." Jacob brought Farny to his camp and taught him to make moccasins and bows and arrows. There, Farny saw the "shy, unkempt [Indian] children with beady eyes." Even though he could not converse with them, Farny said that they "soon learned not to be afraid of each other."[7]

Farny's childhood experiences probably influenced his later decision to paint Indians. When he became an artist these "pleasantest" memories led him to seek a "sympathetic subject." Farny said that he found American Indians to be a more sympathetic subject than painting "Arabs or Breton or Dutch peasants" as most American painters did at that time. Later, after years of friendship, Farny was made a member of the Seneca tribe and given the name "Whizhays," which means Long Boots.[8]

When Farny first met Old Jacob, the Seneca had already been greatly assimilated. By 1784 they had lost their land in Pennsylvania and had been weakened by war, disease, and internal dissension. Lewis Henry Morgan, a scholar knowledgeable about the Iroquois and famous for his 1851 publication *League of the Ho-dé-no-sau-nee or Iroquois*, had observed the "great changes" taking place among the "descendants of the ancient Iroquois" and, for this reason, in 1849 donated Seneca objects for the New York state collection.[9] Even though he was just a boy, Farny probably realized that the "unkempt" Seneca children he encountered were suffering. He probably did not realize that this was due to the encroachment of white society on Indian land and lives.

H. F. FARNY.

FIGURE 24
Old Jacob, illustrated as part of a biographical sketch of Farny in the *Cincinnati Enquirer*, June 24, 1900, 17. From the Collection of the Public Library of Cincinnati and Hamilton County.

This Seneca, who lived near Farny's boyhood home in western Pennsylvania, was the first Indian Farny knew.

The Farny Family Moves to the Queen City

At mid-century Cincinnati's economy centered on its flourishing river trade. Steamer whistles screamed arrivals and departures, while boisterous deckhands piled the cargo high. Thus, by 1859, the year that the Farny family left Pennsylvania and traveled by raft to Cincinnati, the city's population was a teeming 160,000 and the riverfront stretched for six miles.[10]

Once in Cincinnati, Henry Farny attended what was then called Woodward College and left a lasting memento demonstrating his early interest in Indians. On the blank leaf preceding the title page of his public school book, Farny drew a detailed picture of what appears to be an Eastern Woodland Indian and a Scottish highlander—each imaginatively outfitted and facing center, toward a monument bearing the sentiment "Do Unto Others As Thou Woulds [*sic*] Have Then [*sic*]" (fig. 25). The men are positioned beneath a ribbon bearing the inscription "Henry Farny's" and "Book" directly under the ribbon. The date "1861" appears on the shield. Farny has written other dates in pencil on the leaf, "Sept 20 1860" and "1860–1864" on the ribbon, perhaps because he expected to graduate in 1864. The book, *The Singing School Companion*, was a collection of secular and religious music that included an "easy method" of teaching singing.[11]

Farny was not destined to graduate from Woodward, however. His older brother, Eugène, died in 1861, and in December of 1863, when Farny was sixteen, his father died after a lengthy illness. During the last year of his father's life Farny was forced to drop out of school and go to work to support the family. He held various jobs, but, sadly, the details of those remain uncertain.[12]

Farny's next documented drawing of Indians appears in a personal sketchbook dated 1865.[13] The peaceful scene of two frontiersmen greeting Indians takes place in front of Cincinnati's Fort Washington, which was erected in 1789 and demolished in 1808. Without a doubt, Farny saw either H. W. Kemper's 1857 painting *Fort Washington* or the chromolithograph of the painting, because Farny's fort is a dead ringer for the one in Kemper's picture, right down to the militiamen standing at attention outside the fort. The noticeable difference is the unique Indian surroundings.[14] Farny's scene, with naked children running at play, depicts an elm or birch bark canoe pulled up next to a tipi on the shore.[15]

Clearly, Farny was ethnologically confused—tipis provided shelter for Plains Indians, such as the Cheyenne and the Lakota Sioux, and bark canoes provided transportation for Eastern Woodland Indians, such as the Seneca. Nor was either culturally specific object ever seen in Cincinnati, because neither group of Indians lived in the Ohio Valley; in fact, no historic Indians ever inhabited the site of the city proper. Prehistoric earthworks, or mounds, were the only evidence of Indians having lived on the site of what was to be Cincinnati, and that was long before colonial settlement. Cincinnati's first white inhabitants did encounter Indians traveling from nearby areas, but relatively infrequently. There were bursts of violence and bloodshed when the area that is now Cincinnati was first settled, but in comparison to the ongoing hostilities that had characterized New England settlement, bloodshed was rare.[16] Most often, marauding Indians stole the settlers' livestock and destroyed their crops. In 1865, the date on

Farny's sketchbook, Cincinnati was a bustling metropolis and the fort had been gone for decades. Hence Farny never actually witnessed the scene he drew; much of it instead was produced from his fertile imagination. In much the same way Farny continued throughout his life to combine existing images—albeit with increasing knowledge and subtlety as he continued to learn more about Indians and their diverse cultures.

That same year, 1865, the eighteen-year-old Henry Farny produced his first illustrations for *Harper's Weekly*, two views of the Cincinnati Turner Festival (fig. 47, p. 75). Shortly thereafter Farny traveled to Europe, where he began his fine art training and became, in time, "an accomplished draftsman."[17] Many of the specifics about his European training remain uncertain, but by 1868 Farny may have been back in the United States, because three signed illustrations of different "Game Birds and Their Haunts" appear in *Appletons' Illustrated Almanac for 1869*.[18]

Farny, the Artist, Immerses Himself in Cincinnati

By 1872 Farny had returned to Cincinnati and launched his career as an artist by participating in the city's various cultural activities. That year he was appointed to membership in the Literary Club, where, in the future, he would deliver papers on American Indians living in the West.[19]

Farny took advantage of Cincinnati's position as an industrial hub to exhibit his works in the wide-ranging Cincinnati Industrial Expositions, which published catalogues about their art displays. Expositions were held over a number of years: the first in 1870, the thirteenth in 1886. (In 1876, 1877, 1878, and 1885, no expositions were held.) Farny exhibited in all but four and in 1884, though he did not exhibit, he illustrated the cover of the *Official Illustrated Catalogue of the Art Department* for that year's exposition, the twelfth.[20] Over the years he showed a wide variety of works, ranging from a "Turkish rug" in 1879 to an oil painting entitled *Field Mice* in 1880. At least three Farny entries received awards. In the 1872 exposition, for example, his "weird conception" of the *Piper of Hamlin* attracted a great deal of attention and won a silver medal.[21]

For the 1882 exposition—the year after Farny's first trip west—Farny exhibited three artworks with an Indian theme: *The Last Vigil*, depicting an Indian seated below a Plains burial scaffold; *The Camp of the Uncupapas [sic]*; and *Blackfoot Indian*, which holds a description in the lower right corner, "Unke-Unkee-ah /Siah Tappah /Blackfoot" (fig. 26). (Although the name Blackfoot was used in the past, the people today prefer Blackfeet.) Beneath the catalogue image of the Blackfeet man there appeared an excerpt from a Farny letter: "He sat and eyed me with all the legitimate suspicion which would naturally arise in the mind of a man to whom a paper bag of prunes had been offered for the mere pleasure of sketching him."[22]

By this time, the 1880s, Farny had no doubt learned many of the finer points of financial survival as an artist. He consistently kept his name and his art before the public, showing works whose subject proved saleable. He had become inured to the difficulties of becoming a successful artist in the Midwest.

As early as 1874, Farny had complained to a reporter, "Well, it is about the worst place for a large city that a young artist could choose to make his *debut* in." The only way an artist could make a living in a city where the public was largely disinterested in art was by "designing tobacco labels, oyster labels, theatrical bills, or such work as that." For the first couple of years, Farny said that he nearly "despaired of being able to succeed." Most of the city's artists, he said, took "refuge in portrait painting," which was the best paying kind of art in the city.[23]

Another difficulty for artists, Farny lamented, centered on the use of nudity in a painting: "Cincinnati people at once get shocked if they see anything naked." Farny explored many themes and experimented with cartoons, telling the same reporter, "It is easier to convey a truth to the public mind through the medium of caricature." The reporter found Farny's cartoons appealing and thought that the drawings would receive the recognition they deserved.[24]

FIGURE 26
Henry Farny, *Blackfoot Indian*, 1881, in the *Illustrated Catalogue of the Art Department, Tenth Cincinnati Industrial Exposition, 1882*. Mary R. Schiff Library, Cincinnati Art Museum.

Farny "paid" this man, described as "Unke-Unkee-ah /Siah Tappah /Blackfoot," with a bag of prunes for posing. The original pen and black ink drawing belongs to The Literary Club, Cincinnati.

The Farny Persona

Farny was gifted with a personality that was open to experience. He was able to find and revel in the joy of a distinctly different culture. This was not a common trait at the time. Many whites, even the missionaries and Indian agents who worked with them, did not care to understand Indians, let alone enjoy Indian culture. They thought about and judged Indians based on their own white cultural background, rather than from the Indian perspective.

Were it not for Henry Farny's ability to attract reporters to his studio and provide good copy for them, we would have as his Indian legacy his material output of paintings and drawings, but little indication of his knowledge and insight and his concern for Indians. This empathy informs much of Farny's work depicting Indians, even his romanticized and, ethnologically speaking, less interesting works. Few Farny letters, diaries, or personal papers are known. We have a couple of published stories, but mostly we have the newspaper interviews as our most important record of Farny's thought.

Henry Farny could fill a room. He was physically imposing, very tall and broad, but he does not seem to have been intimidating. Perhaps this was because he so enjoyed a joke on himself.[25] He was tremendously outgoing—the Literary Club, the Cincinnati Camera Club, and the Cincinnati Art Club are just a few of the organizations in which he was active. Through these memberships, Farny inched his career forward, making himself an easily recognized figure.

One of the traits that most distinguished Farny was his playfulness. In November 1879, for example, he helped institute the Society for Suppression of Music, formed initially as a "gorgeous joke," and is reported to have drawn the organization's outrageous insignia—"showing a stalwart patriot wielding an axe on a pile of violins, cellos, and cornets."[26] For the 1881 Cincinnati Industrial Exposition Farny illustrated the pseudonymous Clara De Vere's successful tongue-in-cheek catalogue of the event, prompting one newspaper to state that "the illustrations alone are worth the price of admission."[27]

Farny's playfulness was just one manifestation of his charm. He was extroverted and warm-hearted. With his artist's keen powers of observation, Farny very likely focused his attention flatteringly on whomever he was with. Whether the subject of his attention was a potential patron, or an Indian sitting for a sketch, Farny benefited as a less personable artist might not have.

Farny's Early Career

Despite his early struggle to survive as an artist, Farny enjoyed living in the Queen City. Cincinnati was a dynamic thriving city, large enough perhaps to attempt making a commercial success of artistic expression.

In the summer of 1874, Farny and newspaperman Lafcadio Hearn undertook publication of what they hoped would become an American counterpart to the British magazine *Punch*: the short-lived, sensational journal *Ye Giglampz*. The men expected that their illustrated magazine—devoted to art, literature, and satire—would find a sophisticated audience. A few articles addressed national and international issues, but most were devoted to purely local events. Critics contended that Farny's *Ye Giglampz* cartoons represented some of his best work. In addition to producing illustrations for *Ye Giglampz*, Farny also wrote many, if not all, of the columns called "Art Notes"; these were condensed discussions about various topics related to art.[28]

Almost from the beginning the journal suffered financial difficulties. Hearn maintained that Farny kept the treasury for the publication "in his vest pocket." Years later, James Albert Green, a trustee of the city's public library, who knew Farny, said that Farny was a "most gifted artist, but he had no knowledge of dollars or cents." While the death of the magazine probably was due to financial difficulties, the appearance of horrific sketches of the burning of the steamer *Pat Rogers* near Cincinnati sealed

Ye Giglampz's fate. The sketch treatment of the tragedy and insensitive wording of the captions—"fishing for bodies"—was misunderstood by readers accustomed to the elaborate lithographs that illustrated most news stories of the period. Subscribers thought the editors unsympathetic and amazingly hard-hearted. In an editorial Farny attempted to explain, but it was too late; the publication died in August 1874.[29]

Farny's keen ability to express character in a drawing won him another job, this time in conjunction with W. H. Venable, a well-known Cincinnati literary figure. No doubt the two were well-acquainted, because both were members of the Literary Club—Venable becoming a member in 1865 and Farny in 1872. Farny and Venable collaborated on a book, *Dramas and Dramatic Scenes*, published by Van Antwerp, Bragg & Company of Cincinnati. Venable edited and Farny illustrated, receiving title page recognition. The work, published in 1874, presented passages from well-known works of literature and featured Farny's often amusing depictions of the characters, such as Braggadocio from "The Old Bachelor."[30]

Despite the *Ye Giglampz* fiasco, Farny's personality won him friends among the women who organized the local events leading up to the nation's 1876 Philadelphia Centennial Exhibition. Intent on expressing their image of the ideal American woman, they sought his "fine taste" when organizing their display booths.[31] Farny and Frank Duveneck worked together in creating a huge painting, *The Prayer on the Battlefield*, for the French booth. The painting, executed in a "remarkably short time," showed Joan of Arc, the warrior maiden, giving thanks after France's great victory.[32] Newspaper reports of this endeavor—and the appreciation of the ladies involved—advertised Farny as an artist and increased his popularity locally.

Van Antwerp, Bragg & Company again sought Farny for what would become one of the most memorable projects of his career: seventy-six illustrations for the country's beloved McGuffey readers. Most of Farny's McGuffey drawings showed boys and men engaged in familiar midwestern activities; the images sometimes reinforced the moral of the story they accompanied. These beautifully illustrated books, copyrighted in 1879 and used for more than twenty years, influenced millions of young readers and brought huge financial rewards to the publisher. They also brought increased attention to Farny, who delighted in the fact that children recognized him on city streets as the illustrator of the pictures in their schoolbooks.[33]

Farny Goes West

Artists had various motives for visiting the West. Some, such as George Catlin, were interested in painting Indians before they disappeared, while others were interested in the gorgeously wild terrain of the nation's frontier. Exactly what made Henry Farny go west remains unclear, but growing popular interest in the West could not have escaped his attention. One manifestation of this interest was the appearance of William F. "Buffalo Bill" Cody's popular frontier reenactments, one of which played Cincinnati in late December 1872. This engagement, a play based on the dime novel *The Scouts of the Prairie*, brought to live action all the "thrilling romance, treachery, love, revenge, and hate of a dozen of the richest dime novels ever written." Even though only one Indian participated and the remaining braves were mostly white impostors, the audience, who were not from the "cleaner classes" of the city's population—the hall required fumigation after the show—packed themselves into Pike's Opera House.[34] Nostalgia for the nation's disappearing frontier generated activities that reincarnated those unpredictable and uncivilized episodes for which the West was known.

In November of 1881 Buffalo Bill produced another play, *The Prairie Waif*, at Heuck's Opera House.[35] By this time public interest in Cody's indoor staged events, which apparently were not very thrilling, had waned. The following summer, though, Buffalo Bill staged a full-scale outdoor reenactment that was to become his legendary Wild West show, and took it on tour. When, in June 1883, Buffalo Bill brought his Wild West show to the "Base Ball Park," Cincinnati became one of the first cities to witness

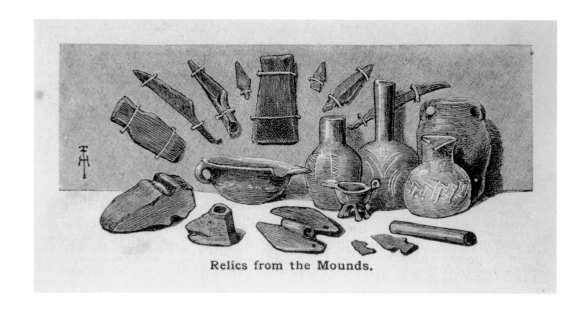

Relics from the Mounds.

this incredible, recreated frontier complete with live buffalo, mountain elk, and Indians in "full war-paint and feathers" displaying their phenomenal horsemanship.[36]

Ohio Valley archaeology, and ongoing scientific investigations into the region's enigmatic earthworks, surely also influenced Farny. His illustration for *The Eclectic History of the United States* of an Adena Indian mound, with a contemporary farmer plowing nearby, suggests a new order of sedentary culture taking the place of the old. Another illustration for *The Eclectic History*, of a group of moundbuilder "relics," indicates Farny was aware of the archaeological excavations going on around Cincinnati (fig. 27). In her January 10, 1881 preface to *The Eclectic History*—written at least eight months before Farny's first trip west—author Mary Elsie Thalheimer acknowledged Farny's illustrations, saying that they "leave nothing to be desired in perfection of finish." The text demonstrates that Thalheimer, and no doubt Farny, was aware of then-current theories about the function of mounds as possible "foundations for watch-towers and signal-stations" and ceremonial sites. All the "relics" Farny drew for *The Eclectic History* are physically accurate, even though his picture mixes together tools and pottery created by different groups of prehistoric Indians. Most likely he saw this kind of exhibit case somewhere in the city.[37]

Although he never witnessed any of the Indian scenes he drew for *The Eclectic History*, Farny obviously considered this business as usual. Perhaps his most intriguing interpretation is the scene *Northmen in Rhode Island* in which a group of "northern natives"—Norse explorers—land on Rhode Island's shore in a ship whose carved prow resembles Puff the Magic Dragon. In another illustration, *Indian Dancing*, Farny inserts Eastern Woodland houses right next to the tipis in a Plains Indian scene (fig. 28).[38] Farny's dancing Indian wears an authentically drawn full-length Plains Indian eagle feather warbonnet, leading an ethnologist to wonder what he saw as an inspiration for this drawing. Farny's studio was conveniently located next door to Robert Clarke's bookstore on Fourth Street between Vine and Walnut Streets. Robert Clarke was known for his publications about Indians and his bookstore served as a literary and cultural center, where local cognoscenti and sophisticated travelers gathered. Farny almost certainly would have seen Catlin's paintings of Indians in books there; Farny's scrapbook dated 1870 quotes Catlin on the making of pemmican.[39]

In August 1881, Sitting Bull, the Hunkpapa Sioux military and religious leader, surrendered and was moved to Fort Yates, Dakota Territory, where Farny hoped to see him. Cincinnati newspapers printed a biography of this "wily and merciless savage" and included a portrait sketch of Sitting Bull wearing non-chiefly attire—in other words, lacking the elaborate eagle feather warbonnet and magnificent fringed leather clothing that whites associated with Indian chiefs. Reporters misunderstood his "lack of display," thinking it was to impress the "sentimental white man with his poverty." Cincinnatians

read a similar statement: "The old man is poor—that can be seen at a glance." In fact, Sitting Bull, a highly respected leader, was demonstrating his lifelong commitment to the culturally important Lakota Sioux virtue, generosity. He shared his material resources with his people.[40]

During one brief interview, Sitting Bull, a participant in the Battle of Little Bighorn, was asked to give his observations on this historic event, in which General George Armstrong Custer and all the men in his command were killed. He responded, "There was not as many Indians as the white man says. They are all warriors. There was not more than 2,000." The *Cincinnati Commercial* told citizens that the details and accounts of the "deeds of treachery and blood . . . were better forgotten."[41]

A few weeks later, in September, Cincinnatians read about another Indian uprising, this time among the Apache. The article, datelined Santa Fe, berated citizens who harbor a "mawkish sentiment in regard to the Indian that has cost the country millions of money and thousands of lives"[42] This statement probably referred to the heated controversy generated by Helen Hunt Jackson's book, *A Century of Dishonor*, that had been published earlier in 1881. Jackson aroused a great deal of sympathy for Indian rights; she condemned government cruelty to Indians and publicly criticized Secretary of the Interior Carl Schurz. This controversy kept national interest in Indians at high pitch. Farny, who moved with the Cincinnati intelligentsia—reporters, authors, publishers—undoubtedly discussed Indian affairs over many a meal.

In late October 1881, readers of the *Cincinnati Daily Gazette* discovered another fact about the rapidly changing American frontier—sighting buffalo on the northern Plains had become an "exceedingly rare" experience. So rare, in fact, that excited soldiers and passengers riding a train poured a "volley of lead" out of the windows into a herd of sixteen animals within range of the track. When the train encountered a larger herd head on, the passengers again leveled every gun, but to no avail—the train was forced to stop as the buffalo sauntered over the track. Arguments then ensued over how much lead it would take to weaken a buffalo.[43]

The rapid succession in 1881 of frontier- and Indian-related news stories—Sitting Bull's arrest, Indian uprisings, Ohio Valley archaeology, the decimation of the buffalo, and Buffalo Bill's latest stage

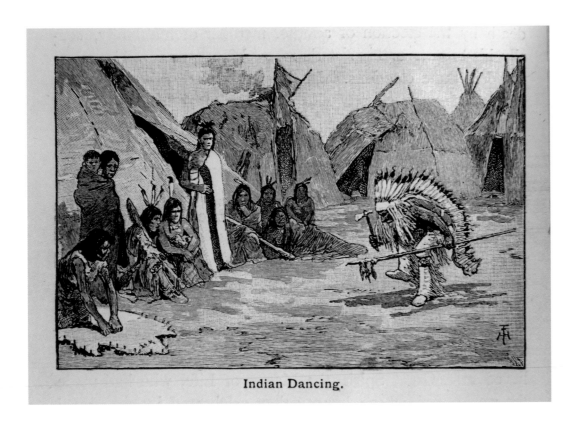

Indian Dancing.

FIGURE 28
Henry Farny, *Indian Dancing*, illustrated in M. E. Thalheimer, *The Eclectic History of the United States*, 1881, 20. From the Collection of the Public Library of Cincinnati and Hamilton County.

Farny drew this image prior to his first trip west, before he learned to pay attention to ethnological detail.

production—must have inspired Farny to look to the West for subject matter.

Exactly when Farny departed for the West remains uncertain. His drawings for the 1881 sketchbook prove he was in Cincinnati for the September 7 opening of the Industrial Exposition. We know, however, his return date of November 5, 1881, and, thanks to his rapport with Cincinnati newspapermen, we have specific information about the trip. Farny's quoted comments tell us that, while in the West, he acquired first-hand experience and knowledge about federal Indian policy and the plight of Indians on the Great Plains reservations.

At Fort Yates on Standing Rock Agency, located about seventy miles from Bismarck, Farny was the guest of the fort commander, Colonel Gilbert of the Seventeenth Cavalry, and Lieutenant Sage, a former Cincinnatian. According to Farny, officers and their families formed a very pleasant society. While at Fort Yates, Farny went sketching with his Indian guide, Louis, who spoke broken English. Louis wanted to be a "white Indian and wear clothes." He rejected one of Farny's old suits offered to him, contending it was only suitable for a woman; he "must have fighting pants," like U.S. soldiers wore. The "discriminating young buck" was then fitted with a pair of cast-off regimentals.[44]

Farny returned home with a portfolio full of "sketches of braves" and with a "great quantity of Indian loot." He reported that he never saw a "jollier camp" than a Sioux village and found the "plains, the buttes, the whole country, and its people . . . to be fuller of material for the artist than any country in Europe."[45] To his great regret, Farny did not see Sitting Bull, who had just been removed to Fort Randall, further down the Missouri River.

In addition to his treasury of sketches Farny took 124 photographs, despite Sioux women's superstitions about the camera being "bad medicine" because it had the ability of looking "clear through them." In this article Farny also spoke about the condition of the Lakota Sioux, saying that "it is a shame such a race should be ground down and well-nigh exterminated. The treatment of the Indian is a mixture of sentimentality and cupidity and between the two we are making them tramps and dead men." Perhaps because the Indians recognized Farny's genuine interest in them, the Lakota Sioux gave Farny an "unpronounceable name . . . which when translated meant, 'the white man who makes faces.'"[46]

By December 1 Farny was "laying in a painting" of Indian women carrying firewood which, according to the reporter, promised to be a good treatment of the subject. Indians, he observed, consumed Farny, and "if properly worked up" would mean that Farny had "struck an artistic bonanza." The key to the reporter's comment lies in the "if properly worked up" statement.[47] Did he realize that Farny could not paint Indians in a realistic manner, meaning in the impoverished way they lived in 1881, if he wished to sell paintings?

A *Daily Gazette* reporter confirmed in a separate article that this same painting, *Toilers of the Plains* (fig. 15, p. 27), was Farny's first work resulting from his trip west: "The landscape is full of sentiment and melancholy into which the resolute but sorrowful face of the Indian woman comes as naturally as the waste of snow and the barren trees." And indeed the painting was on display for only a day at Clarke's bookstore before it found a buyer.[48]

Some critics maintain that Farny's landscapes were a compilation originating from his numerous travel sketches.[49] While this may be so, Farny could well have observed this scene with Sioux women hard at work; the landscape and sky are typical of the northern Great Plains in autumn. What Farny probably would not have seen was the bleached buffalo skull lying exposed on the ground: a Plains Indian would have picked up this increasingly rare object for ceremonial use. Buffalo, by this time, had been hunted to near extinction and Plains Indian lifeways had gone with the animal.

The bobbed hair and bangs on the Lakota Sioux woman in the foreground are puzzling because Sioux women of the time wore their hair long; even today, most traditional women do not wear bangs. Farny may have seen bobbed hair on young women who were students in a missionary school, where students were forced to cut their hair.[50] The painting's success and immediate sale may have stemmed from the belief that Farny's artwork depicted "the real life of a race of people fast disappearing from the face of the earth."[51]

In June 1884 *Harper's Weekly* published a wood engraving (fig. 29) nearly identical to the 1882

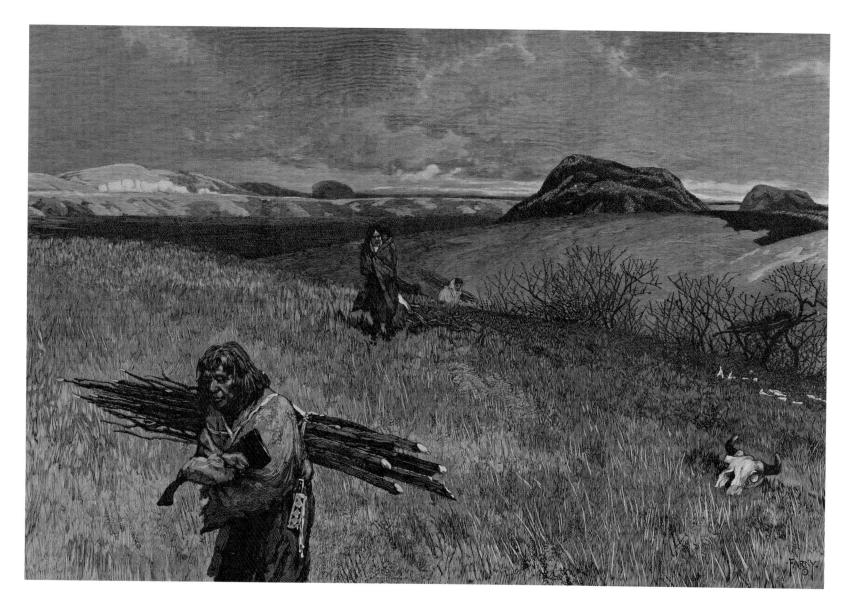

painting and also titled *Toilers of the Plains*. The engraving was based on a gouache, *Toilers of the Plains* (cat. 2), now in the collections of the Cincinnati Art Museum. The *Harper's* illustration was accompanied by an article saying that in the painting "several of these poor creatures . . . have been searching the almost treeless plains for fire-wood with which to cook food for their lazy masters."[52] This pejorative statement also demonstrates white people's lack of understanding of Sioux culture. Traditionally, men hunted and women processed game, preparing the skins and meat. Confinement on reservations and the near-extermination of the buffalo forever changed the role of men as providers.

Farny continued to experiment with his *Toilers* theme, creating a second picture of hardworking Sioux women. He titled this one *The Sioux Women of the Burnt Plains* and submitted the painting to the Paris Salon, where it gained admittance.[53] Before it was sent to France, however, the painting was vividly described in the *Cincinnati Daily Gazette*: "A line of these women crossing the plains gives the only touch of color to the somber landscape which brings out with wonderful vividness the utter desolation of savage life." Oscar Wilde, who was in Cincinnati on a speaking tour and also saw the painting, called it "a monody of solemn grays." Confusion has arisen about the second picture, but this *Daily Gazette* article clarifies the fact that there are two different, though similar paintings.[54]

FIGURE 29
Henry Farny, *Toilers of the Plains*, wood engraving, *Harper's Weekly*, June 21, 1884, 401. Mary R. Schiff Library, Cincinnati Art Museum.

The bleached bison skull refers to the near-extinction of the buffalo and the resulting hard times of reservation life.

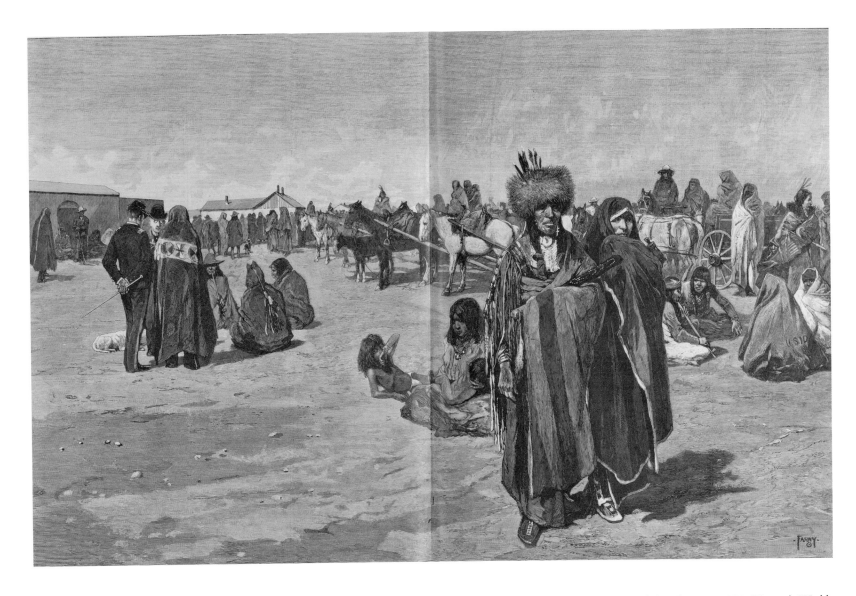

FIGURE 30

Henry Farny, *Ration Day at Standing Rock Agency*, double-page wood engraving, *Harper's Weekly*, July 28, 1883, 472–73. Mary R. Schiff Library, Cincinnati Art Museum.

At the time Farny witnessed this scene most Indians were confined to reservations and forced to accept government annuities.

Prior to publishing the black-and-white illustration *Toilers of the Plains* in 1884, *Harper's Weekly* also published *Ration Day at Standing Rock* (fig. 30), another illustration generated by Farny's 1881 trip. At the time, the editors of *Harper's* used extraordinarily detailed illustrations to reinforce or generate interest in a current topic. *Ration Day* made visual General George Crook's statement that "it is cheaper to feed an Indian than to fight him." At the time, that "simple maxim" was the basis of the government's Indian policy. However, the author of the *Harper's* article accompanying the illustration thought it would be "wiser and more humane, to teach him to feed himself, and to conduct himself in all ways as a civilized person"[55] In 1887 the General Allotment Act, also called the Dawes Act, attempted to establish individual Indian ownership of lands on some reservations; proponents of the act maintained that farming would have a civilizing effect on Plains warriors. Whites at the time did not understand that Lakota Sioux tradition dictated that only women scratch the earth.

Upon his return to Cincinnati in 1881, Farny told a reporter that the Government "kept" Indians by giving them rations in the form of butchered cattle. While at Fort Yates, he said, he had seen the government slaughter two hundred and forty head of cattle for the six thousand Indians at Standing Rock Agency. Farny's *Ration Day* image depicts the Indians enduring the interminable wait for meager amounts of food.[56]

The scene is accurate. Even though it may not have been drawn or photographed on the spot, the artist's direct observation is apparent. Agency buildings, though perhaps not the exact ones at Standing Rock, are in the background, and the hopelessness the Indians would have felt as a result of being confined to the reservation is evident. The blankets they wear are all typically Sioux—one showing a broad blanket strip embellished with trade beads, another showing the white selvage of an English woolen stroud blanket, and another boldly stamped "USID," for the United States Indian Department. The blankets are worn correctly and match Farny's verbal description: they "wrap their blankets about them so as to conceal the face all but the brow and nose and a pair of luminous black eyes, rendered the more horrible by lack of eyebrows."[57] (Farny nevertheless exercised artistic license by giving his Sioux subjects eyebrows, although Indian practice at the time was to pluck them.) The fur hat worn by the Sioux man in the foreground deserves a few words; it could well be Black Dog's turban, described by Farny as a "red fox-skin hat, decorated with eagles' feathers."[58]

Always a keen observer, Farny in his interview with the *Daily Gazette* reporter also noted that the government issued items that the Indians did not want, such as "cook-stoves," which were tossed into nearby bushes. Indians, he said, sold their government-issued overcoats "to roustabouts on steamboats for a dollar apiece. These probably cost the government from $15 to $20 to get there [Standing Rock]."[59] Farny also lamented that the Indians were "not allowed to leave the reservation without a pass."[60]

Farny Draws the Zuñi Pueblo Indians

Prior to the publication of *Ration Day*, *Century Magazine* published a ground-breaking three-part article, "My Adventures at Zuñi," by Frank Hamilton Cushing, accompanied by Farny's illustrations.[61] Cushing, a self-trained anthropologist, was a pioneer ethnologist, the first to work as a participant observer studying a culture. Farny's illustrations and Cushing's fascinating text gave the public an intimate glimpse into the lives of the Zuñi, at that time a little-known group of southwestern Indians. The drawings brought national attention to Farny and to Willard Metcalf, the other artist who participated in the Zuñi illustration project. The first installment of the article appeared in December 1882, and the others in February and May 1883.

Cushing's ethnographic fieldwork leading to the *Century Magazine* account began in 1879 when John Wesley Powell, the director of the recently formed Bureau of (American) Ethnology, under the auspices of the Smithsonian Institution, sent its first anthropological expedition to Zuñi Pueblo, in the Territory of New Mexico. James Stevenson led the expedition to the Southwest and was accompanied by photographer John K. Hillers. When the group moved on to other southwestern pueblos, Cushing remained at Zuñi, learning the language, making a detailed study of the people, and even becoming initiated into the Bow Priesthood society. Hillers documented the expedition with many striking photographs of the people and of the magnificent southwestern scenery.

Century Magazine used both Farny's and Metcalf's drawings to illustrate Cushing's account. We have no evidence that Farny traveled to the Southwest for this project; instead he traveled to Washington, D.C. to meet and sketch a number of Zuñi, a group of whom were touring Washington and Boston with Cushing. Farny returned to Cincinnati, pronouncing his sketches a success, and reported that he had received the name "Cohak-Wah, White Medicine Bead." The Zuñi met a number of artists on their eastern tour, all of whom were fascinated by the "striking faces and brilliant native costumes of the Indians, almost wholly of articles made by themselves." Infatuation occurred on both sides—the Zuñi charmed the easterners and "had a way of giving names to people with whom they were often in contact."[62]

Prior to publishing Cushing's Zuñi accounts in December 1882, *Century* published an article in August describing the Zuñis' unusual journey and explaining why they had always dreamed of visiting the East, "which was to them a land of fable." In Washington, President Chester A. Arthur greeted the Zuñi at the White House and they participated in sightseeing activities, including a tour of the National Museum.

However, their principal mission was to bring the "sacred water" from the "Ocean of Sunrise" back to Zuñi; this meant they wanted to collect water from the Atlantic Ocean for ceremonial use.[63] The article describing the aboriginal pilgrimage included drawings of each participant and his autograph—usually the drawing of a single bird. The endeavor was hailed as a success for Cushing and the Zuñis.

Cushing's scientific expedition to Zuñi captured national attention, leading *Harper's Weekly* in January 1882 to scoop the upcoming *Century* article by informing its readers about the Smithsonian's ethnological project at Zuñi. The *Harper's* editors illustrated the article with five of John Hillers's photographs, showing typical Pueblo architecture and the condition of the people.[64]

Willard Metcalf worked for *Harper's Weekly* as an artist in the Southwest in 1881. He also sketched scenes of Zuñi activities for an article that appeared in *Harper's New Monthly Magazine*.[65] Farny, however, acquired his knowledge of Zuñi life and customs during his brief visit to Washington, where he met Cushing and the men from the pueblo. Farny also used John K. Hillers's photographs as background. No doubt this discrepancy between the two artists' Zuñi experience is what led Alexander Stephen, Thomas Keam's congenial associate at Keam's Canon Hopi trading post, to write Cushing, telling him, "Say to Metcalf that though I think Farny's sketches are wonderfully clever, they do not carry the satisfaction, however, to this

FIGURE 31
Henry Farny, *Zuñi Weaving*, illustrated in *Century Magazine*, February 1883, 501. From the Collection of the Public Library of Cincinnati and Hamilton County.

FIGURE 32 (OPPOSITE, TOP)
John K. Hillers, *Man Weaving Blanket on Vertical Loom Suspended from Adobe Wall*, n.d., photograph. National Anthropological Archives, Smithsonian Institution (neg. no. 02117200).

FIGURE 33 (OPPOSITE, BOTTOM)
John K. Hillers, *Boy in Native Dress with Ornaments Near Eagle and Eagle Cage Made of Adobe and Sticks*, 1879, photograph. National Anthropological Archives, Smithsonian Institution (neg. no. BAE GN 02382).

These three images demonstrate how Farny used photographs as source images, reusing and recombining various elements. John K. Hillers's photographs provided most of the requisite information for Farny's illustrations of Zuñi people. Farny did not know that in Pueblo culture it is men who weave, not women.

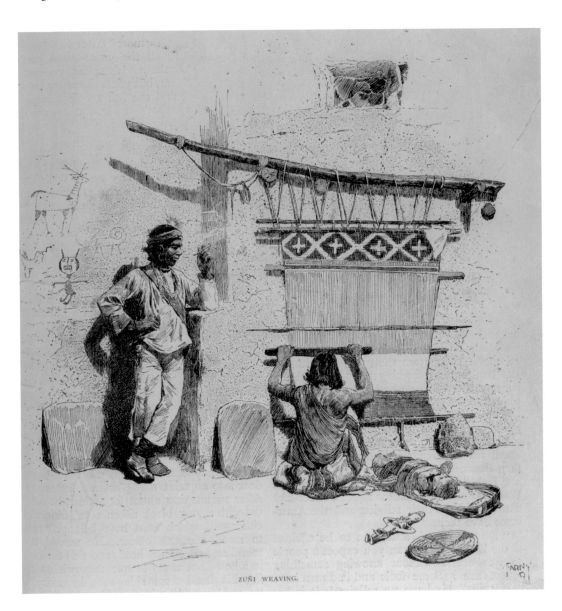

ZUÑI WEAVING.

critic as does [Metcalf's illustration] 'Women Grinding Corn.' That surely is capital with a great big 'C.'"[66]

For an ethnologist, the word "clever" stands out as if lit in neon. Why did Stephen choose "clever?" One Farny illustration for *Century*, *Zuñi Weaving* (fig. 31), points to the source of Stephen's criticism. Farny depicts a weaver, who, based on the surrounding cultural objects—a cradleboard, a doll-figure probably meant to represent a katsina, and a flat Hopi-style basket—appears to be a woman. However, among the Pueblo people, men are the traditional weavers, and Zuñi men frequently wore their hair long. The Hillers image on which Farny's illustration is based is not only a man, but a Hopi man, not a Zuñi man; Farny thus committed not just one but two inaccuracies on the weaver alone (fig. 32). In addition, Farny has altered the weaving to suit his artistic needs. The man in Hillers's photo is actually weaving a Hopi classic white manta—a woman's blanket—with red and blue borders.[67] Farny changed the traditional simple design on the top border to one he found more visually interesting.

Additional light is shed on *Zuñi Weaving* by examining the other Hillers southwestern photographs. For Farny combined two images—the young man standing to the left of Farny's weaver is drawn after a man in another Hillers photograph, this one actually taken at Zuñi (fig. 33). The man, wearing traditional clothing, stands beside an adobe and stick eagle cage, but Farny has moved him into the weaving image and added what appears to be a cigarette in his left hand.[68]

The source of the tiny prehistoric style drawings used as pictographs on the wall in this same *Century* illustration remains unknown, unless Farny extrapolated them from *Century*'s August 1882 article on the Zuñi pilgrimage to Washington. In that article small animals are illustrated and defined as the participants' autographs.

Later in 1883, Farny recycled some of these images in an oil painting, *Zuñi Weavers*. Perhaps his enthusiasm for the illustration project led him to believe he was depicting Zuñi lives correctly. In *Zuñi Weavers*, in place of the young Zuñi man with the cigarette, he incorporates the Hillers image of a Hopi man spinning.[69] (Rookwood Pottery artists also liked Hillers's spinning image. Artus Van Briggle used it on one of the company's ceramic chargers shown in the 1893 Chicago World's Columbian Exposition.) Hillers's photographs captured an actual scene, albeit extracted from its original surroundings and context. However, different impressions are created when an artist combines images from assorted photographs. Farny, true to his storyteller's personality, imposed Anglo culture on Pueblo culture by giving the people smiles and otherwise subtly altering the original images.[70]

Farny's interaction with the Zuñi may have resulted in the distinctive mark with which he signed most of his paintings and illustrations throughout his life. For the first time, under his name on the Zuñi illustrations for *Century*, Farny placed a distinctive circle with a dot in the center. An apocryphal story maintains that the symbol's origin lies with the Sioux, who gave him the motif because it stood for the name they gave him.[71] Farny, however, did not use the emblem on either of his *Toilers* paintings. Perhaps it was the Zuñi who inspired him to use the distinctive circle-dot; they gave him the name "White Medicine Bead," and Farny's circle-dot could be interpreted as a stylized rendition of a native-manufactured bead or a European glass trade bead.

Farny Joins the Henry Villard Excursion

Farny's second trip west, in 1883, was occasioned by an international celebration of a national landmark event. Financier and journalist Henry Villard, president of the Northern Pacific Railroad, planned a truly lush excursion to witness the completion of the track and inaugurate the railroad's transcontinental route—the northern route that many people had maintained would be impossible to complete. Villard invited more than three hundred guests from all parts of the country and from Europe to observe the driving of the last spike. Nearly everyone accepted, necessitating "four special trains from the East and one from the Pacific coast." A Helena paper listed Henry Farny as one of the distinguished guests: "H. F. Farney [*sic*], Esq., artist, *Century Magazine*."[72] Important personages, including former president Ulysses

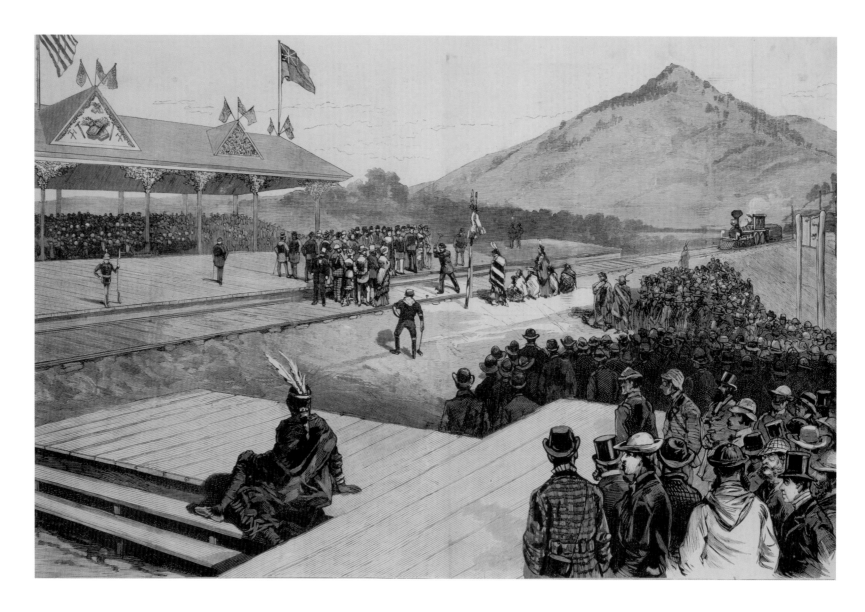

FIGURE 34
Henry Farny, *The Completion of the Northern Pacific Railway*, in *Frank Leslie's Illustrated Newspaper*, September 22, 1883, 73.
From the Collection of the Public Library of Cincinnati and Hamilton County.

S. Grant, mayors, judges, governors, and foreign guests joined the party. The excursionists witnessed two historic events: the laying of the cornerstone for the new Dakota Territory capitol building in Bismarck, and the driving of the last spike commemorating the completion of the Northern Pacific Railroad.

Sitting Bull, who had been brought from captivity for the occasion and rode a train for the first time, gave a few remarks at the cornerstone celebration at Bismarck. *Frank Leslie's Illustrated Newspaper* published two drawings of Sitting Bull: one a portrait and the other a picture of him riding a white horse in the parade.[73]

During his stay in Bismarck, Farny met and spoke with Sitting Bull. Years later, after Sitting Bull's death, Farny recalled the "amusing" circumstances under which he introduced the chief to General Grant. Upon realizing that Grant was the Great Father, Sitting Bull "instantly straightened up and assumed a dignified and important bearing, eyeing the great soldier from the crown of his hat to the soles of his shoes." In return Grant "scrutinized" the renowned chief "pretty closely." Farny talked about how the public "crowded" around Sitting Bull and how "one fool photographer gave him $100 for the privilege of taking his picture" and after that every "Indian wanted money in proportion to his standing in the tribe." Needless to say this gave Farny "a good deal of annoyance."[74]

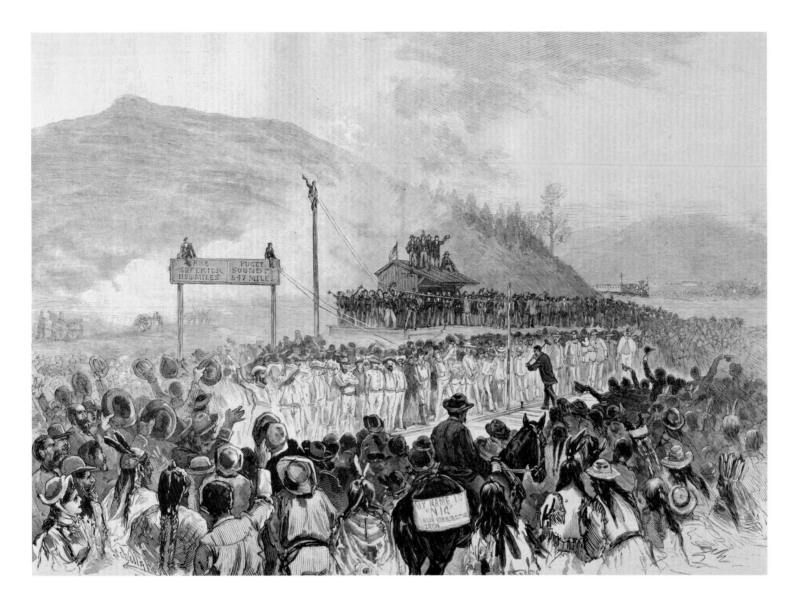

Farny's illustration of the ceremony surrounding the completion of the Northern Pacific Railroad appeared in *Leslie's Illustrated Newspaper* (fig. 34). Again, Farny was there as a participant observer, but he probably placed the participants in a composition designed to create a feeling of awe toward this technological marvel. Apprehensive Indians appear to be contemplating the much-heralded event—a lone Indian in the foreground and a few who stand or sit directly beside the track.[75] *Harper's* countered with its own illustration commemorating the momentous occasion (fig. 35). In comparing the two drawings, Farny's seems to express more character and emotion. The *Harper's* illustration, with throngs of people crowded around the rail, may well have been more historically correct.[76]

Villard used his influence with the Department of the Interior to arrange a purely Western entertainment for his guests. A group of Crow Indians "numbering two thousand warriors, squaws, and pappooses [*sic*], with wigwams and fifteen hundred ponies," the men in "full war array," performed "war dances" for the excursionists. Secretary of the Interior Henry M. Teller had granted permission for the Crow to leave their reservation to perform this "weird spectacle," which particularly appealed to Villard's European guests.[77]

This dance scene is the one that Farny captured and *Harper's Weekly* published as *A Dance of Crow*

FIGURE 35
Charles Graham, *The Northern Pacific Jubilee— Driving the Golden Spike*, wood engraving, *Harper's Weekly*, September 22, 1883, 601. Mary R. Schiff Library, Cincinnati Art Museum.

These two interpretations of the same event demonstrate how Farny streamlined and composed his scene to emphasize the Indian presence at this momentous occasion, which would accelerate the change already taking place in their lives.

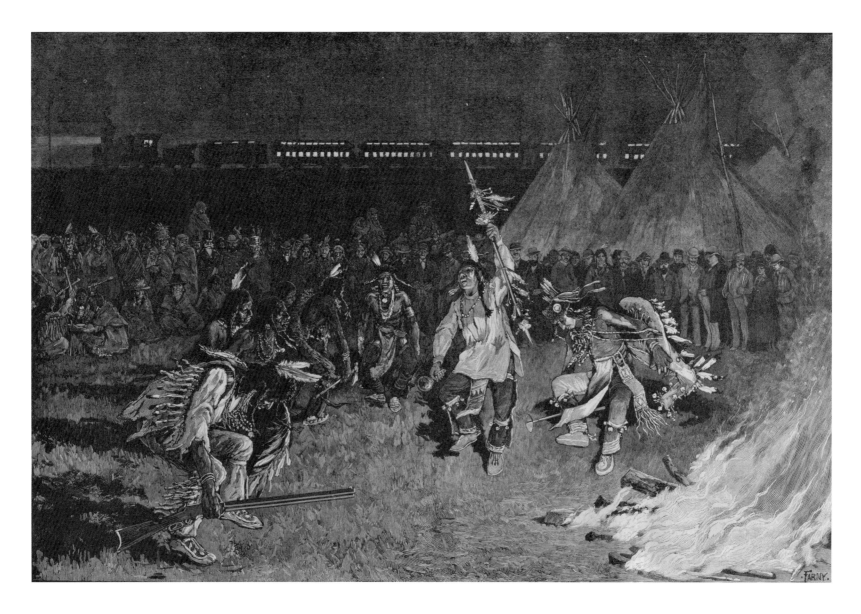

Indians (fig. 36). (A gouache variant of this image, cat. 1, is in the Cincinnati Art Museum collections). In this scene a distant excursion train is parked on the track, its windows glowing brightly in the night. The Crow have pitched their tipis beside the track, and numerous well-dressed spectators have disembarked and are watching the dance. For an ethnologist, the type of dance remains uncertain. The accompanying article states that the Crow "celebrated the occasion by a series of 'grass dances,' which were the most picturesque episode of that notable journey."[78] However, Villard, in his memoirs, called the dance a war dance.

Despite Villard's recollection, it is more likely, although not certain, that the dances were grass dances, so called because the dancers wore braids of sweet-smelling grass in their dance bustles. Although no braided grass or dance bustles are visible in Farny's scene, grass dances were common. It also seems extremely unlikely that the government would give its permission for the performance of a war dance; the government strictly forbad scalp and war dances after the establishment of the Crow Agency in 1883.[79] And yet, Farny shows Plains war shields and weapons in the dancers' hands—a rifle, a pipe-tomahawk (more ceremonial object than weapon), a lance ornamented with feathers, and a long-handled stone-head club.

It is not possible to determine if this scene is exactly what Farny witnessed, but we know that he actually saw the event. Based on his past practice of embellishing an image, he probably did take some artistic license with this highly picturesque scene, described in detail for *Harper's*. "The lurid light of the camp fires, deafening drum-beat, jingling bells of the dancers, and weird monotonous chant of the singers were echoed by the whistle of the locomotives as the excursion trains successively drew up."[80]

An ironic exercise in capitalism occurred that day when the Crow, "the untutored children of the desert sold the brass ornaments and bracelets which the President of the railroad [Villard] had given them in the afternoon at a handsome advance over the original cost of the same." One wonders why the Crow were considered "untutored" when they knew precisely how to turn brass trinkets into "shining silver dollars."[81] The excursionists were thrilled to take home Villard's trifles.

Farny Travels Down the Missouri River

In September 1884 Farny and Eugene V. Smalley, the writer, were part of a small *Century Magazine* information-gathering expedition. There has been scholarly dispute about the year of the expedition and whether Farny participated; however, both his presence and the year are documented in the *Helena Daily Independent*.[82] The object was "to descend the Missouri River in a skiff from some point near Helena, Montana, to the Great Falls," follow the river to Fort Benton, and then cross the country through sheep and cattle ranges. Farny proved an able hand at running rapids. The spectacularly wild scenery visible during the day gave way at night to "weird profiles and masks" looking down from giant steep rocky walls and, at night, gave the "wanderers a sense of loneliness and mystery."[83]

During this journey Farny learned that professional white buffalo-hunters had nearly exterminated the American bison, the animal that was the basis for all Plains lifeways, and that "an Indian might starve to death before he had the luck to find one [a buffalo]." He illustrated this tragic circumstance with a lone buffalo peering down into a steep canyon devoid of animal life.[84]

The excursionists also witnessed the dire straits of the Piegan Indians camped near the town of Fort Benton. Smalley openly discusses Piegan poverty in his article, but Farny's illustration (fig. 37) does not refer to the hardships the Indians endured. Because the Montana winter was rapidly approaching, many Piegan had moved close to the town, hoping to get "such subsistence as they could from the garbage-barrels of the citizens." The Indians, once "valorous hunters and warriors," were now "forced to beg at back doors

FIGURE 37
Henry Farny, *Piegan Camp on Teton River*, illustrated in *Century Magazine*, January 1888, 416. Mary R. Schiff Library, Cincinnati Art Museum.

Even though Farny witnessed the poverty of the Piegan Indians, his illustration leads viewers to believe the Piegan still lived a traditional lifestyle.

for kitchen refuse."[85]

Like Indians throughout the Plains, the desperate Piegan, relatives of the Blackfeet, had crowded around government agencies attempting to exist on the scanty government-issued rations. Indian reservations throughout the West had been stripped of wild game by white settlers and sport hunters, who violated Indian treaties and trespassed freely.

To readers of Smalley's article, none of the Piegans' destitution is visible; instead, Farny's illustration depicts a peaceful Indian camp scene with women carrying babies on their backs, another woman on the ground probably fleshing a hide, and another on horseback pulling a traditional travois—a skid for carrying tipis and other necessary items. Readers saw an idyllic scene reinforcing a romantic stereotype of traditional Plains Indian life, a view that evoked nostalgia for the rapidly disappearing American frontier. Perhaps Farny did not know that only the year before, during the bitterly harsh winter of 1883–84, hundreds of Blackfeet died of starvation on their reservation, unable to feed themselves.[86]

A Matter of Taste

Tranquil domestic situations such as the Piegan scene became Farny's hallmark; they held instantaneous appeal for many people. In fact, he created a gouache similar to his illustration for *Century Magazine*—*Piegan Camp on Teton River*—again without giving any evidence of Indian hardship.[87] Farny once wrote to a friend, "Pictures are essentially 'affaires de gout' [a matter of taste]—one man likes a color scheme, another wants a crass recitative of facts."[88] Farny's illustrations captured the emotion embodied in a specific activity or historic event, but probably were never intended, as he said, to be "a crass recitative of facts."

FIGURE 38
Henry Farny, *A Mountain Ranch*, photograph, illustrated in *Century Magazine*, September 1887, 731. From the Collection of the Public Library of Cincinnati and Hamilton County.

Farny took hundreds of photographs on his trips west. Because this image of a ranch house was published, it is one of the few known today.

Perhaps Farny believed historic facts are best left to photographers. In January 1884 the Camera Club of Cincinnati "came into an actual, if not a legal, existence" and quickly grew to about fifty members. Farny, known to the group as "the artist," traveled with his "servant-model" on the club's various photographic excursions. His friend, Dwight W. Huntington, who wrote an article about the club for *Century Magazine*, told about Farny's 1884 adventure with Smalley to the "far Northwest." He noted that Farny brought back not only numerous "color sketches," but also "many photographs of Indians, cowboys and plain-men, ranches, prairie, badlands, sage-brush, and everything, in fact, which an artist could see in the wilds of Montana" (fig. 38).[89]

The "instantaneous" camera process held a great deal of potential for artists and historians. It was thought to be "an art capable of expressing great artistic skill, elevated thoughts, and all that is beautiful in the creative imagination of genius."[90] Cincinnatians enjoyed experimenting with the new technology, and artists, such as Huntington and Farny, used it to their advantage. By 1893 Cincinnati's camera club membership included women and was hosting entertaining exhibitions of "rare views."[91]

Some of the photos, sketches, and paintings from Farny's 1884 trip west may be included in one of the books Huntington later wrote —*In Brush, Sedge, and Stubble: A Picture Book of the Shooting-Fields and Feathered Game of North America*. Huntington, an avid hunter, naturalist, artist, and photographer, made several trips west. The book included both Huntington's and Farny's artwork and includes excellent descriptions and images of northern Plains Indian lives in transition—for example, a tipi erected beside a government-constructed log cabin.[92]

The two men were close friends and, for this book, Farny undoubtedly reused or reworked images as needed, just as he had done with his Zuñi pictures or the Sioux *Toilers*. An interesting case in point is the picture captioned "Sage-Cock Shooting in Montana," which is nearly, if not identical, to a painting described as *Theodore Roosevelt "Sage Grouse Shooting,"* dated 1901 in an Indian Hill [Ohio] Historical Museum Association catalogue of a 1975 Farny exhibit. There is no documentation for either Huntington or Farny ever participating in a hunting trip with Roosevelt; perhaps the painting was simply an homage to Roosevelt's accomplishments as a game hunter.[93]

Henry Farny Entertains the Literary Club

Farny, considered a "rattling good storyteller" by one critic, presented two papers at the Literary Club in 1882—one, "Lacotah Yappi," in January and the other, "Dakotah Indians," in February.[94] The actual papers are not extant, but given the date, Farny probably talked about his experiences at Standing Rock reservation in 1881.

When Farny delivered another lecture, "About Some Indians," on January 3, 1885, two prominent Americans were present in the club-rooms—Mark Twain and George W. Cable, the southern novelist. While in Cincinnati they visited the famous Rookwood studios, making "quite an investment in pottery."[95]

Two years later, in 1887, Farny presented another paper whose subject was Indians, "The Sorrel Horse and the Thunder God." This paper is likely the same, or nearly the same work as the entertaining story that appeared in the Sunday *Commercial Gazette* on March 12, 1893. "Sorrel Horse's Medicine: A Yarn of the Buffalo Range" is about a "wild and charming" Sioux man, a sort of "Don Juan" (fig. 39). Farny not only wrote, but illustrated the story, which related Sorrel Horse's ability to "hear spirits whispering to him through the 'talking wire.'" He "had a holy dread of that awful and mysterious contrivance of the wicked palefaces." Farny's descriptive powers are superb; he tells of many changes in Sioux lives—for example, a "Fiery Horse which dragged whole rows of tepees [*sic*] full of people." Sorrel Horse's fall from "greatness" among his people and his return to being a "big Ingin" is a delightful tale and probably reflected some of Farny's reservation experiences, even though there may well not have been an actual Sorrel Horse.[96] Some of the descriptions of characters and activities in the story probably provided ideas for future paintings and drawings.

SORREL HORSE.

FIGURE 39

Henry Farny, *Sorrel Horse*, illustrated in the *Cincinnati Commercial Gazette*, March 12, 1893. From the Collection of the Public Library of Cincinnati and Hamilton County.

Farny's drawing accompanied his fictional tale of a "wild and charming" Sioux man who makes ingenious use of modern technology.

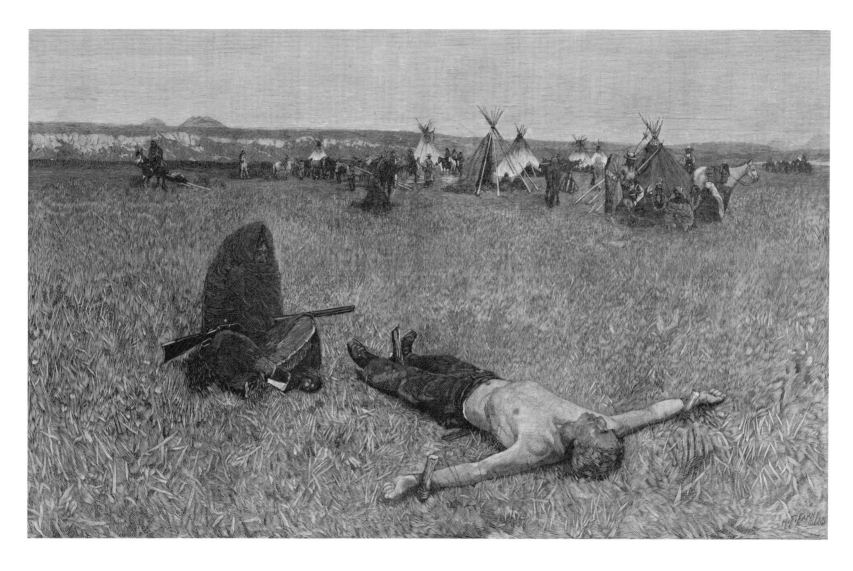

Farny Runs with the Indians

By 1889 the popularity of Farny's western Indian scenes forced him to establish a new studio at an undisclosed location in Covington, Kentucky. As Farny explained to a reporter, "I had so many visitors there [Cincinnati] (heaven bless them, for I like visitors) that at times there was a regular procession of them; and of course a regular procession of visitors interfered with regular hours of labor." The lucky reporter who found him noted that *Harper's* "monopolized" all Farny's black-and-white illustrations, and that a Hopi snake dance scene was already with the magazine.[97]

Indeed, during the 1880s, numerous wood engravings after Farny illustrations appeared in *Harper's Weekly*, all of which helped keep Indians before the nation's eyes and mind. Some were fairly factual, while others tended to be flat-out sensational, such as *The Killing of Abraham Lincoln, the Pioneer, 1786*, illustrating the first installment of *Abraham Lincoln: A History*, a monumental work serialized by *Century Magazine* over thirty-two issues. Farny's illustration vividly depicts the shooting of an Indian who has just killed Lincoln's grandfather. The marauding Indian, who in that time and place would certainly have been an Eastern Woodland warrior—probably a Shawnee—is dressed entirely in gorgeous Plains clothing.[98] In reality, in 1786 few whites had made contact with Great Plains people, let alone fought them in frontier Kentucky.

Farny's popularity increased as he painted more and more Indian subjects. He exhibited a "water-color" of "a subject from Indian life" at the American Art Association in New York, and based on visitors' votes, won a cash prize of $250.[99] *The Prisoner*, a gouache painted in 1885 that has since been retitled *The Captive* (cat. 3), is that painting deemed most popular by the public. This lurid image—right out of a dime novel—of a half-naked white man, staked out on the ground under a relentlessly hot sun, remains one of Farny's most popular works. The painting was reproduced as a wood engraving, also titled *The Prisoner*, for *Harper's* in 1886 (fig. 40); the accompanying article graphically described the staking-out process and was probably meant to engender white hatred for Indians. According to the author, Apache "hostiles" used this "woodenly cruel" torture after capturing a white man, leaving the captive's "buzzard picked bones" to be found at a later date. Here, in Farny's drawing, the Indian guard with his blanket and leggings is typically Lakota Sioux, not Apache; the surrounding scene is definitely reminiscent of Standing Rock.[100]

Farny could not have witnessed such a scene and when asked for the drawing probably did not realize the editors would publish an article with such a hostile tone. His quotes in Cincinnati newspapers let us know that he understood the hardships Indians endured on reservations as a result of federal policy.

Farny also recognized that Plains Indians retained some pleasurable traditions. The drawing of a young Cheyenne suitor courting his sweetheart with a love flute (fig. 41) graced the cover of another 1886 issue of *Harper's*. As with Farny's other illustrations, an article, "A Cheyenne Courtship," accompanied his drawing. The flute in the illustration, a Plains flute, was a common instrument played by some of the Indian groups living on the Great Plains. Traditionally only men played these flutes. A young man might sit at the edge of the camp and woo his intended with a melody; she could then discreetly emerge from her family's tipi to join him. Farny's drawing shows such a young woman moving quietly toward her lover. Farny's Plains flute is stylized but accurate; it depicts a bird, probably a sandhill crane, with an open beak.[101]

Another popular Farny illustration, *Suspicious Guests* (fig. 42), appeared in *Harper's* in 1887. One of the figures pictured is Farny's dear friend, the literary editor of the *Commercial Gazette*, Edwin Flynn, more commonly known as "Ed" Flynn.[102] In the illustration Flynn wears a monocle.[103] A large oil painting now in the Cincinnati Art Museum, *The Unwelcome Guests*, formerly titled *The Truce*, closely resembles Farny's illustration for *Harper's*.[104]

The article accompanying *Suspicious Guests* explained that the West had changed, with the coming of the train, making territory readily accessible without the necessity of holding "diplomatic negotiations with Indians" before proceeding across unmapped open terrain. Yet, the writer explained, even though the West was more easily traversed, some rogue Indians insisted on a "ceremonious parley" if "for no other reason than to enjoy the sensation of making a show of a proprietary interest in the hunting grounds, whether they have it [land] or not." The illustration—an uneasy confrontation between an Indian and white game hunters—shows such a "conference." In the end, "geographical information" was exchanged "for fire-water or a blanket."[105]

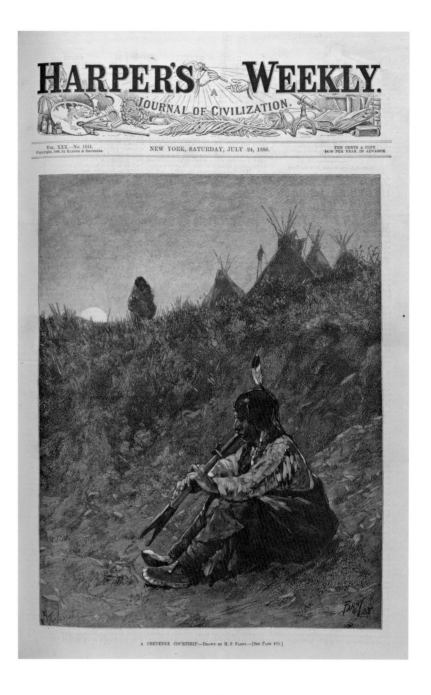

FIGURE 41
Henry Farny, *A Cheyenne Courtship*, wood engraving, cover page, *Harper's Weekly*, July 24, 1886. Mary R. Schiff Library, Cincinnati Art Museum.

This *Harper's* cover is typical of Farny's romantic images of Plains Indian life.

In March 1889 *Harper's* ran a story about Minnewaukau, the Great Salt Lake located about seventy miles from the Canadian border in present-day North Dakota.[106] Dwight Huntington, Farny's friend from the camera club, wrote the story, and Farny illustrated it with a few Sioux Indian images. Huntington called these people the "Cut-head Sioux," but most likely these are the Cuthead Yanktonai Sioux who moved to Fort Totten Reservation in the 1870s.[107] These Sioux, according to Huntington, were not artistically interesting, but "here and there upon the reservation we came upon an Indian grave—a rude scaffold supported by four poles. It would be difficult to imagine a more wild and desolate picture than one of those graves standing alone on the plain."[108]

The "transition" from being a traditional Indian who successfully hunted buffalo, Huntington wrote, to a reservation Indian "must have been startling in its suddenness." "As if by magic, the buffalo entirely disappeared." The Indian today, he said, finds, "himself an 'out-of-door' prisoner."[109]

Huntington, who enjoyed hunting in the West, also fondly recalled his welcoming reception at different forts—giving us a clue to what Farny also must have experienced. When a visitor arrived at a

FIGURE 42

Henry Farny, *Suspicious Guests*, double-page wood engraving, *Harper's Weekly*, February 5, 1887, 96–97. Mary R. Schiff Library, Cincinnati Art Museum.

This uneasy confrontation between an Indian and white game hunters suggests the larger challenges inherent in Indian/white relations.

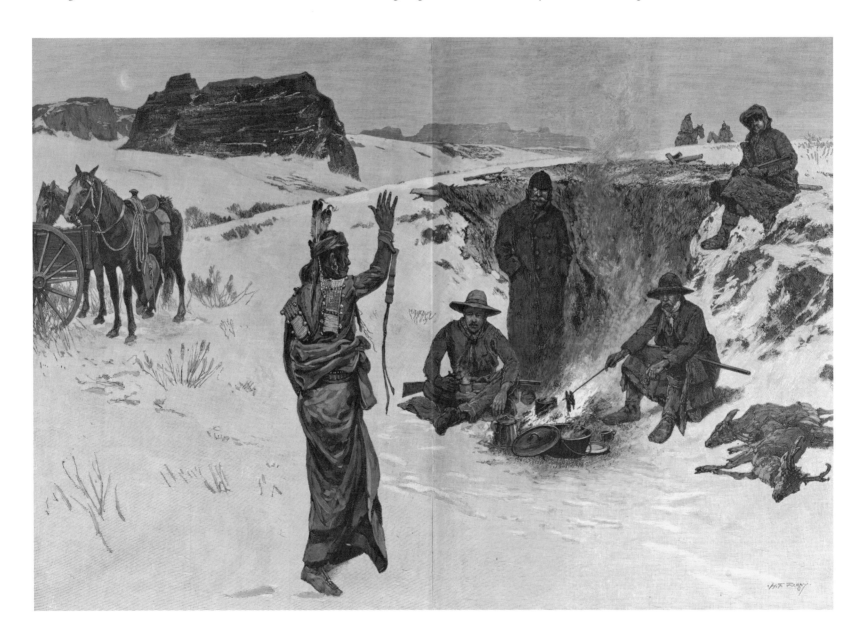

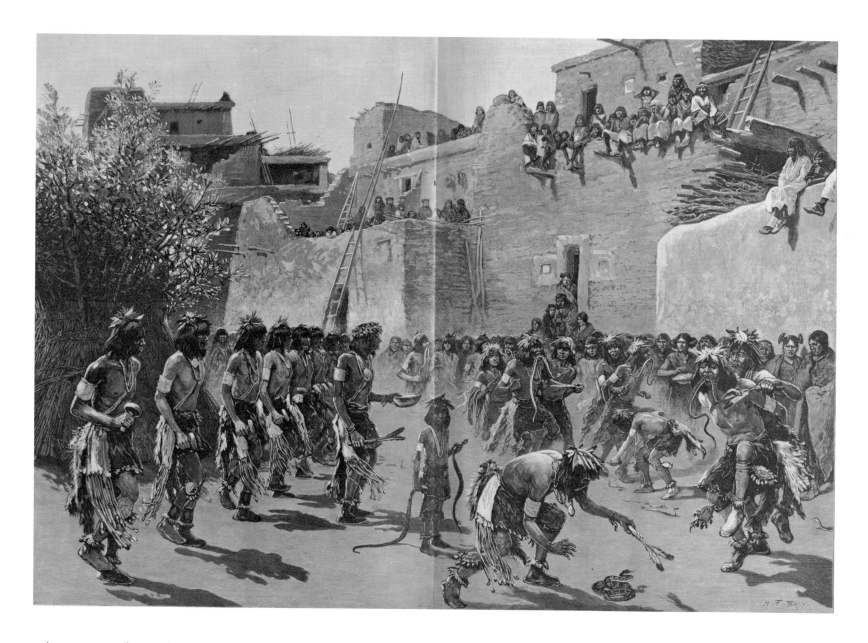

military garrison, the guest's stay became an occasion of "some importance." Officers called and generously invited the fort's guest "to ride, to hunt and fish, and to dine."[110] No doubt this explains why Farny enjoyed and spoke highly of his stays at western forts.

In November 1889 Farny illustrated *The Snake Dance of the Moqui Indians* (fig. 43), using as its image source photographs taken by Cosmos Mindeleff, an untrained anthropologist who participated in southwestern Indian fieldwork for the Smithsonian. "Moqui" is another name for the Hopi. Although we have no evidence that Farny traveled to the Hopi Pueblo, the clothing, ornaments, architecture, and even the dynamic of the dance are accurately drawn. Hand-woven white cotton rain sashes with swaying fringes can be seen on the dancers, who devoutly handle the snakes, a few held cautiously in the dancers' mouths. At the end of the ceremony the snakes are released to carry the Hopis' "message to the gods of the underworld." Whites have always been both horrified and fascinated by this event, during which men handle venomous serpents without any harmful effect. The accompanying article says that the author took great pains to be certain that his description of the ceremony was accurate.[111]

FIGURE 43
Henry Farny, *The Snake Dance of the Moqui Indians*, double-page wood engraving, *Harper's Weekly*, November 2, 1889, 872–73. Mary R. Schiff Library, Cincinnati Art Museum.

Farny used Cosmos Mindeleff's vivid ethnographic photographs as source images.

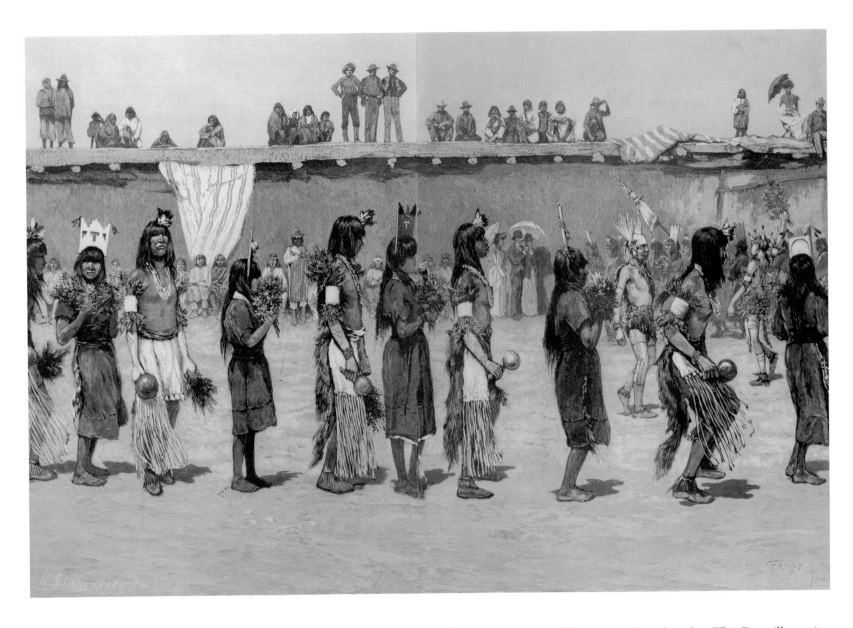

FIGURE 44
Henry Farny, *Indian "Tablet Dance"
at Santo Domingo, New Mexico*, double-page
wood engraving, *Harper's Weekly*, June 7,
1890, 444–45. Mary R. Schiff Library,
Cincinnati Art Museum.

Farny drew this ceremony after Charles F.
Lummis's photographs at Santo Domingo
Pueblo.

June 1890 brought another southwestern Pueblo event to *Harper's* readers. This Farny illustration showed both white and Pueblo spectators watching a "Tablet Dance" at Santo Domingo Pueblo, a village southwest of Santa Fe on the east bank of the Rio Grande River (fig. 44). Farny's drawing is "after" one of Charles F. Lummis's photographs. The genuinely spectacular dance is properly known as the Corn or Tablita Dance, named for the painted wooden headdresses, or *tablitas*, the young women wear. Farny's cutout designs on the *tablitas* are accurate. A Koshare clown, with his upper torso painted white and his hair done up in corn husks, struts beside the dancers. These popular dances are held in conjunction with saint's day festivities and attract Indians and non-Indians alike.[112]

Farny continued to be busy for *Harper's*, which indicates that the editors must have liked the images he produced. In March 1890 *Harper's* published *Sketches on a Journey to California in an Overland Train*, again described in a similarly titled article. It is difficult to know if Farny actually participated in the overland train ride, but his images appear to match the text, including descriptions of the trip and encounters with a few Shoshone and Paiute Indians.[113]

Farny Predicts Wounded Knee

In late 1890, the unarmed Sitting Bull was killed in a bloody shootout on Standing Rock Indian Reservation. Farny, keenly aware of government policy, explained to readers of the *Cincinnati Commercial Gazette* why this was a "needless cruelty" and that he feared the death of the chief "may cause a great deal of bloodshed."[114] Two weeks later, Farny's statement came true; the massacre of nearly three hundred Lakota Sioux, many of them women and children, occurred at Wounded Knee Creek on Pine Ridge Reservation in South Dakota on December 29, 1890. Not coincidentally, the massacring force was drawn from the Seventh Cavalry, Custer's old unit.

In solemn commemoration of the massacre, Farny illustrated *The Last Scene of the Last Act of the Sioux War* (fig. 45) for the February 14, 1891 issue of *Harper's Weekly*.[115] The tragic image depicts a lone Indian leaning mournfully against a burial scaffold on which has been placed the body of a Sioux warrior. His shield hangs from the scaffold. The sorrowful nighttime scene also includes a dead horse and an empty saddle, indicating the Indian will never ride again. The drawing embodies all the hopelessness of Plains Indians in their final horrific confrontation with the U.S. military.

FIGURE 45
Henry Farny, *The Last Scene of the Last Act of the Sioux War*, wood engraving, *Harper's Weekly*, February 14, 1891, 120. Mary R. Schiff Library, Cincinnati Art Museum.

This work commemorates the Massacre of Wounded Knee, expressing the despair that engulfed American Indians.

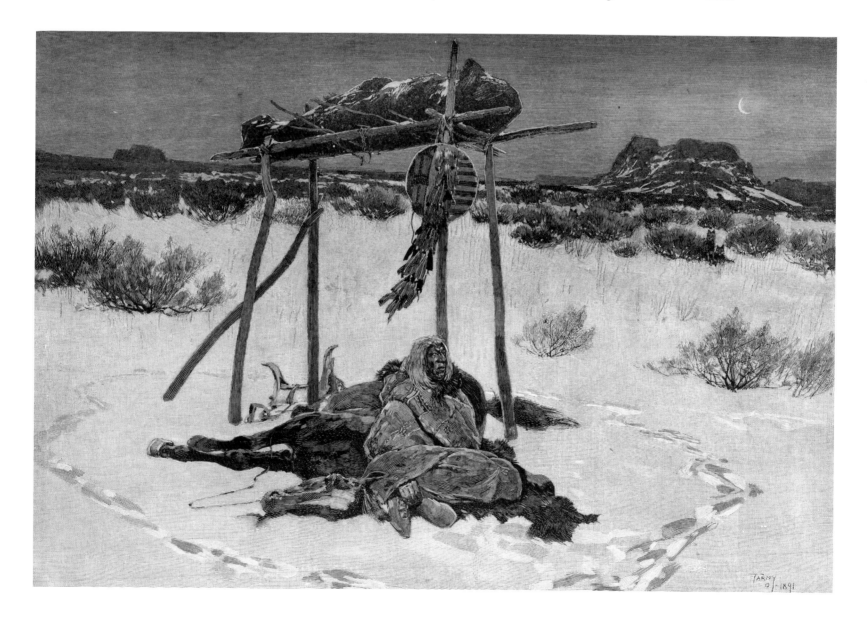

Although Farny did not witness such a scene after the massacre, he surely had seen how traditional Sioux buried their dead. The pathetic figure could well be a Lakota Sioux woman because the figure appears to be wearing a dress and has a bobbed hairstyle similar to the women in *Toilers*. An article, "The Story of Wounded Knee," describing the Wounded Knee Massacre from the military point of view, was published in conjunction with Farny's illustration.[116]

In 1881, sometime after his trip to Standing Rock, Farny had painted a nearly identical oil, *End of the Race* (fig. 12, p. 25).[117] The Indian woman beneath the scaffold ponders the loss of her loved one. Upon his return from Standing Rock, Farny had discussed with reporters the hardships the Lakota Sioux were enduring at the hands of the federal government. Like other Americans at the time, he probably thought Indians were doomed to extinction.

FIGURE 46
Sioux Indian Chief Threatens a Massacre,
illustrated in the *Cincinnati Commercial Tribune*, January 8, 1901, 3. From the Collection of the Public Library of Cincinnati and Hamilton County.

"Ogalalla Fire," a Sioux who lived in Cincinnati and modeled for Farny, was the subject of this tongue-in-cheek newspaper story.

Farny Hires His "Secretaries"

Most of his life Farny remained a bachelor, not marrying until 1906. Over the decades he employed a number of men, usually the down and out, to assist him in the studio and in the field. Farny referred to them as his "secretaries"—"old man Bee or Hennessey and others"—but they served as Farny's models as well.[118]

The most prominent of these "secretaries" was known to Farny's artist friends as "Ogallala Fire" (fig. 21, p. 32), also called Joe.[119] He had been a participant in the Battle of Little Big Horn; it was he who posed for the canvas *The Last of His Race*. Farny met Ogallala Fire at the Kohl and Middleton Dime Museum, where he performed a bear-wrestling act.[120] Besides assisting and modeling for Farny, he also worked as the janitor for the Cincinnati Art Club and was "habitually mistaken by the police for a bad Indian." One arrest resulted in Farny writing the city's mayor, explaining that this was a "monotonous nuisance" and might result in "war whoop" being heard once again on the site of Fort Washington (fig. 46).[121] Ogallala Fire died January 8, 1916, in Chicago at the age of ninety-one.[122]

Indignant over white treatment of Indians and generally sympathetic toward those in need, Farny helped Indians whenever he could. Another Sioux whom Farny met at the Kohl and Middleton Dime Museum was working a side show there. The Indian made a speech before the audience, saying, "me tired of these receptions, me want to see white chief Cleveland." Farny realized the Indian was being duped into believing that he would be taken to Washington to meet the president, when he was actually being exploited in a freak show. Furious over this "outrage," Farny arranged through influential friends for the Indian and his family to return to their home in the West.[123]

Henry Farny Celebrates the 1893 Columbian Exposition

Farny, who by the 1890s clearly was enjoying the success of his Indian paintings, continued to exploit opportunities for free publicity. When he agreed to prepare and hang an exhibit of sixty-two of his oil paintings and watercolors featuring Indians plus thirty-three non-Indian works in the Lincoln Club, he understood the importance of pleasing the wives of the city's most prominent Republican businessmen. The exhibit benefited the Women's Columbian Exposition Association of Cincinnati and Suburbs, a group whose mission was to create a "display of women's art work . . . more creditable even than the display at the Philadelphia Centennial, which gave an impetus to art industries in our city and placed the work of our women in the front rank of American accomplishment."[124]

The Lincoln Club, located at the southwest corner of Race Street and Garfield Place, was incorporated on February 12, 1879 and, as probably Cincinnati's oldest political organization, claimed many of its most influential Republicans as members. Named for the "immortal" Lincoln, the club owned its property and, according to its constitution, cultivated "the wider and broader field of maintaining its influence as a conservator of good government." Photographs of the exterior and interior demonstrate that the elegant facility could easily accommodate large groups of people for social events and business meetings alike. Lincoln Hall, for example, could seat an audience of five hundred people.[125]

At the exhibit opening on March 15, 1893, collectors who had lent their paintings for the exhibit laughed with "the jolly author and finisher of all these Indian braves, rocky canons [sic] and azure skies." Farny clearly found pleasure in the tremendous monetary values the owners had placed on his canvases. At the request of the Cincinnati Columbian Association, Farny hung Indian artifacts among his Indian paintings.[126]

Although the Columbian Association featured Farny's work as the main draw, it also included outstanding examples of artwork by Cincinnati women—pottery, needlework, etchings, prints, and woodcarvings. The exhibit committee planned the display as a prototype for the Cincinnati Room in the Women's Building at the World's Columbian Exposition in Chicago later that year. Through this project, described as an educational and artistic exhibit, the women also hoped to raise money for the upcoming Chicago event. After the exhibit opening, however, attendance was dismal. Even though glowing newspaper articles about the exhibit appeared almost daily, attendance remained so low that one honest reporter was forced to ask, "Will somebody with superhuman penetration explain why attendance . . . has been so slim?"[127]

Attendance did indeed pick up, advancing to "white heat" enthusiasm. Most important, the exhibits were declared a financial success.[128] A "brilliant crowd" attended on March 22, the final day of the exhibit, indicating that Cincinnatians "seemed at last to have awakened to the fact that this is their exhibition."[129]

Part of the history of the exhibit can be found in the association's carefully kept minutes. Even as late as December 19, 1892, the women struggled with the problem of how to raise the necessary funds. Alexander McDonald, president of both the Standard Oil Company and the Consolidated Coal and Mining Company, and the only member of the "gentlemen's advisory committee" to attend the January meeting, "urged" the women to raise $10,000 through the sale of one hundred $100 subscriptions. This money would serve as a guarantee fund and be used for any unforeseen deficiencies. It was suggested that a book for the subscriptions be placed in Robert Clarke's bookstore.[130] McDonald would lend the exhibit his Farny oil, *The Unwelcome Guests*, and Robert Clarke would lend his watercolor, *Apache*.[131]

The meeting minutes of January 30, 1893, noted that the women had received a letter from "Mr. Henry Farny consenting to arrange exhibit of his pictures & Indian curios as per request." His consent appeared in a newspaper article that the enthusiastic women glued into their minutes.[132]

After the opening of the Cincinnati Women's Association exhibit, Farny traveled to Chicago, where he spent a week serving as a member of the national jury of "eminent" painters responsible for selecting works by American artists for the World's Fair. Despite the furor over the fact that a disproportionate number of East Coast artists were selected for the art exhibit, Farny remained unfazed by the stress of the selection process. The stated mission was to select pictures representing the "various mediums from the easels of American artists." Upon his return to Cincinnati Farny said, "There is one thing I can say for that jury, that it was honest, fearless and unprejudiced." For him the effort was not a hardship because he was entertained with "dinners that were poetry in Gorham silver and china, and [I] wouldn't have missed it for a cold, clammy $500 bill."[133] Three of his paintings hung in the section "American Water Colors in Place" and received the following review: "Still more realistic are Farny's Western scenes, *The Sioux Camp*, *The Mountain Trail*, and *Got Him* [cat. 7]. The last named shows the cavalryman's way of settling the Indian question."[134]

General Miles Invites Farny to Fort Sill

Farny's last documented journey west occurred in 1894. General Nelson Miles cabled Farny in October, inviting the artist to participate in an inspection tour of Fort Sill Reservation, in the then Indian Territory, today roughly the state of Oklahoma. Farny packed his art supplies and departed for the West that very day. Comanche and Kiowa warriors, the legendary Geronimo, and Geronimo's group of renegade Chiricahua Apache were at Fort Sill. The Apache had recently been transferred to Fort Sill after captivity first in Florida, then at the Mount Vernon Barracks near Mobile, Alabama, caused so many to suffer and die from the humidity. The old warrior chief Geronimo sat for Farny and "captured" his "heart by tracing his autograph" in large capital letters on the edge of his portrait (fig. 19, p. 30).[135]

Through Colonel Jones, the resident interpreter, Farny talked with a number of Indians living at Fort Sill. He later told a reporter for the *Cincinnati Commercial Gazette* that he "found the Indian at his best as a soldier; at his worst as a gambler, a beggar and a drunkard." "Gambling circles," he said, were seen all around the camp at various times, with "pecans" frequently serving as "the stake."[136]

Farny also made sketches of "Nana." In fact this probably was Naiche, Geronimo's elderly confederate, who had spent most of his life attempting to exterminate the white man. He told Farny that he no longer wanted to fight the white man, because "for everyone whose throat he cut three others sprang up." After Farny's return to Cincinnati, one reporter claimed that the artist's studio, with its new Indian portraits, resembled "a rogue's gallery, composed of the prize murderers of the world."[137] Farny also entertained the Cincinnati Art Club with tales of his adventures and a display of his recent paintings from Fort Sill.[138]

An Unusual Wild West Show

Although we have no documentation that Farny traveled west after 1894, he did have one more occasion for extended contact with Plains people. During the summer of 1896 the Cincinnati Zoological Gardens produced an "educational" Wild West show that rivaled Buffalo Bill's. The zoo program, however, lasted three months. After securing permission from the Bureau of Indian Affairs, the zoo hired eighty-nine Lakota Sioux Indians from Rosebud Reservation in South Dakota. Men, women, and children brought their Plains Indian finery, their horses, and their tipis aboard the train, and upon arrival in Cincinnati camped at the zoo. They presented two shows daily, but otherwise acted as tourists, visiting local attractions, shopping downtown, and making friends with local citizens and artists. The summer's activities made a lasting impression on the Indians and the Cincinnatians who became their friends. Information about the Lakota Sioux encampment survives today in the National Archives in Washington, in Cincinnati papers and libraries, and in artwork created by artists at the time. Several letters from Lakota Sioux visitors to the photographer Enno Meyer tell him that they would like to return to Cincinnati to participate in another play at the zoo; Arthur Belt, whose Lakota name was Blokaciqa, fondly remembered "Farnning" and asked Meyer to give Farny his regards.[139]

Farny Recognizes His Greatest Accomplishment

Henry Farny had many admirers, including the esteemed military and political leaders Ulysses S. Grant and Theodore Roosevelt. When Roosevelt visited Cincinnati in September 1902, he made a point of seeing an art display in Music Hall in which Farny's paintings hung. Roosevelt commented favorably on all the Farny pieces, but *The Sentinel*, *The Captive* (cat. 3), and *The Last Vigil* really captured his attention. Farny is reported to have honored Roosevelt previously by painting a picture of him hunting, *Theodore Roosevelt "Sage Grouse Shooting."*[140] It is uncertain, however, if the man in the painting really is Roosevelt.

Roosevelt was not alone in his admiration of the western landscapes and Indian scenes that Farny depicted in such beautiful detail. Frequently Farny's paintings sold literally off the easel, even before he had finished them. He never had a sufficient inventory of unsold works to hold a solo show outside Cincinnati.

Although Farny loved to paint, there must have been moments in his later years when he chafed under the tyranny of success. A letter to Farny around 1904 from Thomas T. Gaff, a wealthy midwestern businessman who had made his fortune in Cincinnati and had moved to Washington, tells him that he could easily "please" a potential client by inserting an Indian and a buffalo into the painting. Gaff said he hated to make these suggestions because "you told me you had tired of these subjects, but, you see, it's hard for a man to get away from the genre that he has created."[141]

Perhaps that is why, as a featured speaker at a lavish dinner attended by fifty of the city's most prominent citizens, Farny may have startled his audience by saying that his illustrations for the McGuffey readers thirty years before had been his greatest achievement in art, "for that went into the hands of hundreds of thousands of children all over this country."[142]

Farny went on to mention work he had done early in his career for a meat packer—"they called me the 'hog artist'"—with his usual comic flourishes. He reminisced about the tribulations and joys of his life as an artist. Interestingly, he did not once mention the twenty-five years of Indian and western paintings for which he was known.[143]

And is still known. Several of Farny's paintings are so immediately recognizable they have become icons of western art, demonstrating his genius as a storyteller of Indian life.

Ironically, as time moved on and the myth of the West grew, the romantic aspects of Farny's work took on for the popular audience, ignorant of Indian history, an air of reality. Farny clearly understood the allure of the mythic West and, determined to be a successful artist, gave his buyers what they wanted.

The dichotomy between Farny's gorgeous romanticism and the way Plains Indians had come to live was obvious, even at the time. A *Cincinnati Commercial Gazette* reporter wrote that Farny's "genius-guided brush" had "a tendency to revive that romance, or mayhap more correctly speaking, to develop to the senses a real trait of the romantic in the American aboriginie [sic]." Lovers of Indian life and character set in the Great Plains and depicted by Farny had to "feel a bit sentimental over the savage and his fate." If a person is not impressed by the artist's work then let "him listen and amid these surroundings [Farny's studio] to a recital by the artist of the incidents of his visit to Fort Sill."[144]

Very few members of the public had the opportunity to listen to Farny's stories in his studio. They accepted his art at face value—as accurate renditions of Indian life during the glory days of Plains Indians. Ignorant or not of the grim realities of Indian life, people loved Farny's work. And it is even safe to say that Indians did not find a problem with the way he represented them, following traditional life-ways. They signed the portraits Farny made of them on the reservation and appear to have talked freely with him when he visited them or met them elsewhere.

Today, many people still do not realize that Farny really understood Indian hardships and government policy. For this reason, an ethnological examination contributes important information to the study of his work.

* *

Epigraph: Carl Vitz, "Henry F. Farny and the McGuffey Readers," *Bulletin of the Historical and Philosophical Society of Ohio* 12, no. 2 (April 1954): 105.

1. "In Farny's Studio," *Cincinnati Tribune*, October 6, 1895, 22.

2. John C. Ewers, "Fact and Fiction in the Documentary Art of the American West," in John Francis McDermott, ed., *The Frontier Re-examined* (Chicago: University of Illinois Press, 1967), 83.

3. Ibid., 85, 87.

4. "Our Artists," *Cincinnati Enquirer*, March 22, 1874, 7.

5. Denny Carter, *Henry Farny* (New York: Watson-Guptill Publications in association with the Cincinnati Art Museum, 1978), 6, 13–19; Robert Taft, "Pictorial Record of the Old West X. Artists of Indian Life: Henry F. Farny," *Kansas City Historical Quarterly* 18, no. 1 (February 1950): 1–19; George McLaughlin, "Cincinnati Artists of the Munich School," *American Art Review* 2, no. 13 (November 1880): 1.

6. John R. Swanton, *The Indian Tribes of North America* (Washington, D. C.: Smithsonian Institution Press, 1979), 36; Helen Hornbeck Tanner, ed., *Atlas of Great Lakes Indian History* (Norman: University of Oklahoma Press, 1987), 74–75. The Connewango or Conewango village of Seneca Indians was located at Warren, Pennsylvania on the Allegheny River. The Seneca lost all of their land in Pennsylvania in the late 1700s, but undoubtedly some Seneca still remained in the area when the Farny family arrived.

7. "Artist Farny," *Cincinnati Enquirer*, June 24, 1900, 17.

8. Ibid.; "Ancient Indian Lore Familiar to Farny, Who Reveals Secrets," *Cincinnati Times Star*, August 25, 1911, 11.

9. Lewis H. Morgan, "Report," in *Third Annual Report of the Regents of the University, on the Condition of the State Cabinet of Natural History, and the Historical and Antiquarian Collection Annexed Thereto* (Albany: Weed Parsons & Company, 1850), 65–95.

10. Writers' Program of the Work Projects Administration, *Ohio Guide* (New York: Oxford University Press, 1940), 199–200.

11. Joseph Bird, *The Singing School Companion: A Collection of Secular and Sacred Music* (Boston: Oliver Ditson & Company, 1852), free paper in front of book. Farny's copy is in the Rare Books and Special Collections Department of the Public Library of Cincinnati and Hamilton County.

12. Carter, *Henry Farny*, 15.

13. Ibid.

14. I am grateful to Rick Kesterman, who found the early rendition of the fort painted by H. W. Kemper; the date is 1857. The chromolithograph of the painting was printed by Ehrgott & Forbriger. Even though both images give the date 1790, the completed construction date was actually 1789.

15. Carter, *Henry Farny*, 15, 16.

16. Susan Labry Meyn, "Enduring Encounters: Cincinnatians and American Indians to 1900," in Anita Ellis and Susan Labry Meyn, *Rookwood and the American Indian* (Athens: Ohio University Press, 2007), 4–6.

17. Carter, *Henry Farny*, 16–19; Henry Farny, *The Turner Festival at Cincinnati, Ohio, Harper's Weekly* 9 (September 30, 1865): 620–21.

18. *Appletons' Illustrated Almanac, for 1869* (New York: D. Appleton and Company, 1868), 26, 34, 42.

19. *The Literary Club of Cincinnati: Constitution, Catalogue of Members, etc.* (Cincinnati: C. T. Woodrow & Co., 1879), 22; *The Literary Club of Cincinnati, 1849–1903* (Cincinnati: The Ebbert & Richardson Co., [1903]), 69.

20. *Official Illustrated Catalogue of the Art Department Twelfth Cincinnati Industrial Exposition* (Cincinnati: Weisbrodt, 1884), cover.

21. *Third Cincinnati Industrial Exposition, Official Catalogue of the Works of Painting, Sculpture and Engraving Exhibited in the Art Department, 1872* (Cincinnati: Wrightson & Co., 1872), 205; "Our Artists," *Cincinnati Enquirer*, March 22, 1874, 7. I am indebted to M'Lissa Kesterman, reference librarian at the Cincinnati Historical Society, Cincinnati Museum Center, for assisting with the research on Farny's works shown in the expositions.

22. *Illustrated Catalogue of the Art Department, Tenth Cincinnati Industrial Exposition, 1882* (Cincinnati: Robert Clarke & Co., 1882), 7, 11, 12, 25, 67. Again, my thanks to reference librarian M'Lissa Kesterman of the Cincinnati Historical Society, Cincinnati Museum Center.

23. "Our Artists," *Cincinnati Enquirer*, March 22, 1874, 7.

24. Ibid.

25. "The Week in Art Circles," *Cincinnati Enquirer*, December 31, 1916, 6.

26. Hadley Chalmers, "Society for the Suppression of Music," *Bulletin of the Historical and Philosophical Society of Ohio* 11, no. 4 (October 1953): 314–19.

27. Clara De Vere, *The Exposition Sketchbook: Notes of the Cincinnati Exposition of 1881* (Cincinnati: H. W. Weisbrodt & Co., 1881), not paged. Clara De Vere is probably a pseudonym for Clara Anna Rich Devereux, a well-known Cincinnati newspaper-woman. "The Ninth Exposition," *Cincinnati Daily Gazette*, September 15, 1881, 9.

28. Yeatman Anderson III and Carl Vitz, compilers, "Ye Giglampz," 2, 6. This is an unpublished manuscript, dated July 1952, in an uncatalogued vertical file located in the Rare Books and Special Collections Department of the Public Library of Cincinnati and Hamilton County. Carl Vitz, "Henry F. Farny," in William Coyle, ed., *Ohio Authors and Their Books* (Cleveland: World Publishing Company, 1962), 201.

29. Jon C. Hughes, "The Short Life and Death of 'Ye Giglampz,'" *The Cincinnati Historical Society Bulletin* 40, no. 2 (summer 1982): 100–123; Anderson and Vitz, 7.

30. W. H. Venable, *Dramas and Dramatic Scenes* (Cincinnati: Van Antwerp, Bragg & Co., 1874).

31. William D. Andrews, "Women and the Fairs of 1876 and 1893," *Hayes Historical Journal* 1, no. 3 (spring 1977): 173–84; "The Centennial Fair," *Cincinnati Enquirer*, May 20, 1875, 8.

32. "The Women's Work," *Cincinnati Enquirer*, May 21, 1875, 8.

33. Carl Vitz, "Henry F. Farny and the McGuffey Readers," *Bulletin of the Historical and Philosophical Society of Ohio* 12, no. 2 (April 1954): 90–108; Alfred Segal, "Mr. Vitz Goes Back to McGuffey's and Brings Old Mr. Farny to Light," *Cincinnati Post*, May 12, 1954, 15.

34. "Amusements," *Cincinnati Daily Gazette*, December 31, 1872, 4; January 6, 1873, 4.

35. "Buffalo Bill at Heuck's," *Cincinnati Daily Gazette*, November 15, 1881, 3.

36. "Buffalo Hunt," *Cincinnati Commercial Gazette*, June 3, 1883, 2.

37. M. E. Thalheimer, *The Eclectic History of the United States* (Cincinnati: Van Antwerp, Bragg & Co., 1881), iv, 9; Meyn, "Enduring Encounters," in *Rookwood*, 14.

38. Thalheimer, *The Eclectic History*, 11, 20.

39. In 1880 the internationally renowned Robert Clarke's bookstore was located at 65 West Fourth Street between Vine and Walnut Streets; Henry Farny's studio was located in room 62 in Pike's Opera House Building, also between Vine and Walnut Streets. According to a city atlas Farny's studio was the next building west. Cincinnati street numbering changed in 1896. I am grateful to Rick Kesterman for confirming the locations. Farny's composition book is in private hands in Cincinnati and was reviewed by Meyn on January 29, 2007.

40. "Sitting Bull," August 2, 1881, 5; "The War Chief Sitting Bull," August 10, 1881, 5; "Sitting Bull," August 27, 1881, extra sheet 1. The articles are in the *Cincinnati Commercial*. Robert M. Utley, *The Lance and the Shield: The Life and Times of Sitting Bull* (New York: Henry Holt and Company, Inc., 1993), 236–41.

41. "The War Chief Sitting Bull"; "Sitting Bull," August 27, 1881, extra sheet 1.

42. "The Apache Outbreak," *Cincinnati Daily Gazette*, September 14, 1881, 5. The outbreak was also discussed in "Massacred by Apaches," *Cincinnati Daily Gazette*, September 5, 1881, 2.

43. "Lo, the Bouncing Bison," *Cincinnati Daily Gazette*, October 29, 1881, 4.

44. "Lo! The Poor Indian," *Cincinnati Enquirer*, November 8, 1881, 8; "Mr. Farny Among the Sioux," *Cincinnati Daily Gazette*, November 8, 1881, 8.

45. "Mr. Farny Among the Sioux."

46. "Lo! The Poor Indian."

47. "Studio Studies," *Cincinnati Commercial*, December 1, 1881, 4.

48. "Some Art Notes," *Cincinnati Daily Gazette*, January 28, 1882, 6.

49. Carolyn M. Appleton and Natasha S. Bartalini, *Henry Farny: 1847–1916* (Austin: University of Texas, 1983), 12.

50 Raymond J. DeMallie, "Yankton and Yanktonai," in William C. Sturtevant, ed., *Handbook of North American Indians*, vol. 13, part 2 (Washington, D.C.: Smithsonian Institution, 2001), 782.

51. "The Women's Columbian Association Art Exhibit," *Cincinnati Commercial Gazette*, March 14, 1893, 9. This article was written by Ed Flynn, who is actually Edwin F. Flynn, the literary editor for the *Cincinnati Commercial Gazette*. Flynn has been called "Edward," but there is no Edward Flynn listed in the 1893 *Williams' Cincinnati Directory*, only an "Edwin Flynn" on page 524. Flynn's manuscript for the newspaper article is in the Rare Books and Special Collections Department of the Public Library of Cincinnati and Hamilton County.

52. Henry Farny, *Toilers of the Plains*, *Harper's Weekly* 28 (June 21, 1884): 393; "Toilers of the Plains," *Harper's Weekly* 28 (June 21, 1884): 395. The Cincinnati Art Museum accession number for *Toilers of the Plains* is 2003.63.

53. *Explication des Ouvrages de Peinture, Sculpture Architecture Gravure et Lithographie des Artistes Vivants Exposés au Palais des Champs-Élysées* (Paris: Charles de Mourgues Fréres, 1882), 88. Farny's painting is listed as "Femme Sioux dans les plaines brulées" and this document is in the Cincinnati Art Museum curatorial research file on Farny. Farny's address is given as both Cincinnati and Paris.

54. "Art Notes," *Cincinnati Daily Gazette*, May 6, 1882, 6; Robert Herron, "Have Lily, Will Travel: Oscar Wilde in Cincinnati," *Bulletin of the Historical and Philosophical Society of Ohio* 15, no. 3 (July 1957): 229.

55. Henry Farny, *Ration Day at Standing Rock Agency*, *Harper's Weekly* 27 (July 28, 1883): 472–73; "The Indian Problem," *Harper's Weekly* 27 (July 28, 1883): 470.

56. "Lo! The Poor Indian"; *Ration Day*, 472–73.

57. "Mr. Farny Among the Sioux."

58. "Lo! The Poor Indian."

59. Ibid.

60. Ibid.; "Mr. Farny Among the Sioux."

61. Frank H. Cushing, "My Adventures in Zuñi," parts 1–3, *The Century Magazine* 25, no. 2 (December 1882): 191–207; 25, no. 4 (February 1883): 500–11; *The Century Magazine* 26, no. 1 (May 1883): 28–47. All issues of *Century* from 1881–1899 are digitized for online viewing as part of Cornell University's Making of America Journal Collection, http://cdl.library.cornell.edu/moa/

62. Untitled, *Daily Gazette*, July 29, 1882, 7; Sylvester Baxter, "An Aboriginal Pilgrimage," *The Century Magazine* 24, no. 4 (August 1882): 530, 532.

63. Baxter, "An Aboriginal Pilgrimage," 526.

64. "The Zuñi Indians," *Harper's Weekly* 26 (January 28, 1882): 58–59. Hillers's images appear on page 57.

65. Jesse Green, ed., *Cushing at Zuñi: The Correspondence and Journals of Frank Hamilton Cushing, 1879–1884* (Albuquerque: University of New Mexico Press, 1990), 142, 155, 225, 243. Excerpts from Metcalf's journal are in the same publication. Sylvester Baxter, "The Father of the Pueblos," *Harper's New Monthly Magazine* 65 (June 1882): 72–91.

66. Green, *Cushing at Zuñi*, 225, 268, 271.

67. Kate Peck Kent, *Pueblo Indian Textiles: A Living Tradition* (Santa Fe: School of American Research Press, 1983), 59. The image number for the Hillers photograph *Man Weaving Blanket on Vertical Loom Suspended from Adobe Wall* is 02117200, National Anthropological Archives, Smithsonian Institution.

68. The image number for the Hillers photograph *Boy in Native Dress with Ornaments Near Eagle and Eagle Cage Made of Adobe and Sticks* is BAE GN 02382, National Anthropological Archives, Smithsonian Institution.

69. The image number for the Hillers photograph *Man in Native Dress on Blanket Using Spindle* is BAE GN 01837B, National Anthropological Archives, Smithsonian Institution. The curatorial research file on Farny's oil painting *Zuñi Weavers* is in the Cincinnati Art Museum. Farny's painting also includes a young girl from another image and, as did many people, the curator assumed the weaver was a woman.

70. Cushing, "My Adventures in Zuñi," part 2, 25 (February 1883): 501, 504.

71. Carter, *Henry Farny*, 24.

72. Henry Villard, *Memoirs of Henry Villard*, vol. 2 (Boston: Houghton, Mifflin and Company, 1904), 309; "Villard's Guests," *Helena Daily Herald*, September 7, 1883, 1.

73. Utley, *The Lance and the Shield*, 261; "The Completion of the Northern Pacific Railway," *Frank Leslie's Illustrated Newspaper* 57 (September 22, 1883): 72, 77. Articles accompany the drawings.

74. "A Needless Cruelty," *Commercial Gazette*, December 18, 1890, 12.

75. "The Completion of the Northern Pacific Railway," 73.

76. "The Northern Pacific Jubilee—Driving the Golden Spike," *Harper's Weekly* 27 (September 22, 1883): 601.

77. Villard, *Memoirs*, 311.

78. Henry Farny, *A Dance of Crow Indians*, *Harper's Weekly* 27 (December 15, 1883): 800; "Dance of the Crow Indians," *Harper's Weekly* 27 (December 15, 1883): 798–800. The Cincinnati Art Museum accession number for *A Dance of Crow Indians* is 1964.159.

79. Fred W. Voget, "Crow," in William C. Sturtevant, ed., *Handbook of North American Indians*, vol. 13, pt. 2 (Washington, D.C.: Smithsonian Institution, 2001), 707.

80. "Dance of the Crow Indians," 798–99.

81. Ibid.

82. Eugene V. Smalley, "The Upper Missouri and the Great Falls," *The Century Magazine* 35, no. 3 (January 1888): 416. Articles discussing the other participants also appeared in the *Helena Daily Independent*: "Down the Missouri," September 16, 1884, 5; "Down the River," September 30, 1884, 5. Farny is the only artist mentioned.

83. Smalley, "The Upper Missouri," 408–18. Taft, "Henry F. Farny," 15, note 45 confirms the year of this "expedition."

84. Smalley, "The Upper Missouri," 414, 417.

85. Ibid., 417.

86. John C. Ewers, *Artists of the Old West* (New York: Doubleday & Co., 1965), 226.

87. Carter, *Henry Farny*, 51.

88. H. F. Farny to Mr. Anderson, May 3, 1902. The letter is located in the curatorial file at the Cincinnati Art Museum.

89. Dwight W. Huntington, "The Camera Club of Cincinnati," *The Century Magazine* 34, no. 5 (September 1887): 729–32.

90. "An Art Reception," *Cincinnati Daily Gazette*, October 26, 1881, 9.

91. "The Camera Club," *Cincinnati Commercial Gazette*, March 18, 1893, 6.

92. Dwight W. Huntington, *In Brush, Sedge, and Stubble: A Picture Book of the Shooting-Fields and Feathered Game of North America* (Cincinnati: The Sportsman's Society, 1898), 15.

93. Elting E. Morison, *The Letters of Theodore Roosevelt* (Boston: Harvard University, 1951). This annotated eight-volume series contains numerous references to Roosevelt's hunting trips, but makes no mention of either Farny or Huntington.

94. *The Literary Club of Cincinnati, 1849–1903* (Cincinnati: The Ebbert & Richardson Co., [1903]), 69; James Normile, "Images of the American Indian," *Architectural Digest* 31, no. 2 (1974): 46–49.

95. *The Literary Club of Cincinnati, 1849–1903*, 69; "The Literary Club," *Cincinnati Enquirer*, January 4, 1885, 4; Carl Vitz, "J. B. Pond and Two Servants," *Bulletin of the Historical and Philosophical Society of Ohio* 17, no. 4 (October 1959): 277–84.

96. Henry Farny, "Sorrel Horse's Medicine: A Yarn of the Buffalo Range," *Cincinnati Commercial Gazette*, March 12, 1893, 19.

97. "Hidden from the World," *Cincinnati Times Star*, September 12, 1889, 8.

98. Henry Farny, *The Killing of Abraham Lincoln, the Pioneer, 1786*, in John G. Nicolay and John Hay, *Abraham Lincoln: A History*, *The Century Magazine* 33, no. 1 (November 1886): 17. Nicolay and Hay were two of Lincoln's secretaries. Installments of *Abraham Lincoln* were published in every issue of *Century* from November 1886 through February 1890.

99. "Personal," *Harper's Weekly* 29 (November 28, 1885): 771; Carter, *Henry Farny*, 26, 67. The bronze award plaque for this painting is in the Cincinnati Art Museum object file.

100. Henry Farny, *The Prisoner*, *Harper's Weekly* 30 (February 13, 1886): 109; "Staked Out," *Harper's Weekly* 30 (February 13, 1886): 107. The Cincinnati Art Museum accession number for *The Captive* is 1927.38.

101. Henry Farny, *A Cheyenne Courtship*, *Harper's Weekly* 30 (July 24, 1886): cover illustration; "A Cheyenne Courtship," *Harper's Weekly* 30 (July 24, 1886): 471.

102. Henry Farny, *Suspicious Guests*, *Harper's Weekly* 31 (February 5, 1887): 96–97; "Suspicious Guests," *Harper's Weekly* 31 (February 5, 1887): 94–95.

103. *Williams' Cincinnati Directory* (Cincinnati: Williams & Co., 1893), 524. This year was chosen because that is the year Flynn authored a lengthy article about Farny for the *Commercial Gazette*. "Edwin Flynn," *Cincinnati Times Star*, June 22, 1954, 3 is his obituary.

104. Carter, *Henry Farny*, 27, 68. The Cincinnati Art Museum accession number for *The Unwelcome Guests* is 1943.14.

105. "Suspicious Guests," 94–95.

106. Dwight W. Huntington, "Minnewaukau, The Great Salt Lake of Dakota," *Harper's Weekly* 33 (March 9, 1889): 187; Henry Farny, *The Great Salt Lake of Dakota*, *Harper's Weekly* 33 (March 9, 1889): 192.

107. DeMallie, "Yankton and Yanktonai," *Handbook of North American Indians*, vol. 13, part 2, 784.

108. Huntington, "Minnewaukau," 187; Farny, *The Great Salt Lake*, 192.

109. Ibid.

110. Ibid.

111. Henry Farny, *The Snake Dance of the Moqui Indians*, *Harper's Weekly* 33 (November 2, 1889): 872–73; William M. Edwardy, "Snake Dance of the Moqui Indians," *Harper's Weekly* 33 (November 2, 1889): 871.

112. Henry Farny, *Indian "Tablet Dance" at Santo Domingo, New Mexico*, *Harper's Weekly* 34 (June 7, 1890): 444–45; "The Tablet Dance at Santo Domingo," *Harper's Weekly* 34 (June 7, 1890): 447.

113. Henry Farny, *Sketches on a Journey to California in the Overland Train*, *Harper's Weekly* 34 (March 22, 1890): 220–21; Clarence Pullen, "To California by the Overland Train," *Harper's Weekly* 34 (March 22, 1890): 223.

114. "A Needless Cruelty," *Cincinnati Commercial Gazette*, December 18, 1890, 12.

115. Henry Farny, *The Last Scene of the Last Act of the Sioux War*, *Harper's Weekly* 35 (February 14, 1891): 120.

116. John C. Gresham, "The Story of Wounded Knee," *Harper's Weekly* 35 (February 14, 1891): 106–07.

117. Carter, *Henry Farny*, 66.

118. Huntington, "The Camera Club of Cincinnati," 731; "The Week in Art Circles," *Cincinnati Enquirer*, December 31, 1916, 6; J. F. Earhart, "Henry Farny, the Artist and the Man," *Cincinnati Commercial Tribune*, January 21, 1917, sec. 5, 1–2.

119. "Ogallala" is a variant spelling of a Lakota Sioux band of people more properly known as the Oglala Sioux.

120. "The Week in Art Circles," *Cincinnati Enquirer*, December 31, 1916, 6.

121. "Sioux Indian Chief Threatens a Massacre," *Cincinnati Commercial Tribune*, January 8, 1901, 3.

122. This information, taken from a funeral service pamphlet, is located in the "Farny" artist file in the Mary R. Schiff Library of the Cincinnati Art Museum.

123. "The Week in Art Circles," *Cincinnati Enquirer*, December 31, 1916, 6; Frank Y. Grayson, "Farny, the Indians, and Uncle John," in *Pioneers of Night Life on Vine Street* (Cincinnati: not known, 1924): 72–75. There are two endings to the tale; most likely Farny did arrange for the Indians to return to the West.

124. "1892 Minutes 'Women's Columbian Exposition Association of Cincinnati & Suburbs,'" 65, 67, 71, 77, Mss fw872c RMV, vol. 1, also 17, 19. The minutes are in the Cincinnati Historical Society, Cincinnati Museum Center.

125. *The Lincoln Club Cincinnati* [1892], 10, 12. This pamphlet is in the Cincinnati Historical Society, Cincinnati Museum Center.

126. "World's Fair Women's Week of Festival," *Cincinnati Commercial Gazette*, March 16, 1893, 5. This exhibition article and one in the *Times Star* (March 15, 1893, 5) list the title and the owner of each of Farny's artworks. "Success Attends Opening Night of the Woman's Columbian Exhibit," *Cincinnati Enquirer*, March 16, 1893, 4.

127. "Woman's [sic] Columbian Association Engrosses Society's Attention," *Cincinnati Commercial Gazette*, March 19, 1893, 13.

128. "The Columbian Association," *Cincinnati Commercial Gazette*, March 21, 1893, 2.

129. "The Wind-Up," *Cincinnati Commercial Gazette*, March 22, 1893, 5.

130. *Williams' Cincinnati Directory*, 1893, 990; "1892 Minutes 'Women's Columbian Exposition Association,'" 65, 67.

131. "World's Fair Women's Week of Festival," *Cincinnati Commercial Gazette*, March 16, 1893, 5. This article lists all Farny's works that were exhibited, and includes the names of the owners. The newspaper used "H." as McDonald's middle initial, but neither his obituary nor his cemetery records give a middle initial. I am grateful to Rick Kesterman for clarifying this point.

132. "1892 Minutes 'Women's Columbian Exposition Association,'" 71, 77.

133. "The National Jury," *Cincinnati Commercial Gazette*, March 12, 1893, 9.

134. "Chicago World's Columbian Exposition: Scrapbook of Clippings Relating to Fine Art Exhibits," 2. The scrapbook of newspaper clippings is in the Chicago History Museum, Research Center, call number qF38Mz/W1893/H1S42.

135. "A Painter on the Plains," *Cincinnati Commercial Gazette*, October 28, 1894, 22.

136. Ibid.

137. "Farny in the West," *Cincinnati Tribune*, October 28, 1894, 15.

138. "The Art Club," *Cincinnati Tribune*, October 28, 1894, 15.

139. Susan Labry Meyn, "Cincinnati's Wild West: The 1896 Rosebud Sioux Encampment," *American Indian Culture and Research Journal* 26, no. 4 (2002): 1–20; Meyn, "Enduring Encounters," 34–47.

140. "Roosevelt Interested in Art and Animals," *Cincinnati Commercial Tribune*, September 21, 1902, 3 and continues on 2; Charles Baltzer, *Henry Farny* (Cincinnati: Indian Hill Historical Museum Association, 1975), back cover.

141. T. T. Gaff to Henry Farny, undated letter in American Archives of Art, reel 961, frame 60–62. I am grateful to Rick Kesterman for helping me identify Gaff, who is Thomas T. Gaff. The Washington D.C. address on Gaff's letter provided the clue.

142. *Dinner by A. Howard Hinkle in Honor of A. Benziger*, 22. The quote is in a published program dated October 19, 1906 and in the Cincinnati Art Club Archives. I am grateful to Gene Hinckley, the archivist for the club, for sending me a copy of the program.

143. Ibid.

144. "A Painter on the Plains," 22.

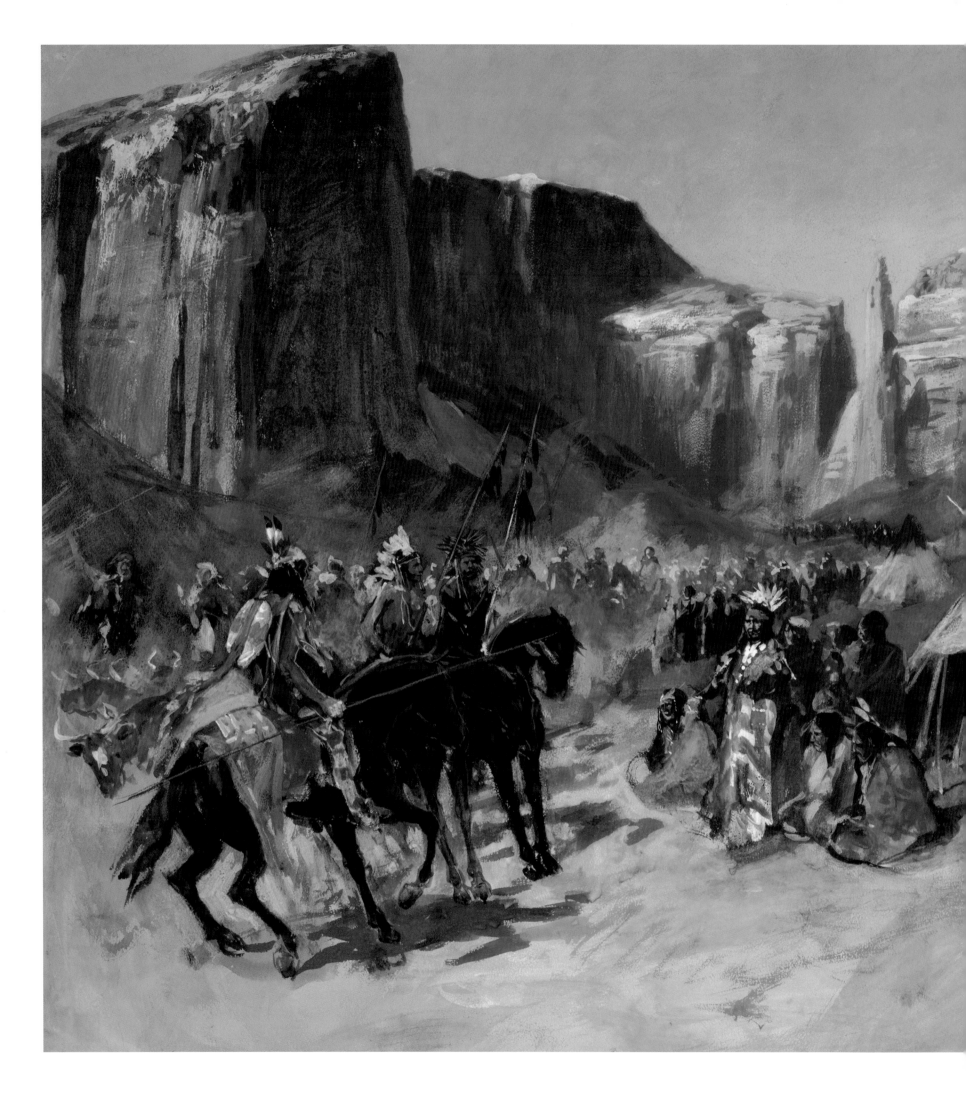

CECILE D. MEAR

THE ARTIST'S MATERIALS AND TECHNIQUES

A collection of Farny's pictures can not fail to be of intense interest to people, for, aside from the technical beauty of the actual work, the paintings touch the imaginative sense of a person and send him wandering off with Farny in his world of yarn and fable. For his pictures have the true charm of the storied picture builder.
MARY L. ALEXANDER, 1919

Henry Farny was an accomplished artist in many media: pen and ink, etching, lithography, gouache, watercolor, and oil. Even a few three-dimensional objects are known. It is Farny's gouache and oil paintings, however, that are the most technically complex examples of his talent, and are the works for which he is best remembered.

Early Artistic Endeavors

Farny's earliest works are similar to those of many budding artists. He used whatever materials were available, and, in the northwest Pennsylvania wilderness where he lived from the age of six to age eleven, the young boy probably had only the most basic writing material with which to draw. A 1930 *Cincinnati Enquirer* article recounts his drawing as a child: "His mother would tell how she could keep him amused for hours by keeping him supplied with paper and a pencil. And in the backwoods when paper was scarce there was a smooth pine board wall in the kitchen of the log house that he would cover with drawings, which he then would beg someone to scrub off so he could start over again."[1]

OPPOSITE: Henry Farny, *Sketch for "The Return of the Raiders,"* n.d. (detail, cat. 38).

73

A recounting after his death of a story Farny told to his friend, fellow Cincinnati artist Martin Rettig, described his sketching a picture of a Seneca Indian who came to his house in the woods. "Farny, then but five years old and alone in the house, opened the door only to bounce quickly back again, for there in that door stood a huge Indian garbed in festive array. His question where his parents were was meekly answered with 'Out in the woods cutting timber.' With the words 'The tribe wishes you all a happy Christmas' the Indian disappeared. This first impression of an Indian became so fixed in his mind that he was able to make a little colored crayon drawing of him the same day."[2]

Farny's parents employed a live-in teacher for the children, but it is unknown if the curriculum included drawing.[3] Farny's father had been an architect and builder before emigrating from France, and he may have encouraged his young son's interest in drawing. As a student during the period between 1859 and 1863 at Woodward High School in Cincinnati, Farny was taught to draw.[4] His composition books from the 1860s and '70s are examples of the inexpensive and generally poor-quality materials that he used for sketches as a child and into his early career. The notebooks are made of common, machine-made paper with drawings in what appear to be cheap brown iron gall ink and permanent black carbon ink, often referred to as "India ink."[5]

By the time Farny was a teenager, he had used oil paints. A small oil painting on copper, *Portrait of a Boy in a Blue Jacket and Red Cap in a Landscape* (private collection), is dated to about 1860, when Farny was thirteen years old. Oil paint in tin tubes, developed in 1841, would have been available in Cincinnati, which had long been a thriving art center, but it is unlikely that they would have been found in rural Pennsylvania, where the Farnys lived until 1859.[6] Copper had been used as a support for oil paintings since the seventeenth century, but at the time this painting was executed, canvas or wood panels were more common, and it is unclear why the young artist chose this unusual support. Perhaps Henry's father knew of its use in Europe, and young Farny used it in imitation of the masters of panel painting from earlier times. The Cincinnati city directories from these years list artists' suppliers, brush manufacturers (including artists' brushes), and paper manufacturers and distributors.

Lithography and Illustrations

Farny left school in 1863, sometime prior to the death that year of his father; by the mid-1860s, Farny was earning money with his artistic talents. He still had not received any formal training, although he was working as a commercial lithographer for Gibson & Company in Cincinnati.[7] He had made drawings that had been used as illustrations in local newspapers, and soon was sending illustrations of Cincinnati events to Harper Brothers in New York. The first illustrations credited to Farny in *Harper's Weekly*, September 30, 1865 (fig. 47), appear to have been reproduced from pen and ink drawings. Shading may have been done with ink washes applied with a brush. The illustration on page 620 measures 9 x 13 7/8 inches and fills the entire page; the illustration on page 621 fills half the page. The accompanying article about the Cincinnati Turner Festival is short in comparison, only half a column of text. These achievements show that Farny's drawing skills had improved during this period. He was invited to work as an engraver and cartoonist for Harper Brothers in New York, where he moved in 1866.[8]

Whether Farny worked for *Harper's* purely as an illustrator or as an engraver is unknown (no illustrations bear his signature during this year), but Farny was surely familiar with the process of transforming a drawing into a printed illustration. The common technique used by large publishing firms in the 1860s was to provide drawings, either on paper or drawn by the artist directly on the woodblock, to wood engravers. Some of the original images, particularly portraits, were photographs, and others were paintings.[9] The men who carved the blocks might render the design accurately, but they often reduced what the artist had provided to a standardized appearance, rather than allowing the artist's individual style to be expressed in the finished print.[10] At *Harper's*, craftsmanship was valued, and the engravers were instructed to reflect the original medium and quality of line in reproducing the

drawings.[11] If Farny drew his designs directly on the block, as other artists are known to have done, none of his original work during this year in New York could have survived; all that remains are the published prints.[12]

Later in his career, Farny's illustrations for *Harper's Weekly*, *Century Magazine*, and other publications were conceived in his Cincinnati studio and then sent to the publishers as drawings or finished paintings in gouache on paper. The gouache paintings, done in grisaille, or shades of gray, were painted to reflect how they would look in the monochromatic publications, and show Farny's understanding of the printing process. From the late 1870s onward, the printing technology used by publishing firms evolved from wood engraving to process engraving, which used photographic and mechanical methods to more efficiently transform an original work of art into a reproducible illustration. The original drawing was photographed, and the image was reproduced on a metal plate that was then rolled with ink and etched in acid. The wood engraving process in use when Farny began work as an illustrator required the originals to be drawn to the exact size of the printed reproduction. The newer process, however, allowed the artist to make a drawing of any size.[13]

FIGURE 47
Henry Farny, *The Turner Festival at Cincinnati, Ohio*, wood engraving, *Harper's Weekly*, September 30, 1865, 620. Mary R. Schiff Library, Cincinnati Art Museum.

Farny was only eighteen when this illustration was published in *Harper's*.

The gouaches Farny painted for publication were of a size similar to the oil and gouache paintings created for exhibition or sale to his patrons, and they can stand on their own as finished works of art. *Issue Day at Standing Rock*, in the collection of the University of Texas, is 16 x 24 inches.[14] The printed illustration, *Ration Day at Standing Rock Agency*, in *Harper's Weekly*, July 28, 1883 (fig. 30, p. 48), is 12 1/4 x 19 3/8 inches and fills two pages. A variant version of another grisaille, *A Dance of Crow Indians* (cat. 1), was reproduced in the December 15, 1883, issue of *Harper's Weekly* at 9 x 13 1/2 inches (fig. 36, p. 54). The original gouache is 13 15/16 x 19 7/8 inches. A full-page cover illustration would have been printed approximately 11 x 10 inches on a sheet approximately 16 x 12 inches, and many of the printed illustrations filled only a portion of a page.

Farny's images throughout his years creating illustrations for *Harper's* continue to have the appearance of wood engravings, but a photographic step was surely used to reproduce the original design. It is likely that the original gouache paintings were photographed, the images printed in reverse on woodblocks, and the blocks then carved using the traditional wood engraving techniques. The resulting illustration would have the same orientation from left to right as the original drawing.[15]

At *Harper's* in 1866, Farny worked for Mr. Charles Parsons, manager of the art department, who was known for encouraging young artists. In New York, Farny had contact with other artists and would have had the opportunity to see exhibits of work by established artists. Perhaps the environment of the publishing house, where he would have been tied down to a regular schedule, did not suit Farny, whose contemporaries regularly described him as a bon vivant, a charming raconteur, and nighttime prowler of the streets.

Whatever the reason, the following year, 1867, when Farny was twenty years old, he left the United States for Europe, where he studied traditional painting methods at established academies.

Studies on the Continent

Letters to his mother, written in French, record some information about Farny's education in Europe, but details remain sketchy. Farny traveled to Rome, where his first teacher was the American portrait and genre artist Thomas Buchanan Read (1822–1872). Read had met Farny in Cincinnati and encouraged him to study in Europe. Read painted portraits and literary subjects in a highly finished, realistic style. His subjects often appear stiff and show little expression, as was common for formal portraits of the time. Read gave Farny instruction in, or may only have allowed him to observe, drawing and painting. Farny worked as Read's studio assistant and spent his evenings drawing, painting, and attending classes at an art academy.[16] Drawing was required of art students in the academies, both from casts and from life, and was prerequisite to painting.

After less than a year in Rome, Farny moved on to Germany to train under the landscape artist Hermann (Herman) Herzog (1831–1932). Herzog, well known in Europe by the time Farny met him, had studied painting in Düsseldorf, where artists at the academy were taught to work from nature.[17] Herzog was influenced by the French Barbizon painters and his landscapes were painted with attention to atmosphere and color.[18] These qualities would have been familiar to Farny and can be seen in the paintings he produced as a professional artist. The "Düsseldorf style," popular in America, was defined by meticulous detail. Its influence can be seen in the landscapes of Albert Bierstadt (1830–1902), whom Farny met in Düsseldorf in 1868, and who exhibited a painting that same year at the Cincinnati Academy of Fine Arts' first exhibition. For years before Farny left for Germany, Düsseldorf paintings had been popular in Cincinnati, and collectors continued to buy them even after the taste for that painting style had diminished in other parts of the United States. According to the literary historian John Clubbe, "Cincinnatians preferred Düsseldorf's literal representation and careful detail over Munich's heady flamboyance and loose brushwork That Düsseldorf's impact lasted longest in Cincinnati would ... prove beneficial to Farny."[19]

Early Professional Efforts

Farny studied and traveled through European art centers until 1870, when he returned to Cincinnati. He had learned to paint successfully in oils, and he exhibited an oil painting of the coast of Capri at the 1870 Cincinnati Industrial Exposition, which the judges noted as "admirably well painted" and awarded a diploma.[20] In the 1871 exposition Farny exhibited a marine scene. These works were probably painted under the influence of Herzog.

The Cincinnati Industrial Expositions were significant events, attended by hundreds of thousands of visitors and attracting exhibits from artists throughout America and Europe.[21] German artists and Americans trained in Germany were well represented. Herzog, who moved to Philadelphia in the 1870s, exhibited eighteen paintings in the 1872 Cincinnati Industrial Exposition. His paintings reflect the Düsseldorf style, but they are more loosely painted and can be compared with those of the American Hudson River School artists. Herzog's paintings, like Farny's later western paintings, contain many details of the landscape suggested with quick strokes of the brush.[22] Although figures may be included in Herzog's landscapes, the landscape predominates, whereas in Farny's paintings, the figures and landscapes are often of equal importance.

Herzog's influence on Farny may have included his choice of media as well as subject matter; Herzog's 1872 exposition entries included six oils and twelve watercolors and drawings of marine scenes, mountains, waterfalls, sunsets, and night scenes. Farny's entries in that year were an oil painting, *Solitude*, and two drawings, *Rip Van Winkle* and *Piper of Hamlin*.[23] The oil was owned by the prominent Cincinnati attorney and distinguished Civil War general Manning Ferguson Force, so we know that by 1872 Farny had begun to sell his paintings locally.[24]

For Farny, the decade of the 1870s was a time of working in various media; associating with local artists; teaching at a Cincinnati technical school, the Ohio Mechanics Institute; and traveling to Europe. While Cincinnati had been fertile ground for artists during the early part of the nineteenth century, it was conservative and remained so at the time that Farny was beginning to establish himself as a professional artist. The School of Design of the University of Cincinnati (later to become the Art Academy of Cincinnati) required its students to spend their first three years of study drawing from plaster casts of classical sculpture, moving on to special classes in painting or sculpture only in the third year. Students who were interested in a freer expression of art and wished to move beyond this rigid academic approach went to Europe or New York, sometimes before completing their coursework at the Academy. American artists trained in Munich were coming home after learning to draw in life classes, and their painting techniques reflected the looser brushwork, deep palette, and "buttery" impasto of their German teachers.[25] Farny's early oils show some influence of the French Barbizon artists Jean Baptiste Camille Corot (1796–1875) and Gustave Courbet (1819–1877), artists whose style had begun to influence German painters by the 1860s. Munich was the German city most influenced by the work of French artists, whether landscapes or figure paintings.[26] In 1873, and again in 1875, when Farny traveled to Munich with the Cincinnati artists Frank Duveneck, Frank Dengler, and John Twachtman, he studied under Wilhelm von Diez (1839–1907), an influential instructor of academic realism at the Royal Bavarian Academy. References to Diez usually mention his work at the academy and his influence on his students, but he is also credited with being an excellent draftsman and illustrator for *Fliegende Blätter*, a widely admired comic newspaper.[27] (The Cincinnati Art Club subscribed to this publication in the 1890s.[28])

Diez's work as an illustrator as well as a painter would have resonated with Farny; Farny had experience with illustrations and was well known for his comic sense. "Pen drawing is a painter's process, and nearly all these artists [German illustrators of the last half of the nineteenth century] were painters as well as pen draughtsmen."[29] Farny's paintings benefit from his skills as a draftsman, and his skills would have improved by studying under Diez.

In 1878 Farny was back in Cincinnati. He painted a significant work in oil on canvas, *The Silent Guest*, which was also bought by Manning Ferguson Force, and is now in the collection of the Cincinnati Art Museum. This picture is a portrait in the truest sense of the word. It is a sensitive rendering of a man

Farny knew, accompanied by a few small props that indicate his place in society. One of Farny's larger works, *The Silent Guest* shows Farny's mastery of oils and that he could paint in the Munich style as well as the Düsseldorf style. As described by Denny Carter in *Henry Farny:* "In this painting we can see the Munich influence in the sober colors; the colors are somber: the gray-green wall and the brown floor act as a foil for the black-clad figure. The man's head and hands are painted with the blocky, sketchy stroke typical of the Munich school. The realistic subject matter—an ordinary man caught in an everyday moment, and the inclusion of the still life, including the glass, hat, handkerchief, and snuff box—are also Munich-inspired. To the left of the chair the cigar stub adds another prosaic touch to the composition."[30]

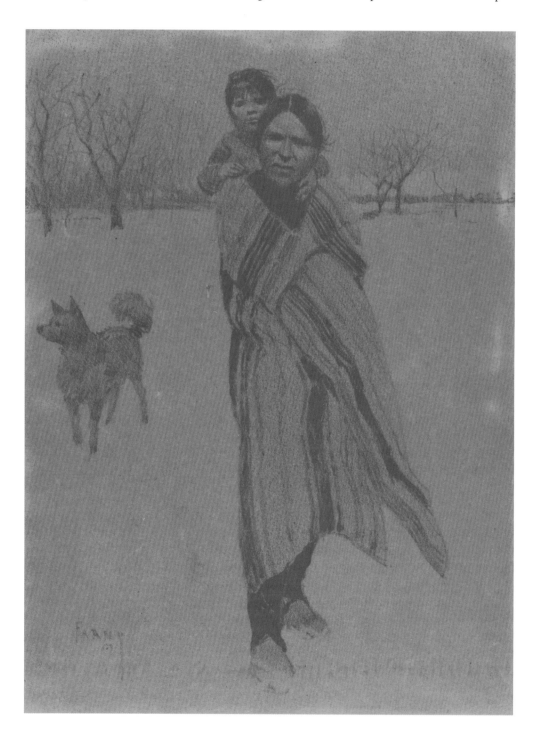

Farny Etchings and Lithographs

Farny also etched the head of the *Silent Guest* sitter, wearing the same hat that appears in the oil painting, for the Cincinnati Etching Club.[31] It is composed of fine lines, quickly and confidently drawn, and the darks are achieved with cross-hatching. Although Farny's first steady employment was with printing companies, there is no indication that the prints he made after completing his art training were intended for reproduction. Farny apparently did not devote a lot of time to etching and perhaps just dabbled in the technique as a club member in 1878 and 1879. If his etchings are compared to those of Duveneck, for example, it is easy to see that Duveneck's technique was much more polished.

Farny also made a few lithographs. He had worked for the Strobridge Lithographing Company in Cincinnati in the 1870s. (Farny's signature appears on an undated poster advertising Bartley Campbell's stage production *The Galley Slave* in the collections of the Cincinnati Historical Society Library, Cincinnati Museum Center.) Farny's own lithographs are very different from the brightly colored advertising posters produced by Strobridge. These lithographs were made later in Farny's career and are examples of another medium he mastered. The lithographs are printed in red-brown ink on tan paper. *Papoose and Squaw* (fig. 48) has the appearance of a quick crayon sketch that could have been drawn from a photograph taken during one of Farny's western trips. The bare branches of the trees in the background give it the appearance of a fall or winter scene. The darkest details of the woman's costume were done with litho ink brushed onto the stone, resulting in more solid darks with sharper outlines than the areas drawn with the lithographic crayon. There is little detail, but the print conveys the feelings of the figures as they look directly at the viewer; even the dog gazes alertly at something unseen beyond the edge of the composition. The figures are almost identical to those in several gouache paintings Farny completed in the 1890s and 1900s, and suggest that he may have taken a series of photographs of a woman carrying her child as she went to chop wood. The dog in the lithograph also appears in several paintings, in different poses.

The 1899 lithograph *Shoulder Length Portrait of a Warrior* was also drawn with a combination of crayon and ink.[32] Farny used scrapers to remove narrow lines of ink in the hair, face, and part of the costume to help define shape and texture. The costume is left unfinished below the finely drawn face. The costume identifies the man as a Native American, but by leaving the costume unfinished and concentrating on the face, Farny lets the viewer know that this is a portrait of an individual gazing intently at the artist. This image could have been drawn from a sketch or photograph taken on one of Farny's western trips, or perhaps at the Cincinnati Zoo when it hosted Cree Indians during 1895 and Sioux in 1896.[33] Another possibility is that this is a portrait of Sitting Bull; the face strongly resembles that in an 1899 Farny oil on panel portrait of Sitting Bull, now in the Blanton Museum of Art at the University of Texas at Austin. Farny met Sitting Bull in 1883 in Bismarck, during the same trip on which he witnessed the completion of the Northern Pacific transcontinental railroad.[34] It has been suggested that the portrait in oil was painted from a photograph.[35]

Farny Watercolors

Henry Farny began painting in watercolors while still a young artist. Lafcadio Hearn, writing for the *Sunday Enquirer* in 1874, described Farny's studio and its contents, which included "little water-colored paintings of Italian scenery—ocean sunsets painted en voyage"[36] Farny's earliest surviving watercolor, *Winter*, in a private collection, is undated, but it was probably painted in Munich.[37] The snowy landscape through which a hunter and two dogs stalk a rabbit is loosely painted, but it is a finished painting, not a preliminary sketch for an oil painting, as watercolor was commonly used. While the composition is competent, the application of the watercolor is unrefined, as though the artist were still learning how to handle the paint.

Watercolor is a convenient medium for an artist working outside the studio, even on an ocean voyage or transcontinental journey. By Farny's day, artists' suppliers were offering all the tools necessary to equip artists working outdoors. An artist needed paints—available dry or moist in pans or moist in tubes—clean water, brushes, and paper. These basic necessities could be augmented with a stool—sometimes combined with an easel—a sketching umbrella, porcelain palettes, and stretching frames to keep papers flat during painting. Farny's watercolors from the early 1880s show that by this time he had mastered the use of transparent watercolors for quickly painted portrait sketches and illustrations.

Two watercolor portraits from Farny's 1881 trip to Fort Yates, in the Dakota Territory, appear to have been done from life with no preliminary sketching in pencil or charcoal. The Dakota climate was dry enough that the paintings would have had to be painted quickly, before the watercolor dried on the sheet. As in the lithograph *Shoulder Length Portrait of a Warrior*, the sitters' faces are more fully finished than their costumes, although Farny records more details of the clothing in the watercolors than in the lithograph. One of these portraits, *Ukchekehaskan, Minneconjue Sioux*, a small watercolor on board in a private collection, was painted with the color diluted in water and brushed broadly across the sheet to define the subject's clothing.[38] The wash in the background provides the outline of the figure's proper right shoulder and arm, while the rest of the figure is defined by the color of the costume. ("Proper right" means the sitter's right, regardless of which side of the picture it appears on as the viewer looks at it. The wash outlines the figure's right shoulder, on the left side of the composition.) The facial contours are formed with successive layers of transparent washes; the features are drawn in with a drier brush and less dilute color.

Farny continued to work occasionally in transparent watercolor throughout his career, sometimes placing figures in landscapes, but more often painting single figures. His technique remained consistent as he used broad sweeps of dilute color, layering the washes to define the contours of the figures and filling in details with strokes of pure color using the tip of the brush. Backgrounds were left bare except for a bit of thinly washed color to set the figures on the page, so they do not appear to float in space. The bare paper was sometimes used for highlights or middle tones, depending on its color, but Farny often heightened the brightest areas with opaque white gouache. The watercolors exhibit a freedom of brushwork and looseness more akin to his ink drawings than to his gouache and oil paintings.

Photography and the Artistic Process

Farny returned to Cincinnati from Fort Yates bearing artifacts, watercolors, sketches, and photographs to use as references for paintings he would complete in his studio. The collecting of photographic images was not new to artists; since the invention of photography in 1839, many artists had taken advantage of the speed at which an image, whether landscape or portrait, could be captured. By the 1850s, artists could make their own photographs—using readily available brochures to help them learn the craft—or they could purchase photographs from professionals who provided stock pictures of famous paintings, sculptures, buildings, and other subjects for artists' reference.[39] Albert Bierstadt's brothers were professional photographers, and in the late 1850s (a decade before he met Farny in Germany) Bierstadt was already collecting photographs of landscapes and Indians.[40]

Photographing the unsettled West was no easy task. Early photographers hauled large wooden tripod-mounted cameras and glass plate negatives to remote locations, developing their work on the spot in makeshift darkrooms. By 1878, however, just a few years prior to Farny's first trip west, gelatin dry plate negatives became available, making it unnecessary to develop negatives immediately after exposure. In 1888, celluloid film became available as a replacement for glass plate negatives, and by 1889 Kodak offered a lightweight, hand-held box camera with a fixed-focus lens; it could take a hundred pictures on film.[41]

That same year, the head of the nature class at the Munich art academy wrote of the camera as a tool for the artist: "The apparatus is now a necessary part of the studio inventory. Out in the open, alongside the artist's umbrella, stands the camera, and if formerly the artist was only busy underneath the umbrella, now he just as frequently sticks his head under the black cloth to make a 'setting.' . . . With its help, the work of art is pieced together in all its parts; the apparatus helps in preparing the draft for completion through all its various phases."[42]

It is thus not surprising that Farny brought 124 photographs back from Fort Yates as a record of the people and landscapes he had seen.[43] Indeed, he may have learned about photography as an artist's aid while a student in Germany.[44] In his Cincinnati studio, Farny occasionally worked from live models, but more often he used the memorabilia collected during his travels. Farny's Fort Yates photos, and images by other photographers that he continued to collect, would serve as sources for published illustrations, as well as for the oils and gouaches he would paint for clients the rest of his career.

A newspaper report about Farny's last known trip west, to Fort Sill, Oklahoma in 1894, describes the artist's attempt to photograph an Indian girl: "Of course an artist's visit to an encampment of native children of the plains must have its idyl. Mr. Farny found his underneath a pecan tree. A maiden in her early teens garbed in the native close-fitting garment of buckskin, reaching to the knees, and clothed thence to the ground by Nature's covering. Poised in most graceful pose, with head thrown back and arms extended, a stick in hand, and mind intent on the shower of pecans that was to follow her throw, she was a picture for the artist's eyes. The camera was quickly brought to a focus, but, like a frightened partridge, the little savage vanished, and the idyl became but the dream of an autumn day."[45]

Farny and Gouache

Farny began working in gouache, or opaque watercolor, early in the 1880s, probably first for magazine illustrations, as discussed earlier. His use of gouache for works of art probably developed in the mid-1880s, after he had used it for monochromatic illustrations and saw the possibility of painting more quickly than he could in oil while achieving a similar look. Gouache, like transparent watercolor, is made of pigments ground in a vegetable gum, usually gum arabic. Unlike watercolor, all but the deepest of the colors are mixed with chalk or zinc oxide (Chinese white) to render them opaque. The addition of white to the colors results in a lighter overall palette. Opaque, water-based paints were used on the illuminated manuscripts of the Middle Ages, for early portrait miniature paintings on vellum, and in eighteenth-century France for landscape painting.[46] In the nineteenth century, watercolor painting was becoming respected as a medium for finished works of art and was being exhibited, if not in the same galleries as oil paintings, at least nearby.

Farny had probably learned to use transparent watercolors—more popular in Germany and France in the 1870s than opaque watercolor—while studying in Europe. At the same time, English artists were beginning to favor gouache over transparent watercolor and were exhibiting these new paintings on the Continent. Farny adopted what became known as the "oil" watercolor manner, by which artists used gouache to imitate the texture and impasto of oil paintings.[47] Application of the pasty gouache to paper is similar to applying oil to canvas, but Farny relied on his skills with watercolor washes in the skies of many of his paintings, brushing the color across the dampened sheet to give an even tint to the paper.

Other artists of the American West worked in gouache, including Thomas Moran (1837–1926) and John Hauser (1859–1913). Hauser was a Cincinnati artist, twelve years younger than Farny, who worked in a studio near Farny's and painted similar subjects. His gouaches, however, do not have the delicacy of Farny's paintings. Many members of the Cincinnati Art Club completed works in gouache, although the subjects and styles varied. A design for a fan painted in gouache on silk by Martin Rettig (1866–1956), possibly a duplicate of a fan painted for a Cincinnati Art Club "social affair" in honor of "The Ladies of the Columbian Association" in 1893, is identical in format and medium, if not in subject, to one in a private collection painted by Farny in 1890.[48]

FIGURE 49
Bottom left corner, *The Captive*.
Detail showing edges of the paper
originally attached to the wooden
stretcher.

Farny successfully exhibited several of his gouaches at the national level. Although not a member of the American Water Color Society, in 1893 Farny entered a gouache, *A Mountain Trail—Crow Indians*, in the society's Twenty Sixth Annual Exhibition in New York. The painting was chosen for illustration in the catalogue and had a sale price of $1,000, much higher than the prices of most other paintings exhibited.[49]

In 1885, Farny painted what would remain one of his most important images in gouache and watercolor. *The Captive* (cat. 3), formerly known as *The Prisoner*, was originally presented in the format of an oil painting on canvas, attached around the edges to a wooden stretcher (fig. 49). A linen canvas was present under the paper support and was fastened to the stretcher with tacks. The stretcher and underlying canvas provided additional support to the large sheet of paper, and by gluing the edges of the paper to the stretcher, the artist was able to keep the painting flat. (Another large gouache, *The Black Robe* (cat. 34), was also originally attached to linen on a wooden stretcher.) The edges of *The Captive* are covered with buff-colored paint that was probably applied over the entire surface of the paper. A layer of dark blue paint was applied over the buff paint from the top of the sheet to below the horizon line. The background was painted over this dark blue underpainting. Farny mixed additional gum with the paint in the landscape to give it a glossier, less chalky look. The foreground figures were painted after the ground, but before the individual blades of grass. The foreground can be compared with that of "some of the best English water-colorists, whose discipline in drawing in monochrome for engravers, has given them power in foreground detail."[50] The proportions of this, as well as other Farny paintings, emphasize the landscape. Scenes in which figures inhabit the mountains or forests are usually vertical, while those on the plains are usually horizontal, to give the viewer a sense of the expanse of space.

Sketch for "The Return of the Raiders" (cat. 38) was probably painted in 1904 as a preparatory sketch for an oil painting that was never completed. This unfinished painting better reveals Farny's working technique than his finished paintings. He applied a tan wash over the paper in the areas of the foreground and the mountains. The paint was diluted and applied with soft, round brushes. In some areas the wet paint mixed with the underlying paint, but in most areas the layers of different-colored gouache are discrete. Farny apparently worked quickly and vigorously. Tiny air bubbles are caught in some of the paint strokes, and brush hairs remain on the paper where they dried with the paint. Upper layers that give the cliff faces shape and texture were painted with a drier, flat brush and less dilute paint, allowing the underlying colors to show through. The darkest areas of the picture—the horses, the figures' hair, and details in the figures' faces—are enhanced with a layer of gum, saturating the blacks and emphasizing particular details in contrast to the broader strokes of black paint. The blue sky was painted first with dilute, intense blue over the lighter ground layer, followed by a thicker blue mixed with white. The cliffs were painted over the darker blue, and the lighter, opaque blue was painted after the landscape forms to more clearly define their edges.[51]

These qualities are found in other finished gouache paintings. If Farny had completed the painting, it is likely that the foreground would have been painted thinly, with more fluid paint than the sky and the landscape. The figures, built up of layers of discrete colors from outlines in transparent wash, are almost as detailed as any in his finished paintings. Transparent underlying paint is often left visible in Farny's figures and animals, but the landscapes are usually built up of opaque paint layers that completely cover the initial paint layers. The edges of this sketch are trimmed, as are the edges of most of Farny's finished paintings.

It is not possible to know exactly how Farny supported his paper as he worked. A late photograph of Farny in his studio shows a board propped against the wall that he could have used when painting his works on paper (fig. 50). Another photograph that appears to have been taken at the same time shows the elderly artist seated with a board propped up on the table before him, a small palette next to the board.[52] This is a typical way for an artist to work on paper, whether in dry or wet media. When painting watercolors, the edges of the paper would have been glued to the board to keep it flat as he worked. The finished painting would then be cut from the board, leaving the edges glued to the board.

Winter Squaw (cat. 23) is one of the few paintings that was not trimmed. The small painting has

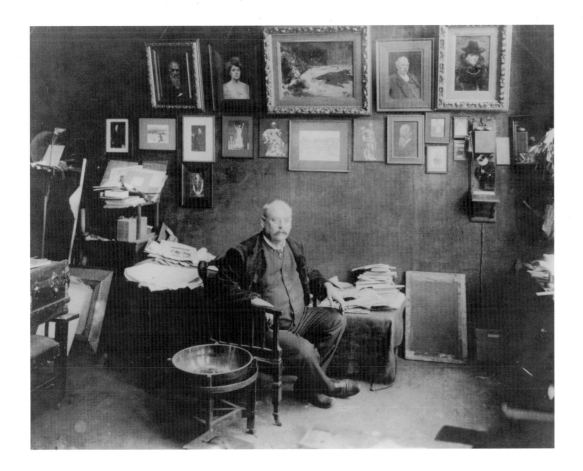

FIGURE 50
Unidentified photographer, *Farny in his studio*,
n.d. Private Collection, North Bend, Ohio.

graphite pencil lines drawn around the outline of the picture under the paint, apparently to define the size and proportions of the composition. The pencil has been erased but is still visible in the transparent yellow sky. The painting is slightly larger than the pencil lines and has a broad, white border painted in gouache, applied over the painting to give it clean edges. The ivory-colored paper used for *Winter Squaw* is about one and a half inches larger on each side than the composition, and the white border covers most of the margins. This kind of white border is present on many of the gouache paintings, but the border usually is only about a quarter-inch wide, and in some cases it has been trimmed off, probably to fit the painting into a frame.

Indian Hunting Scene (cat. 37) combines watercolor and gouache. The entire surface of the tan-colored paper is covered with paint, but the light color of the paper allows the transparent yellow sky to glow. The paint is more dilute at the top of the picture, and the yellow becomes more intense toward the horizon. The snow and some of the details are gouache, but the evergreen trees in the background are painted with pure, undiluted watercolor. Transparent watercolor remains exposed in the figures, but touches of gouache have been laid over it to add definition to the forms. The figure of the hunter has been worked more than the deer, so very little of the underlying wash remains visible. As in other Farny paintings, the darkest tones in the hair and eyes have been glazed with additional gum to completely saturate the black paint and make it stand out from the surrounding matte colors. This was a common technique of artists working in both opaque and transparent watercolor.

Graphite is visible on top of the sky and landscape. A graphite pencil was used to sketch in the shapes of the trees and figures, but it also adds fine details to the painting. The hunter's tracks in the snow are emphasized with short graphite marks, and the foliage in the trees at the center of the picture has been overdrawn with graphite. (This type of foliage, though lacking the graphite, can be seen in several of Farny's oil paintings.) Graphite is also visible in the deer, horse, and hunter on top of the

opaque paint used for the snow. Farny may have been refining the shapes of these figures after initially indicating their forms in dilute paint.

Graphite used this way is uncommon in Farny's paintings; occasionally graphite underdrawing is present, but in *Indian Hunting Scene* the graphite was used after much of the painting had been completed. In *A Dance of Crow Indians* (cat. 1), the brightly lit windows of the train were outlined with graphite to sharpen their edges, but this painting was made for reproduction in a magazine, and the graphite lines are not visible on the printed page. Though the graphite is not obvious in *Indian Hunting Scene*, on close inspection the shiny graphite can be distinguished from the matte gouache.

Conservation Issues in Farny's Work

Because Farny's gouache paintings so closely resemble his paintings in oil on canvas, they have often been displayed as oil paintings without consideration of the light sensitivity of the colors. Consequently, many of the gouaches have faded, as can be seen on paintings where the edges were covered by a mat or frame rabbet and now appear deeper and more intense than the paint that has been exposed to light year after year.

Fortunately, watercolor artists have been aware of the fugitive qualities of different pigments since the earliest days of portrait miniature painting in the sixteenth century. Watercolor manuals and artists' colormen advised which pigments were unsuitable for watercolor painting because of their tendency to fade, the coarse texture of the pigment particles, or other undesirable characteristics. An American manual from 1882 describes 120 different colors from which the watercolor artist can choose. It includes information on which colors can be mixed together, whether the pigment works well for thin washes, and which country manufactures the best variety of a particular color.[53] The manual opens with a chapter on color theory, something that was likely part of Farny's training at the European academies. However, in a newspaper article from January 1917, shortly after Farny's death, the artist is remembered as saying "that he knew very little about the laws of light governing the production of color—but that he felt the truth of his coloring—he was governed by feeling in his use of color more than by actual knowledge of its laws."[54] Farny's colors are generally realistic, although in a significant number of his gouaches and a few of his oils he painted a yellow sky. The yellow makes the landscapes more dramatic, but the color is exaggerated.

For the most part, gouache paintings by Farny have survived well. The fading of the colors is often apparent only when the unfaded edges are exposed, and the colors remain strong with appropriate color balance.

Farny chose high-quality papers for his gouaches, which have contributed to the good condition of his paintings. From the 1890s onward Farny's paintings are on medium-weight rag papers. Some show partial watermarks indicating that they are Whatman papers, made in England specifically for artists' use. Artists' manuals often recommended Whatman as the best paper for watercolor because of the purity of the linen pulp used to make the sheet, the availability of different surface textures, and the sizing that allowed the paper to absorb just enough watercolor—but not too much—as the artist worked.[55]

It is interesting that some of Farny's paintings are on blue paper. Three small portraits—*A Young Squaw*; *Sioux Brave*; and *Tashkoniy/Comanche* (cat. nos. 10, 11, and 16)—are typical of Farny's watercolor portraits described above. The paper of each of these portraits has faded, resulting in cream- or tan-colored backgrounds rather than the original light blue. For his gouaches from 1899, Farny completely covered the blue surface with paint rather than using the paper color as an element in the paintings. The exception in which paper is left exposed is *Tombola*, but this work was painted to advertise an art exhibit and thus made for a different purpose than the "fine art" paintings from that year.[56] The texture and thickness of the blue paper is very similar to that of Farny's usual cream and tan papers, and from the front, it is not obvious that the paper is a different color. The papers Farny

favored do not have highly textured surfaces, so that the paper rarely influences the final appearance of the paintings.

Gouache is more like a paste, similar to oil paint, than transparent watercolor; the paint sits on top of the paper rather than being absorbed into the paper fibers. This quality contributes to a conservation problem often seen in paintings in gouache, including those by Farny. The paints do not contain a lot of binder, and when they dry they become brittle. This results in cracking of the paint, especially in thickly painted areas. In some cases, upper layers of paint can flake off of the underlying layers.

The technique of glazing with additional gum contributes to cracking and flaking of works in gouache. Frequently, when details are heavily glazed, the gum contracts and cracks as it ages, pulling the paint off the paper.

The flexible paper support, too, can exacerbate the cracking of the paint. Some of Farny's gouache paintings were mounted to thick cardboards by framers soon after their execution, perhaps to flatten the paper that had distorted as the wet paints were applied. Before painting *Got Him*, Farny himself mounted his paper over thick cardboard with the edges of the paper wrapped around and glued to the back of the board (cat. 7). The cardboard mounts prevented the paper from flexing, possibly preventing some cracking and loss of paint. Unfortunately, the cardboard was made of common wood pulp fiber and was acidic, so Farny's selection of long-lasting linen papers was compromised by adhesion to a mount that would speed the degradation of the paper.

Farny Oils

Despite his affinity for gouache, Farny painted in oil on canvas throughout his career. It is fortunate that he was well trained in painting techniques and that he did not experiment with methods and materials that would not last over time. Farny's oil paintings, like his gouaches, are generally in good condition, although often the canvas supports have become dry and brittle. Farny bought prepared canvases from artists' suppliers in Cincinnati. Paintings from 1898 and 1902 bear stamps on the reverse from Emery B. Barton and Traxel & Maas, both Cincinnati suppliers of artists' materials.[57]

Farny's choices of materials and oil technique can be seen in the relatively early painting *Silence* (1881), an oil on canvas in a private collection.[58] Farny used plain weave linen canvas coated with a thin white ground, probably applied by the supplier. A century and a quarter after its execution, the paint layers are for the most part secure and in good condition. Some areas of *Silence*, such as the trees, are thinly painted. The sky, in contrast, is painted very thickly to achieve a mottled appearance. The horizon where the sun is setting was painted very thickly after the trees were painted; as a result, the paint seems to ooze out between the tree trunks. Farny did not add a lot of paint thinner or extra linseed oil to the thick paint used in the sky. The rocks at the center right are painted very thinly, probably with the oil paint diluted with solvent. It looks almost like the watercolor washes that he left exposed in some areas of his gouaches. The snow is painted over and around the rocks and the tree trunks, just as a real snowfall would lie on top of the elements in the landscape; Farny used this technique frequently in painting snow scenes.

Farny probably worked from a sketch done in thinly applied paint and continued to refine the design with denser paint with more body until he was satisfied. Although the contrast between the thickly painted sunset and the very thinly painted rocks and trees is more extreme than in his other paintings, it illustrates how Farny typically left areas thinly painted while continuing to add many layers of paint elsewhere.

The Last of the Herd (fig. 51), another oil on canvas in the Cincinnati Art Museum, was painted in much the same way as *Silence*, painted twenty-five years earlier. There are areas of brushwork that resemble that of the snow in the foreground and sky of *Silence*. In the later painting, Farny used a palette knife to apply the thick green paint in the left and right center. The foreground has a fluid, thinly applied white that reveals a purplish-brown layer covering the proprietary off-white ground layer. The sky is an

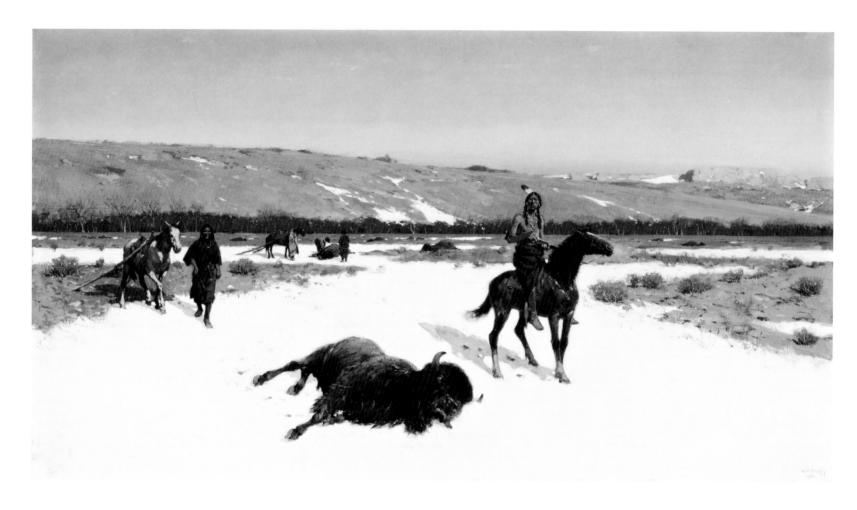

FIGURE 51
Henry Farny, *The Last of the Herd*, 1906,
oil on canvas, 22 x 39 15/16 in.
(55.9 x 101.4 cm). Cincinnati Art Museum,
Gift of the Farny R. and Grace K. Wurlitzer
Foundation. 1964.321.

almost solid blue. It, too, is painted over a darker color, in this case a somewhat translucent blue, similar to the sky in the gouache *Sketch for "The Return of the Raiders."* The various colors that make up the green of the hill may have been partially mixed on the palette, with further mixing and layering of colors done on the canvas. The small details in the figures are left as unblended dabs of color, as they are in the gouaches. The fallen buffalo has similarities to the deer in *Indian Hunting Scene*: it appears to have been painted quickly, with thin applications of paint. The white of the foreground is painted in around the edges of the form to solidly ground it in the space.

Unlike many artists in America and Europe at the turn of the twentieth century, Henry Farny was not an experimental artist. His talent was apparent when he was still a young man, and, with his early training as an illustrator followed by study in Europe, his skills were honed. Farny was not an innovative artist either, although artists from Cincinnati whom he taught or later associated with in the Cincinnati Art Club worked in newer styles ranging from impressionism to art deco.

Farny was, however, a successful artist, because he was able to produce paintings that were popular with the Cincinnati collectors who were his major clients. His technical skill, as much as his new style of portraying his landscapes and Indian subjects, created a strong market for his paintings during his lifetime. Farny's numerous paintings in gouache might in fact be attributable to the demand for his work: paintings in gouache can be completed more quickly than oils, and because Farny was often hounded for paintings that he had promised but not yet produced, he may have resorted to this medium as a way of satisfying his clients.[59]

Farny earned the respect of fellow Cincinnati artists. Shortly after Farny's death, Lewis Henry Meakin remembered Farny as "a man of rare gifts and unusual personality. His art was of the kind that

was understood and cared for by a wide range of people. His skill in craftsmanship, the invisible excellence of his design or composition, his fertility of invention and his remarkable ability in making use of the material at his command; his clearness of vision and the readiness and dexterity with which he caught and embodied an idea commanded the respect and admiration of his fellow-artists and the artistically cultured at the same time the vividness with which he told the story . . . appealed to the many whose interest is more in that side of the picture than in the other qualities that go to make its complete value."[60]

The skill with which Farny used oil and gouache continues to make his paintings valuable today.

. .

Epigraph: Mary L. Alexander, "Stroll Through a Collection of Works from Brush of Farny," *Cincinnati Times-Star*, October 6, 1919.

1. Robert Allen, "Wrecking Of Duveneck's Downtown Atelier Recalls The One He Had In 1873–75—Farny's Early Adventures—A Girl Model Who Posed Without Assistance," *Enquirer Sunday Magazine*, June 8, 1930. The article also notes that Farny had drawn charcoal murals—using Egyptian motifs—in the alcove of the Cincinnati studio where Lafcadio Hearn visited him in 1874.

2. "The Week in Art Circles," *Cincinnati Enquirer*, December 31, 1916, 6. This material is located in the "Farny" artist file in the Mary R. Schiff Library of the Cincinnati Art Museum.

3. Denny Carter, *Henry Farny* (New York: Watson-Guptill Publications in association with the Cincinnati Art Museum, 1978), 15.

4. Joseph S. Stern, Jr., "Cincinnati's Butch Cassidy and the Sundance Kid," *Queen City Heritage* 50, no. 2 (summer 1992): 16.

5. James Watrous, *The Craft of Old Master Drawings* (Madison: The University of Wisconsin Press, 1967), 66-73. Iron gall ink, made from oak galls, ferrous sulfate, and gum arabic, was the most common ink used for writing until the early twentieth century. Iron gall was also used by artists for drawing; the ink initially appears purple-gray, darkens to near black on the page when exposed to air, then changes to brown with time. Carbon ink, often referred to as "India ink," is a higher quality ink that is a much deeper black, produces sharper lines than can be formed with iron gall, and remains black over time. Carbon ink is composed of various forms of finely divided carbon derived from soot, burnt wood or bones, or other sources, mixed with gum arabic and water.

6. Marjorie B. Cohn, *Wash and Gouache: A Study of the Development of the Materials of Watercolor* (Cambridge, MA: Center for Conservation and Technical Studies, Fogg Art Museum, 1977), 55.

7. Carter, *Henry Farny*, 15; "The Women's Columbian Association Art Exhibit," *Cincinnati Commercial Gazette*, March 14, 1893, 9.

8. Carter, *Henry Farny*, 16.

9. Van Deren Coke, *The Painter and the Photograph: From Delacroix to Warhol* (Albuquerque: University of New Mexico Press, 1964), 45. Winslow Homer produced wood engravings for *Harper's Weekly* from photographs as early as 1860, sometimes after being directed to do so by the magazine's editors. He usually made drawings for the magazine's wood engravers, but sometimes he "copied a photograph on a white-painted block of wood and then engraved the picture himself."

10. Joseph Pennell, *Modern Illustration* (London: George Bell & Sons, 1895), 48.

11. Ibid., 114–115.

12. *The Rocky Mountain News*, February 28, 1874, 4, quoted in Robert Taft, *Artists and Illustrators of the Old West: 1850–1900* (New York: Bonanza Books, 1953), 96.

13. Pennell, *Modern Illustration*, 41–44.

14. Illustrated in Carolyn M. Appleton and Natasha S. Bartalini, *Henry Farny: 1847–1916* (Austin: Archer M. Huntington Art Gallery, University of Texas, 1983), 22–23. The Cincinnati Art Museum archive contains a letter from Tom Keilman and Son Auctioneers, Round Rock, Texas, with a list of Henry Farny items to be auctioned in March 1986. Among the items listed is an album, "11 3/4 x 9 1/4 bound with red cloth, collection of 111 photographic reproductions of original Farny drawings used for illustrative purposes, black and white, probably proofs that publisher sent back to Farn[y] for approval."

15. Joseph Pennell, *Etchers and Etching*, 4th ed. (New York: The Macmillan Company, 1936), 6.

16. Carter, *Henry Farny*, 16.

17. Kermit S. Champa and Kate H. Champa, *German Painting of the Nineteenth Century* (New Haven: Yale University Art Gallery, 1970), 11.

18. Jean Stern, *Western Masters: A Comprehensive Exhibition* (Beverly Hills: Peterson Galleries, 1981), 77.

19. John Clubbe, "Cincinnati and the Great West: The Case of Henry Farny," *ANQ: A Quarterly Journal of Short Articles, Notes and Reviews* 9, no. 4 (fall 1996): 8.

20. *Report of the General Committee of the Cincinnati Industrial Exposition, held in Cincinnati, under the auspices of the Ohio Mechanics' Institute, Board of Trade, and Chamber of Commerce, from September 21st to October 22nd, 1870* (Cincinnati: published by the General Committee), 361; excerpted from the Report of Judges on "Landscape Oil Painting." Reproductions of the works were not included in the exhibition catalogues, so we do not know if they are the same paintings as oils of similar subjects from this time. The listing in the exposition catalogue appears as a descriptive name for the picture rather than a formal title. Farny's oil landscape described as "the coast of Capri" in the exposition catalogue therefore may or may not be the painting now known as *Mediterranean Coastal Scene* (illustrated in Carter, *Henry Farny*, 37).

21. Ibid.

22. Joan Carpenter Troccoli, *Painters and the American West: The Anschutz Collection* (Denver: Denver Art Museum, 2000), 148, 150.

23. Illustrated in Appleton and Bartalini, *Henry Farny*, 10.

24. *Third Cincinnati Industrial Exposition. Official Catalogue of the Works of Painting, Sculpture and Engraving Exhibited In the Art Department* (Cincinnati: Wrightson & Co., Printers, 1872).

25. James M. Keny, "Duveneck, et. al.," *Timeline* 20, nos. 2 and 3 (March–June 2003): 54.

26. Champa and Champa, *German Painting*, 57–59.

27. Joseph Pennell, *Pen Drawing and Pen Draughtsmen* (New York: The Macmillan Company, 1920), 138. Pennell refers to the illustrations for *Fliegende Blätter* of a "W. Dietz." In the 1889 edition, page 73, he writes, "W. Dietz/ I suppose this is by the well-known Dietz of Munich. In the title of the drawing given in *Kunst für Alle*, where it was published, the name was printed Diez. In English publications it is usually spelt with a T. It is scarcely probable there could have been two men of the same name, both working at the same time, and in the same place. The late Munich professor, I know, made any number of illustrations for *Fliegende Blätter*, and I believe this to be one of his drawings."

28. Cincinnati Art Club, "History of the Cincinnati Art Club: 1890–1971," (typescript, [1972]), 46.

29. Pennell, *Pen Drawing and Pen Draughtsmen*, 21.

30. Carter, *Henry Farny*, 19. The Cincinnati Art Museum accession number for *The Silent Guest* is 1894.19.

31. The Cincinnati Art Museum owns two impressions of this etching, accession numbers 1882.252 and 1882.253.

32. The Cincinnati Art Museum accession number for *Shoulder Length Portrait of a Warrior* is 1977.121.

33. Clubbe, "Cincinnati and the Great West," 5.

34. Carter, *Henry Farny*, 25.

35. Appleton and Bartalini, *Henry Farny*, 34.

36. Quoted in Allen, "Wrecking Of Duveneck's," 3.

37. Appleton and Bartalini, *Henry Farny*, 10.

38. Carter, *Henry Farny*, 42.

39. Dorothy Kosinski, *The Artist and the Camera: Degas to Picasso* (Dallas: Dallas Museum of Art, 1999), 44–45.

40. Coke, *The Painter and the Photograph*, 197.

41. Kosinski, *The Artist and the Camera*, 29.

42. Ibid., 54.

43. Carter, *Henry Farny*, 21.

44. Champa and Champa, *German Painting*, 35–36.

45. "A Painter on the Plains," *Cincinnati Commercial Gazette*, October 28, 1894.

46. Cohn, *Wash and Gouache*, 11.

47. Ibid., 13.

48. Cincinnati Art Club, 23. The Cincinnati Art Museum accession number for the Rettig gouache on silk is 1939.128.

49. *The American Water Color Society Illustrations of Pictures and Catalogue of the Twenty Sixth Annual Exhibition* (New York: The Knickerbocker Press, 1893), 15. The painting's present location is unknown, however, it is unlikely that it is the same painting referred to in Fannie Manser Lawrence, "Farny The Artist and Farny The Man," *The Journal: C. M. C. Souvenir Edition*, July 9, 1953. "The first Indian picture that attracted attention to him as a painter was 'The Last Vigil' which is now in the possession of Mr. Charles Fleishman [sic]. This canvas won the thousand dollar cash prize at the exhibition of the New York Water Color Society." The assertion that an oil painting on canvas was exhibited and won a prize at a watercolor exhibition is probably incorrect.

50. H. W. Herrick, *Watercolor Painting* (New York: F. W. Devoe & Co., 1882), 93.

51. The cliffs on the right are the same as those in *Through the Pass*, private collection, illustrated in Carter, *Henry Farny*, 74.

52. Photograph by Paul Briol in a newspaper clipping headlined "Henry R. Farny, Noted Painter of Indians, at Work in His Studio." This material is located in the "Farny" artist file in the Mary R. Schiff Library of the Cincinnati Art Museum. There is no source and no date, however, a photograph of *Father Jogues*, painted in 1909, is printed with the portrait.

53. Herrick, *Watercolor Painting*, 35–128.

54. J. F. Earhart, "Henry Farny, the Artist and the Man," *Cincinnati Commercial Tribune*, January 21, 1917, sec. 5, 1–2.

55. Cohn, *Wash and Gouache*, 16–20.

56. The Cincinnati Art Museum accession number for *Tombola* is 1984.154.

57. Florence N. Levy, ed., *American Art Annual* (New York: The Macmillan Company, 1899), 535. Barton is the only Cincinnati art supplier listed in the 1898 *American Art Annual*.

58. Illustrated in Carter, *Henry Farny*, 67.

59. ". . . Henry Farny was never a prolific painter, and for a person to order a picture and get it from him meant more than the price of the picture. . . . It meant repeated visits and persistent effort on the part of the purchaser to induce him sometimes to finish a picture, but more often to even start it. Years would elapse in many cases before the painting was finally delivered into the hands of the purchaser." Mary L. Alexander, "Stroll Through a Collection of Works From Brush of Farny," *Cincinnati Times-Star*, October 6, 1919.

60. L. H. Meakin, "Henry Farny: An Appreciation," in "Death of Farny Is Loss to Art World," *Cincinnati Times-Star*, December 25, 1916, 4.

CATALOGUE

Note to the Reader

Titles are the titles currently associated with the gouaches.

Measurements are height before width, given in inches followed by centimeters.

Inscriptions are recorded by location as they appear on the gouaches.

Accession number: The works owned by the Cincinnati Art Museum carry the donor credit line followed by the Museum identification number. The accession number reflects the year of acquisition followed by the object number. For example, 1996.1 would be the first work acquired in 1996.

Lenders of the gouaches to the exhibition are cited except for those who wish to remain anonymous.

1

A Dance of Crow Indians

1883
black, white, and gray gouache over graphite pencil
13 7/8 x 19 3/4 in. (35.2 x 50.2 cm)
signed in the lower right: • Farny • / ⊙
Gift of Charles Dabney Thomson
1964.159

In 1883 Henry Villard, president of the Northern Pacific Railroad, invited Henry Farny to join hundreds of distinguished guests on a special excursion inaugurating the railroad's transcontinental route. The group traveled in elegance on four trains, making predetermined stops along the way. One stop was to witness the driving of the last spike, symbolizing the completion of the track approximately sixty miles west of Helena. Another was to observe a purely western event: a Plains Indian camp with a dance in progress.

The government granted permission for approximately two thousand Crow Indians to leave their nearby reservation and pitch their tipis along the track. The Crow men performed a dance for Villard's guests, and Farny captured the men in their Plains finery dancing around a blazing fire. The hard geometric glare of the passenger car windows, perhaps lit by the Pintsch compressed gas newly available in America that year, contrasts with the irregular light thrown by the flames. Perhaps Farny, like other artists of the time, wanted to suggest that Indians, impoverished and confined to remote reservations, might not be able to adjust to the technological marvels of the dominant white society.

Although Farny witnessed the Crow dance, it is impossible to know if the scene he painted is exactly what he saw. *Harper's Weekly* published a variant of this grisaille image (fig. 36, page 54) in December 1883. This variant, in which several dancers brandishing weapons have been added to the scene, sold at Christie's, New York, on May 23, 2001, lot 86.

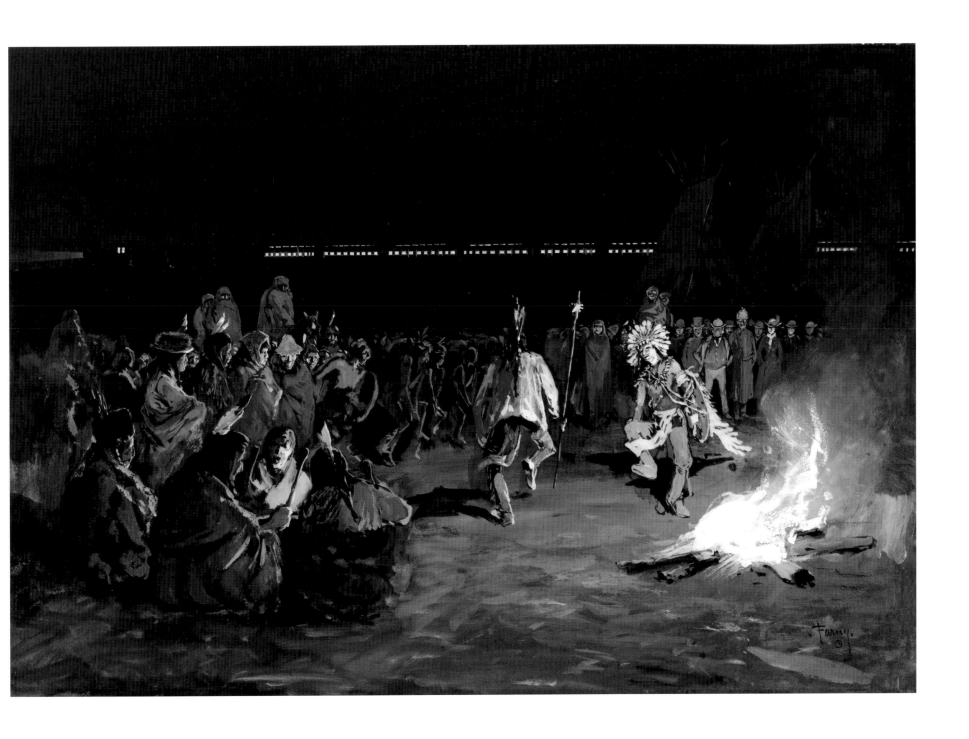

2
Toilers of the Plains

1884
black, white, and gray gouache
18 5/16 x 27 5/8 in. (46.5 x 70.2 cm)
signed in the lower right: • FARNY• / ☉
Gift of The Procter & Gamble Company
2003.63

In late 1881 Henry Farny made his first trip west, to Standing Rock Agency, where he listened to tales of Indian battles.[1] Farny became obsessed with Plains Indians and upon his return began a painting of Lakota Sioux women burdened with firewood. A *Cincinnati Commercial* reporter visiting Farny's studio wrote about his work in progress, *Toilers of the Plains* (fig. 15, p. 27). A couple of months later a *Daily Gazette* reporter also wrote about the painting, noting that *Toilers* sold only a day after it was first displayed in Robert Clarke's bookstore.[2,3] The *Daily Gazette* reporter described the painting: "The landscape is full of sentiment and melancholy into which the resolute but sorrowful face of the Indian woman comes as naturally as the waste of snow and the barren trees."

Farny subsequently painted this gouache of the same subject, now in the Cincinnati Art Museum, for *Harper's Weekly*, which published a wood engraving of the image (fig. 29, p. 47) in June 1884.[4]

In this gouache, as in the oil, Farny alludes to one of the numerous hardships Plains Indians were enduring by depicting a bleached buffalo skull. This animal upon which the Indians' very lives had depended was nearly extinct. In fact, the artist probably did not see a buffalo skull lying exposed on the ground; a Plains Indian would have picked up this increasingly rare object for ceremonial use. By choosing this symbol and making drudgery visible on the women's faces, Farny conveyed the Plains Indians' hopeless situation to his audience. Even the somber landscape and oppressive sky confirm the tragedy overtaking Indian lives.

The oil on which the gouache is based sold at Sotheby's, New York, on December 3, 1998, lot 222.

1. *Cincinnati Enquirer*, November 8, 1881, 8.

2. *Cincinnati Commercial*, December 1, 1881, 4.

3. *Cincinnati Daily Gazette*, January 28, 1882, 6.

4. *Harper's Weekly*, June 21, 1884, 393.

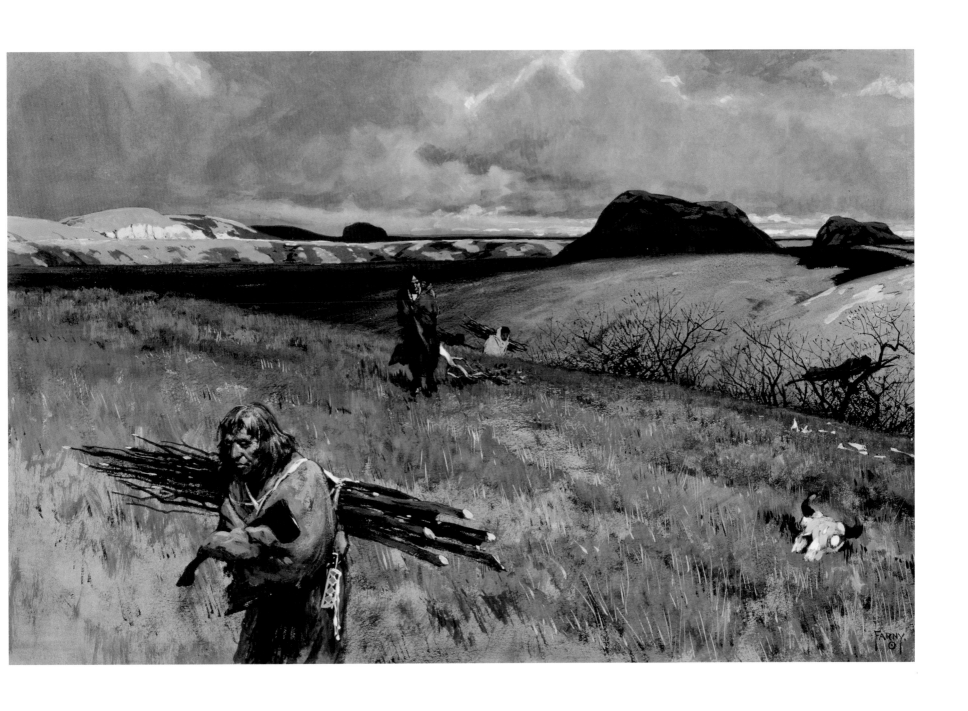

3

The Captive

1885
gouache and watercolor
22 5/16 x 40 in. (56.7 x 101.6 cm)
signed and dated in the lower right:
H. F. FARNY / ☉ / 85
Gift of Mrs. Benjamin E. Tate and Julius Fleischmann
in memory of their father, Julius Fleischmann
1927.38

When exhibited at the 1885 American Art Association autumn exhibition of watercolors, this painting, then titled *The Prisoner*, won a substantial cash prize awarded by popular vote.[1] The title of the painting was subsequently changed to *The Captive*. To this day it remains one of Farny's most popular paintings, widely recognized as an icon of western art.

In 1886 *Harper's Weekly* published a nearly identical wood engraving after Farny's painting, also titled *The Prisoner* (fig. 40, p. 58). The engraving accompanied a gruesome description of a white captive staked in the sun to die, a practice the *Harper's* article attributed to Apache Indians.[2] Both this painting and the engraving, however, incorporate images from Plains Indians scenes Farny witnessed on Standing Rock reservation in 1881, including typical Plains Indian objects: tipis, a travois, and a Plains trade blanket with a beaded blanket strip. The sentry is wrapped in a dark blanket just like those seen in Farny's wood engraving *Ration Day at Standing Rock Agency* (fig. 30, p. 48).[3]

The peculiar intimacy of the two figures in the torture scene—the pale, naked torso of the helpless captive, stared at by the dark unwavering eyes of the sentry—is heightened by its juxtaposition with the tipi inhabitants in the background, who carry out their ordinary activities on this warm, peaceful day with no apparent interest in the prisoner or his suffering. Farny uses the captive's outstretched arms to reiterate the expansive Plains landscape and to counterbalance the uncomfortable intimacy between captive and captor.

This grisly image perpetuates a stereotype that late-nineteenth-century whites wanted to believe about Indians: that they were capable of unspeakable savagery, of inflicting pain and enjoying the enemy's suffering. Sensationalism is no stranger in Farny's work, but there is no other image remotely like *The Captive* in his oeuvre. Perhaps Farny repented of this portrayal of the Indians he admired and cared for.

1. "Personal," *Harper's Weekly*, November 28, 1885, 771.
2. *Harper's Weekly*, February 13, 1886, 109.
3. *Harper's Weekly*, July 28, 1883, 472–73.

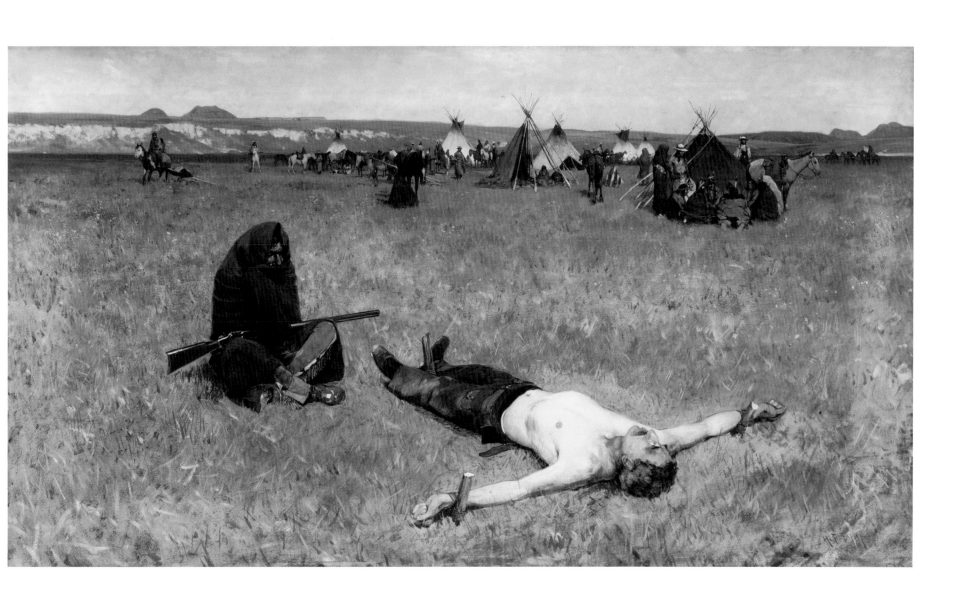

4

Indian Encampment

1890
gouache and watercolor with touches of gum
13 11/16 x 21 in. (34.7 x 53.4 cm)
signed and dated in the lower right: H. F. FARNY• / ⊙ / 1890
Bequest of Ruth Harrison
1940.697

By the time Farny painted this peaceful scene he had already made three trips to the Great Plains, in 1881, 1883, and 1884. Tipis, traditional Plains Indian housing, stand tranquilly on the ground. One, with its entry flap raised, even beckons. A war shield, protected by its hide cover, stands on its wooden tripod and absorbs the sun's powerful rays, thereby collecting power for its owner.

The rounded structure is probably a hide sweat lodge—an important ceremonial structure in which Plains Indians conducted prayerful sweats. No doubt Farny, on his excursions, would have seen tipis and probably even sweat lodges, because these are still used today. The unusual thing about this lodge is its location in close proximity to the tipi; sweats are sacred ceremonies and traditionally the lodges are carefully situated away from dwellings. Farny exercised artistic license in placing the sweat lodges so close to the tipis because he needed a diversity of structures for visual interest.

However, Farny probably did not see Indian men carrying guns as he has painted here: the two seated figures and the man on the horse all carry rifles. Such behavior in Farny's time would have made Indian agents nervous—government officials and military men knew Plains Indians were brave warriors who earned honor through daring combat.

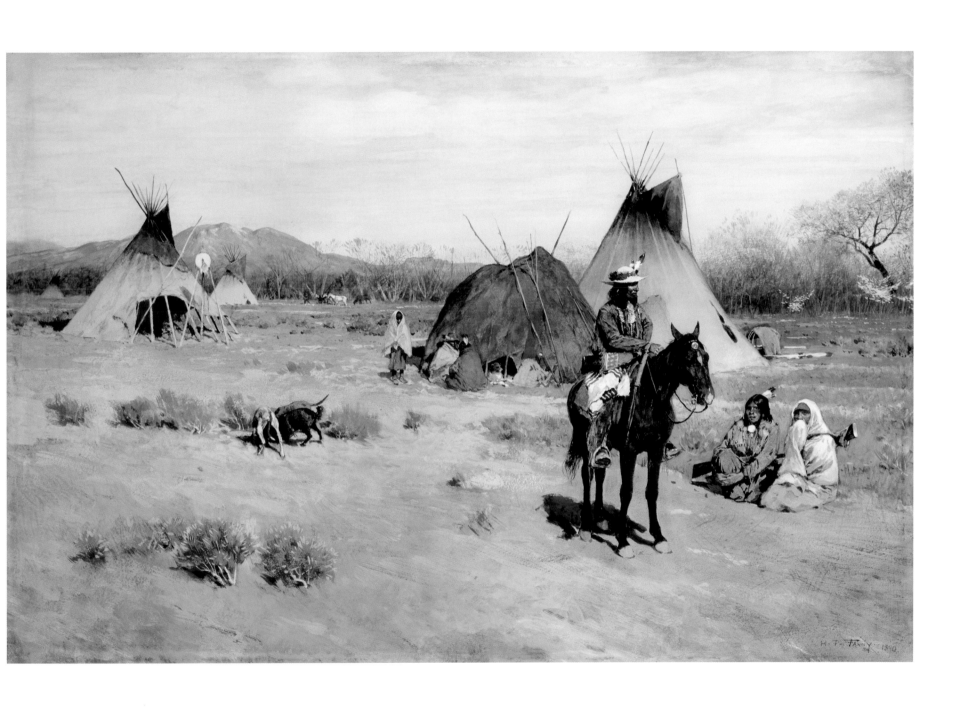

5

Plains Indian

1890
gouache with touches of gum over
graphite pencil on blue-gray paper
9 3/4 x 7 3/4 in. (24.8 x 19.7 cm)
signed and dated in the lower right:
FARNY / ☉ / 90
Bequest of Mary Hanna
1956.95

This painting answers a question that has
plagued many whites to this day: How were
Indian leggings worn? Careful inspection reveals
that each legging, resembling a sleeve, has a long
strap attached to the outside. The strap is tied
to the man's belt. A breechcloth between his
legs covers his genitals and buttocks. Here, the
outer edge of the breechcloth is barely visible.

Farny knew that whites wanted to see a
"real" Indian—a man wearing a long eagle feather
warbonnet—so he makes the Indian and his
horse the focal point of the composition.

A Plains warrior would have had to
accomplish many warrior deeds to earn this
headdress; therefore it would have been
unlikely for such a young man to be wearing
such an elaborate warbonnet. Around 1900
these headdresses embodied the stereotype for
all Indian people. George Catlin, an American
artist who traveled among Plains Indians in the
early 1830s and painted them in their traditional
homelands, helped establish this stereotype.
Later, others, especially William F. "Buffalo Bill"
Cody, reinforced the image so that for a time,
even the Cherokee of North Carolina wore
eagle feather warbonnets. Today, however,
the Cherokee wear their traditional Eastern
Woodland clothing, which is distinctly different
from traditional Plains clothing.

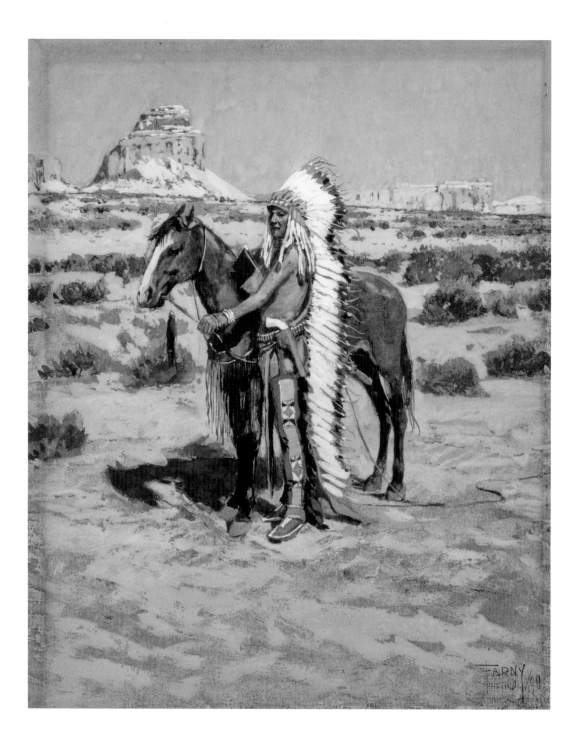

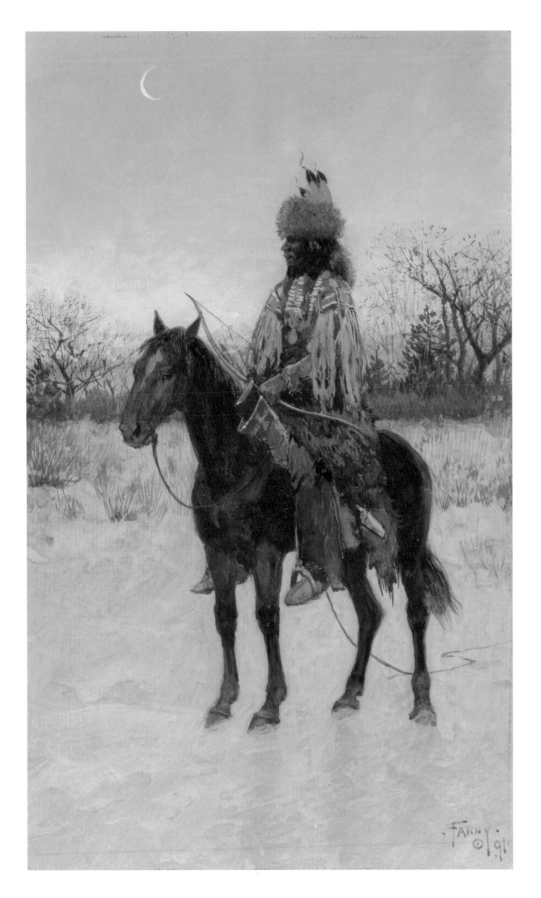

Indian on Horseback

1891
gouache with touches of gum
10 x 6 1/16 in. (25.5 x 15.4 cm)
signed and dated in the lower right:
• FARNY • / ⊙ / 91
Lent by Ron and Florence Koetters

This northern Plains man wears all his traditional finery. His fringed leather clothing is ornamented with colorful geometric beadwork and strips of soft white ermine—winter weasel fur. His fur turban is surmounted by eagle feathers. Red trade cloth wraps his braids. A large silver-colored ornament worn as a pendant is probably a peace medal, given to him or to a close relative by the "Great Father," the President of the United States.

Peace medals were given to important Indian chiefs, warriors, leaders and visitors. The Great Father presented these medals as a symbol of friendship with and allegiance to the U.S. government. Even though the practice did not originate in the United States, the distribution of these tokens followed strict rules, stating for example that the largest should be given to principal chiefs and that presentation should be accompanied by the proper formalities in order to impress the Indians. The medals were highly prized and passed down as treasured family heirlooms.

Farny also depicted this brave warrior with his weapons. A gunstock emerges from its beaded hide gun case, and a recurved bow is also ready should he see a prey animal on this wintry day. No sensible hunter would be likely to wear such a magnificent shirt, or his cherished medal, out alone in the woods where no one would be around to admire them, but Farny undoubtedly realized that this striking figure would appeal to buyers.

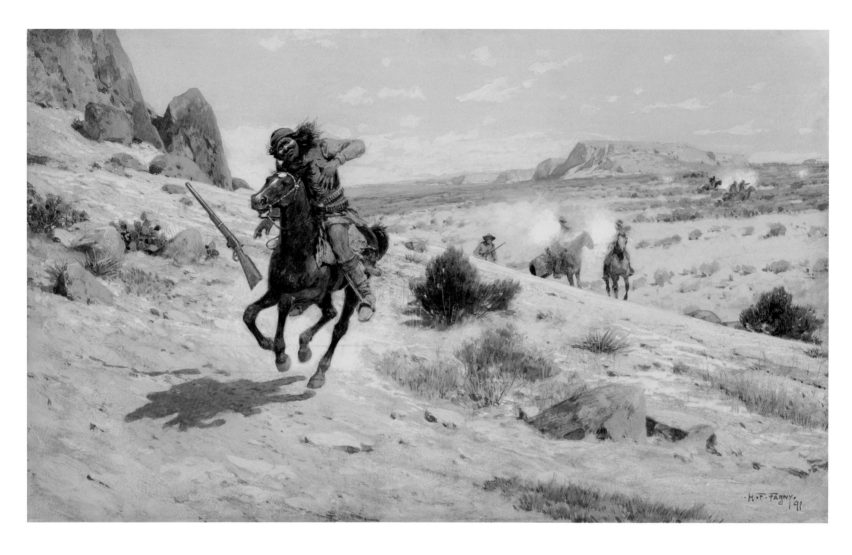

7

Got Him

1891
gouache with touches of gum over
graphite pencil
9 1/16 x 14 13/16 in. (23 x 37.6 cm)
signed and dated in the lower right:
•H•F• FARNY• / ☉ / 91
Lent by Mr. and Mrs. Stephen G. Vollmer

An Indian attempts a futile escape from whites across a southwestern landscape. The Indian's grimace, the placement of his left hand, and the falling Spencer carbine indicate he has been shot by his pursuers. He is well prepared for a lengthy fight because he is wearing two 1876 prairie belts, each made to hold twenty-five to thirty cartridges, which he probably picked up on the battlefield from a dead or injured U.S. trooper.[1] Although Farny does not give the subject's tribal affiliation in the title, the Indian's clothing and the cactus plants imply that he is most likely Apache.

In the right background of this painting another group of pursuers chases and fires upon an unseen quarry, probably a comrade of this wounded Apache. In the far distance is the suggestion of a third pursuit. The complexity of the scene reveals itself only on careful inspection, demonstrating Farny's ability to tell a story. In this instance, he creates suspense by scattering bursts of gunsmoke across the image, giving us to understand that there are other confrontations in process whose outcomes we do not know.

Got Him is one of three watercolors Farny exhibited at the 1893 World's Columbian Exposition in Chicago.

1. Personal communication, Jack Lewis, July 17, 2007.

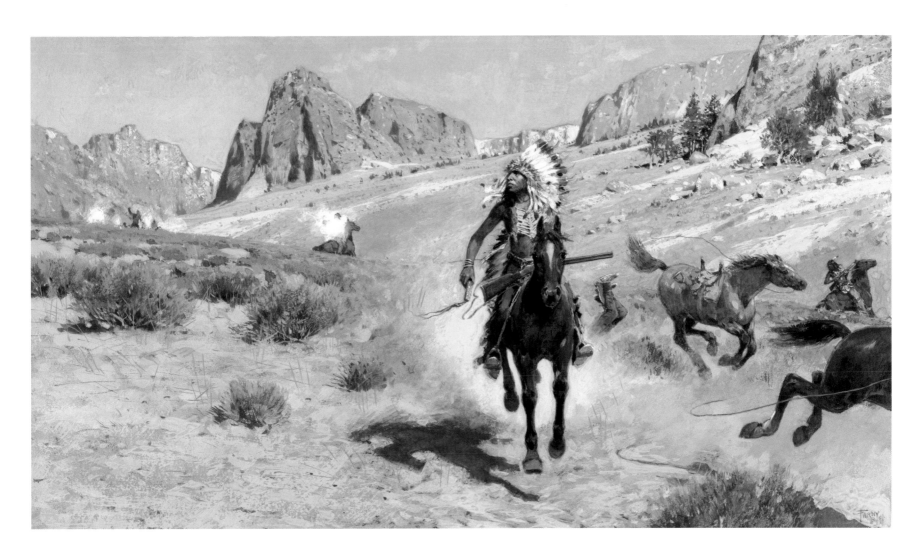

8

In Pursuit

1891
gouache with touches of gum over
graphite pencil
9 9/16 x 16 7/8 in. (24.3 x 42.8 cm)
signed and dated in the lower right:
FARNY / ⊙ / 91
Lent by W. Roger and Patricia K. Fry

Here the U.S. Cavalry rides in hot pursuit of a group of Plains Indians—one, with his navy trade cloth legging and moccasin barely visible, has fallen from his horse. The Indian at the focal point of the scene runs straight at the viewer, urging his horse to greater speed with the quirt in his right hand. Farny was surely aware of Eadweard Muybridge's pioneering studies in animal locomotion, in which Muybridge proved that at one point in its stride, a galloping horse has all four hooves off the ground, as does the horse right center that has just lost its rider. The chase occurs in a typical Badlands landscape, where Indians intimate with the confusing terrain successfully escaped pursuing enemies, whether soldiers or rival Indians.

By painting this Plains Indian warrior in an eagle feather warbonnet, Farny reinforced the Indian stereotype that whites expected to see. However, it is highly unlikely that a warrior would wear such elaborate and cumbersome headgear into battle.

Farny painted this work in 1891, the year after the Wounded Knee Massacre on Pine Ridge Indian Reservation in present-day South Dakota. Approximately 300 men, women, and children were literally gunned down in that tragic event, the last armed conflict between the Lakota Sioux and the U.S. military. Farny's elegiac illustration *The Last Scene of the Last Act of the Sioux War*, published as a wood engraving in the February 14, 1891 issue of *Harper's Weekly* (fig. 45, p. 63), demonstrated his keen awareness of the ramifications of that battle for all Indians, especially the Lakota Sioux.

9

A Moment of Suspense

1891
gouache and watercolor with touches of gum over graphite pencil
10 x 6 1/16 in. (25.4 x 15.4 cm)
signed and dated in the lower right: FARNY / ⊙ / 91
Gift of Dr. and Mrs. Robert S. Leake in memory of Mr. and Mrs. Edwin C. Landberg
1996.335

The source photograph for this painting is a studio portrait of a man identified as Peso (fig. 52), reproduced on a cabinet card advertising railroad travel. The card currently belongs to a Farny relative.

Peso, a Kiowa Apache better known as Pacer, is described on the front of the card as being responsible for capturing the great Apache warrior Geronimo. This claim is difficult to document and may not even be true. Geronimo was notorious for eluding government troops. He either surrendered or was taken prisoner on a number of occasions, but he escaped every time until his final capture in 1886.

Farny used his artistic license in creating this suspenseful instance in which Pacer sits alert in the saddle, perhaps on the lookout for Geronimo. The rugged landscape and blinding light are reminiscent of the mountainous southwestern terrain in which Geronimo so often evaded the United States military. Pacer's bold, colorful clothing reflects the Apaches' frequent contact with Mexican peasants. Farny dramatizes Pacer's persona by adding face paint and weaponry and exposing a length of muscular thigh.

In 1898, Rookwood artist Frederick Sturgis Lawrence used a different portrait of Pacer as a source image on a decorative mug, illustrated in *Rookwood and the American Indian*.[1]

1. Anita Ellis and Susan Labry Meyn, *Rookwood and the American Indian* (Athens: Ohio University Press, 2007), 181.

FIGURE 52
Unidentified photographer, *Signor Pacer, Chief of Scouts who Captured Geronimo*, n.d., photograph on cabinet card.
Private Collection, North Bend, Ohio.

This image advertising rail travel was among Farny's papers at the time of his death.

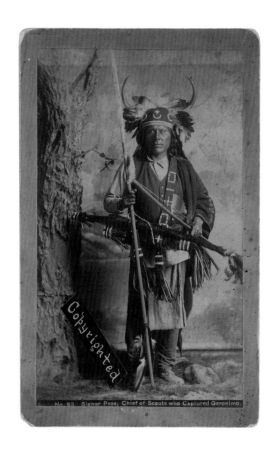

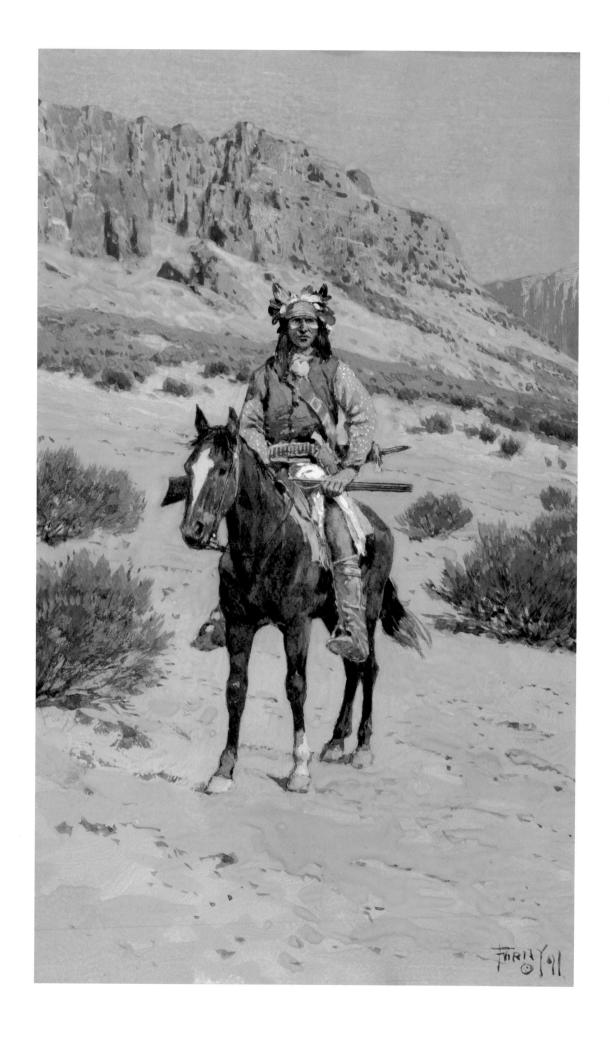

10
A Young Squaw

1892
watercolor and gouache with touches of gum
on gray paper
6 x 4 9/16 in. (15.3 x 11.6 cm)
signed and dated in the lower right:
FARNY / ☉ / 92
Lent by W. Roger and Patricia K. Fry

This young woman wears her hair unbraided;
the part in her hair is painted red, indicating
that she has reached puberty. Plains Indians
valued and celebrated feminine virtues such as
chastity and generosity. By this age, a young
woman would have learned a vast array of
traditional domestic skills, all economically
valuable to her family. Her diverse skills would
have included gathering and preparing wild
foods such as chokecherries and wild turnips,
jerking buffalo meat and making pemmican,
sewing hide clothing with sinew, and making
and erecting tipis. Other skills involved
culturally important activities, such as
performing traditional female ceremonies and
passing her tribal knowledge to her children
and grandchildren.

Farny's talent as a portraitist is evident in this
carefully rendered watercolor. He accentuates
the sitter's face, and conveys all the dignity and
serenity of a traditional Plains woman. Thus the
use of the vulgar term "squaw," used frequently in
the past by people ignorant of its real meaning,
is completely inappropriate. The word is in fact
a particularly derogatory term for a prostitute.

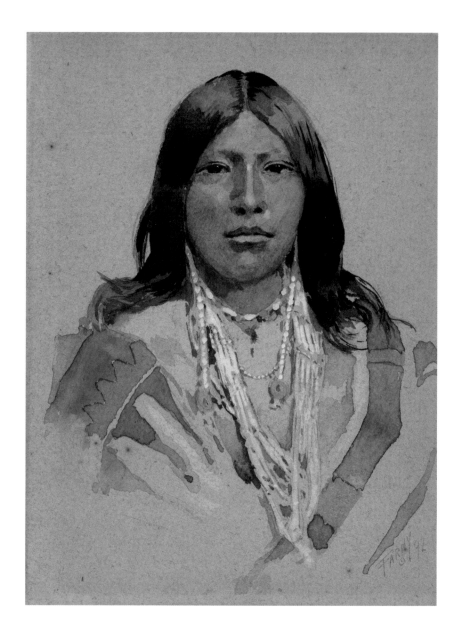

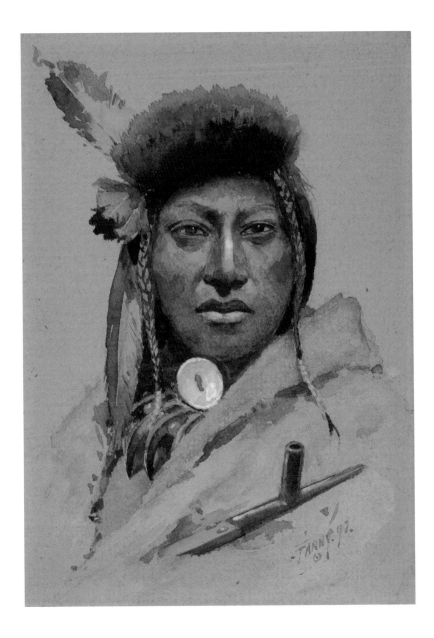

11

Sioux Brave

1892
watercolor and gouache over graphite pencil
with touches of gum on gray paper
6 1/8 x 4 7/16 in. (15.6 x 11.3 cm)
signed and dated in the lower right:
•FARNY•92• / ⊙
Lent by W. Roger and Patricia K. Fry

Although the subject of this portrait is said to be a Sioux, his short upright bangs and narrow braids on either side of his forehead are distinctive, and identify his tribe as Crow. He wears a spectacular grizzly claw necklace, each claw separated by a large turquoise-colored bead. Most likely these large beads are made of glass and were traded to the Plains Indians. Such beads are called "trade beads" to distinguish them from traditional Indian beads, which were made laboriously by hand from readily available materials such as bone and shell.

The subject's physical features are not typically Native American. The sitter may well have been one of Farny's "secretaries," as he called the men who helped him around the studio and sometimes served as models. Some of their names have survived to this day—Bee, Hennessey, and Ogallala Fire (a variant spelling of the Oglala band of Lakota Sioux), to name a few. This man's name remains unknown.

Farny has made a point of placing a Plains catlinite pipe in the foreground of the portrait for compositional balance. The pipe is accurately rendered in some detail; the bowl has a pronounced tapering anterior projection and is typical of pipes used at the time. Catlinite is a red stone still quarried by Indians since at least 1200 A.D. from a site in southwestern Minnesota, now designated as Pipestone National Monument. The stone is named for George Catlin, who was the first artist to sketch the quarry site.

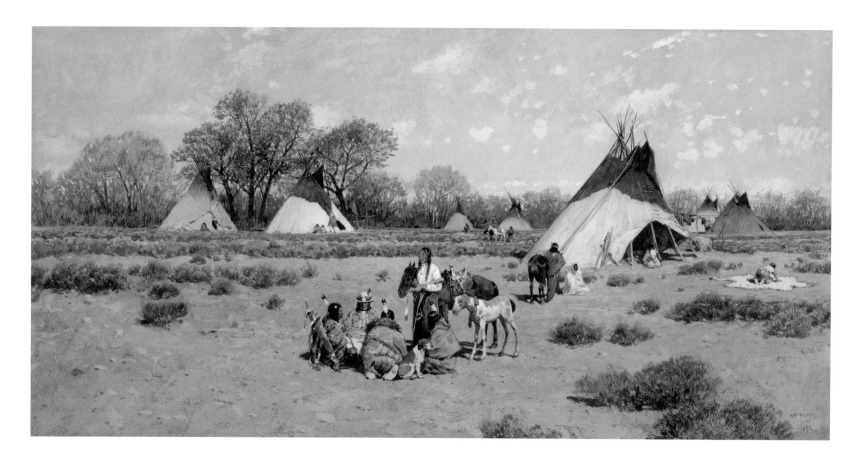

12

Cheyenne Camp

1892
gouache with touches of gum over
graphite pencil
12 x 23 15/16 in. (30.5 x 60.8 cm)
signed and dated in the lower right:
• H • F • Farny • / ⊙ / • 1892 •
Gift of William Procter in memory
of his father, Harley T. Procter
1942.93

On his first trip there in 1881, Farny fell in love with the Far West, claiming it "to be fuller of material for the artist than any country in Europe."[1] Cincinnatians read about his stay among the Lakota Sioux in the *Daily Gazette*, which quoted him as saying that he had never seen a "jollier camp" than a Sioux village. We do not know if Farny ever visited a Cheyenne camp, but historically it is known that, for a period, some Cheyenne lived in the vicinity of the Lakota Sioux.

In this scene Farny depicts a warm day with the tipi flaps lifted invitingly and daily activities in progress, which draw the viewer into the painting. At the focal point of the picture men relax together, either talking or gambling, an activity that filled many leisure hours. Gaming often included outrageous wagers, especially when the stakes were high and the event highly charged, such as a horse race between two particularly speedy animals, in which case even non-Indian spectators could be caught up in the suspense.[2]

To the far right a woman, on her knees, fleshes a hide staked to the ground. After she scrapes away the fat and connective tissue she will tan the hide with a mixture of brains, liver, and fats. Once the hide dries, she will soften it and make it flexible by working it back and forth over a twisted rawhide thong or a pole to completely break down the tissue. The resulting leather can then be made into a garment, a tobacco bag, or other utilitarian object, which can then be decorated either with trade beads or porcupine quills.

1. *Cincinnati Daily Gazette*, November 8, 1881, 8.

2. Charles Erskine Scott Wood, "An Indian Horse Race," *The Century Magazine* 33, no. 3 (January 1887): 447–50. Farny illustrated the event of the title.

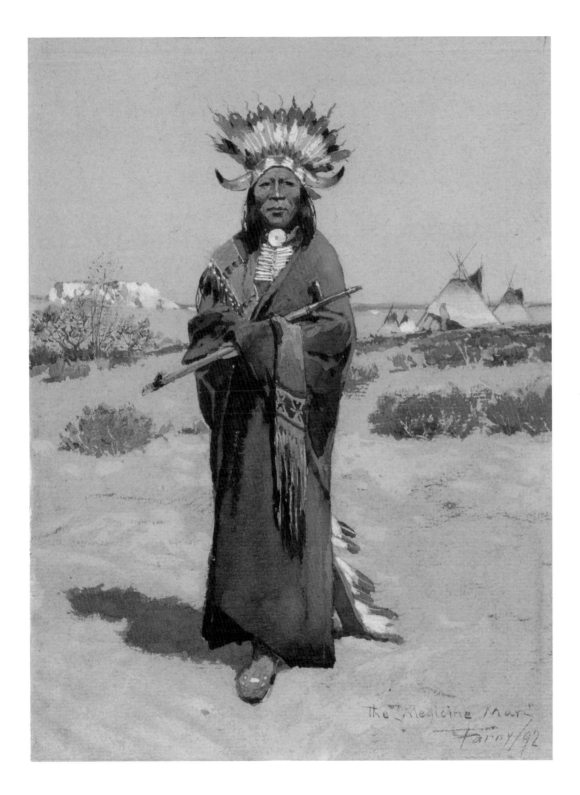

13
The Medicine Man

1892
watercolor and gouache
8 3/8 x 6 1/4 in. (21.3 x 15.8 cm)
inscribed in the lower right:
The Medicine Man / Farny / ⊙ / 92
Lent by Ron and Florence Koetters

Medicine men, or holy men, were knowledgeable about Lakota gods and thus responsible for interpreting the complexities of the universe and giving advice on proper behavior, such as the best time to hunt, conduct war, or pursue a female lover. Medicine men had the power to cure injury or disease, and were responsible for the proper performance of rituals and ceremonies.

The reservation period witnessed religious change. As missionaries determinedly attempted to establish Christianity, the Indian prophet Wovoka introduced the Ghost Dance religion on the Plains. This new religion prophesied the death of white men and a return of the buffalo. Despite the upheavals in their lives and religious prohibition, Plains Indians continued in secret to practice traditional sacred ceremonies, such as the important Sun Dance, which was a prayer of thanksgiving or prayer for the wellbeing of the people. This intense ritual included self-torture, usually a piercing through the chest skin.

Farny depicted this Medicine Man holding his catlinite pipe and beaded hide tobacco bag. For Plains Indians smoking could also be a spiritual act; the smoke, as it rose upward, carried the people's prayers.

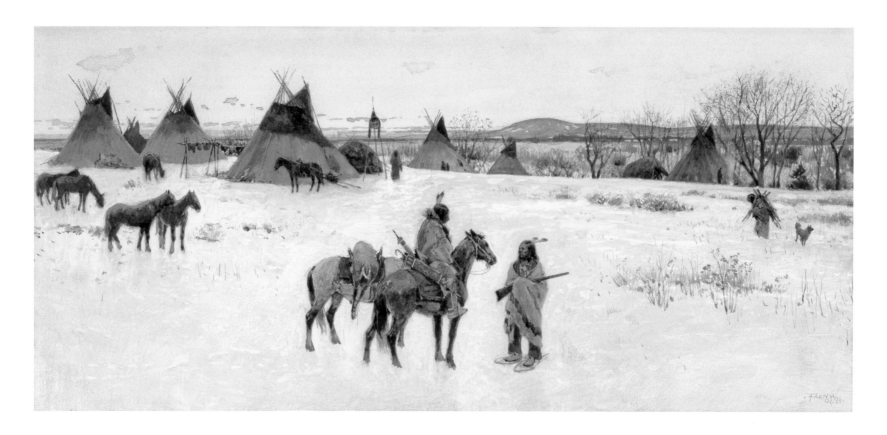

14

Return from the Hunt

1894
gouache and watercolor over graphite pencil
7 1/4 x 16 1/8 in. (18.4 x 41 cm)
signed and dated in the lower right:
•FARNY• / ☉ / 94•
Gift of the Starbuck Smith, Jr., Family
2004.1145

Indian life on the Great Plains centered on the movement of buffalo and other wild game; therefore the location of tipi camps was always temporary. Everything Plains Indians owned could be moved readily—skin tipis, parfleche (rawhide) containers holding the family's possessions, and cradleboards for infants. A travois, or skid, was loaded and attached to a dog—or later, a horse—and dragged to a new campsite. Plains Indians did not make pottery; instead they used parfleche pouches to store dried wild turnips and jerked meat—meat preserved by cutting it into long, thin strips and hanging it on a horizontal pole to dry in the sun.

Before the snows of winter fell, large Indian groups divided into smaller ones, dispersing over the plains in search of game. In this painting, a hunter has just returned home with a fresh kill. By the time Farny painted this scene, however, Indians already had been confined to remote reservations, where they were unable to hunt the few remaining buffalo and were forced to rely instead on government annuities.

Farny's use of subtle color reinforces the stark beauty of the Plains winter landscape. He painted these tranquil scenes of Indian life in all seasons because they appealed to white buyers who yearned for the romance of America's wild frontier.

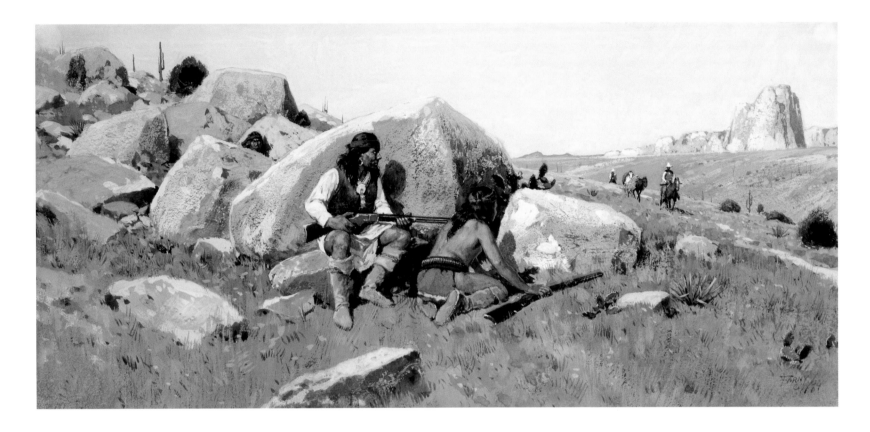

15

An Apache Ambush

1894
gouache and watercolor over graphite pencil
7 11/16 x 16 5/16 in. (19.5 x 41.4 cm)
signed and dated in the lower right:
FARNY / ☉ / 94
Gift of Alfred T. and Eugenia I. Goshorn
1924.73

In October 1894 General Nelson Miles cabled Farny, inviting him to tour Fort Sill, in the then Indian Territory, where Farny met the now legendary Geronimo, the renowned military leader of the Chiricahua Apache. The old warrior sat for Farny and "captured" his heart (fig. 19, p. 30). Through an interpreter, Farny talked with some of the other Indians living there. It is likely that those tales provided inspiration for this painting. Farny never witnessed an Apache ambush, but this scene demonstrates his ability to assimilate diverse kinds of information into paintings that vividly convey the spirit of a moment. The clothing the Apache wear and the features of the terrain they inhabit are accurately portrayed, but the painting is most memorable for the tension inherent in its narrative.

Following the treaty of Guadalupe Hidalgo in 1848, when the United States acquired New Mexico and California, the Apache world changed profoundly and rapidly. The relentless expansion westward put pressure on Apache land and resources, but it was only after maltreatment by the American military that the Chiricahua Apache went to war against Americans. Despite periodic cessations in the hostilities, during which many Apache moved to reservation lands provided for them, the Americans' continued breaking of treaties and acts of outright treachery led the Chiricahua Apache war chief Cochise, and then his successor Geronimo, to escape back into the rugged mountains straddling the Mexican border and conduct an ongoing guerilla war against the United States. Geronimo's band of Chiricahua Apache fought on long after other Apache groups—even those who had also engaged in prolonged bitter warfare— had given up the struggle to retain their lands.

16
Tashkoniy / Comanche

1894
watercolor
8 7/8 by 7 5/16 in. (22.5 x 18.6 cm)
inscribed in the lower left:
Tashkoniy / Comanche;
lower right: Farny / ☉
Lent by Leonard A. Weakley, Jr.

This is a rare example of one of Farny's sketches
in situ, which was then adapted as a newspaper
illustration. The date of the watercolor was
determined by an identical sketch, titled
Tachkoniy / Comanche [sic] (fig. 53), published
in the *Cincinnati Commercial Gazette*. Farny, the
invited guest of General Nelson Miles, painted
Tashkoniy while touring Fort Sill Reservation,
where he also met and sketched the great
Apache military leader Geronimo. Upon Farny's
return to Cincinnati, the artist expressed his
gratitude to the resident interpreter, Colonel
Jones, saying he felt "indebted for much of the
insight he [Jones] had of Indian character."

Tashkoniy wears a traditional man's hair-
style—his long braids are wrapped with strips of
red wool flannel, brought to the Plains by traders.
Plains Indians also liked and wore neck kerchiefs,
a useful as well as decorative fashion accessory the
Indians probably adopted after seeing them on
white soldiers, settlers, and cowboys.

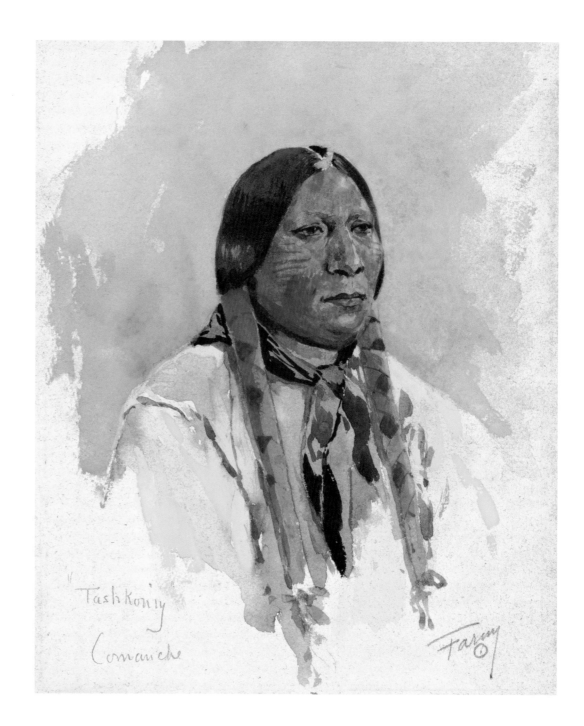

FIGURE 53
Henry Farny, *Tachkoniy / Comanche*, illustrated
in the *Cincinnati Commercial Gazette*, October
28, 1894, 22. From the Collection of the Public
Library of Cincinnati and Hamilton County.

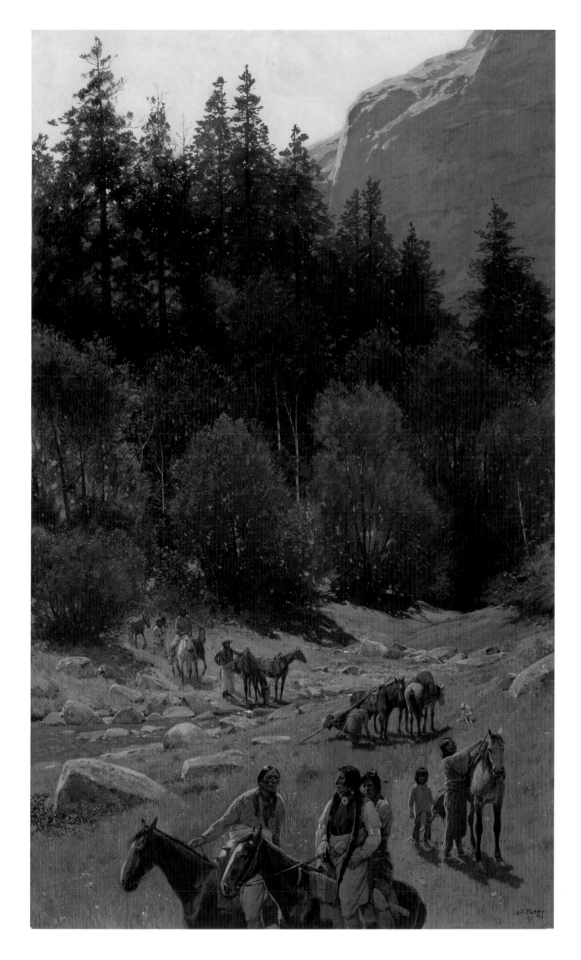

17

Mountain and Meadow

1897
gouache
28 9/16 x 17 3/16 in. (72.5 x 43.7 cm)
signed and dated in the lower right:
•H•F• FARNY / ☉ / 97
Private Collection

A band of Indians and their beloved horses moves through a magnificent northern Plains setting, much like those Farny himself passed through in 1884 on his expedition for *Century Magazine*. Farny excelled in his ability to convey the huge scale of the western landscape in a small painting by using a vertical format. Here, the Indians, totally at home in their environment, cross a quiet mountain stream beneath the massif that dominates the scene. Farny leads the viewer to ponder what this small band of Indians with so many pack horses has been doing prior to emerging from the thick forest. Perhaps the Indians had gathered for a hunt, or for a visit with extended family members.

The Indian man in the foreground wears a striped cotton shirt and two eye-catching metal armbands, probably made of nickel silver and traded to the Lakota Sioux. Farny saw Lakota Sioux Indian men from Rosebud Reservation at the Cincinnati Zoo wearing similar manufactured cotton shirts; a photograph Farny himself took at the zoo of the Lakota Young Iron Shell proves this.[1] This work was painted the year after the Sioux encampment at the zoo; perhaps that is why the subjects' clothing is reminiscent of that event.

1. The photograph is in the Rare Books and Special Collections Department of the Public Library of Cincinnati and Hamilton County.

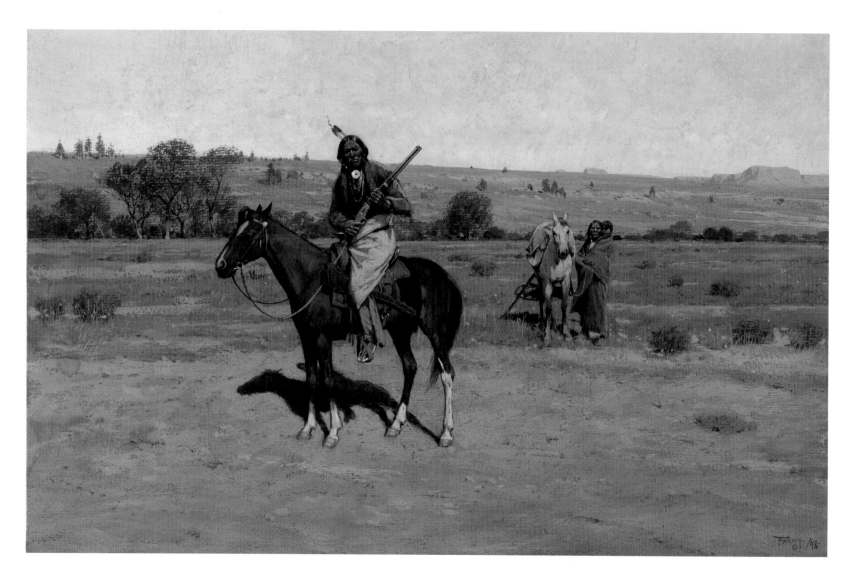

18

On the Alert

1898
gouache with touches of gum
11 x 16 7/8 in. (27.9 x 42.9 cm)
signed and dated in the lower right:
FARNY / ☉ / 98
Lent by Mr. and Mrs. Stephen G. Vollmer

The wary attentiveness of this Plains man and woman indicates they are prepared for an unexpected event, perhaps an enemy or wild animal. Farny captures the dynamic quality of Plains Indian life; Plains peoples were nomads, and their lives revolved around instant mobility and constant readiness.

The painting vividly illustrates two non-native elements that changed Plains Indian lives forever: the horse and the gun. Modern horses entered North America with the Spanish in 1540, and by about 1750 had spread into the northern reaches of the Great Plains. Guns entered North America via the fur trade, spreading onto the Plains at approximately the same time that horses became more readily available. Stone war clubs and rawhide shields made from the extra-thick hide of buffalo or elk gave way to firearms, often shifting the balance of tribal power on the Plains. Early guns, however, were no match for bows and arrows, which for some time surpassed guns in accuracy and range. Most important, bows could be reloaded easily, with homemade ammunition—arrows.

Guns and horses—called the "sacred dog" by the Plains Indians—became prized possessions indicating status and wealth. These new acquisitions greatly enhanced Plains Indian lives, enabling them to evolve the "classic" lifestyle that George Catlin and other early artists admired and painted. The ease with which men could now hunt buffalo freed them to concentrate on the central focus of a Plains man's life: war. For their part, women, with the horse as a pack animal, could move larger tipis and family possessions more quickly. The compatibility between horses and Indians continues as a powerful image to this day.

By the time Farny painted this scene, Plains Indians had been forced to quit their traditional nomadic life and were confined to reservations, which they were not supposed to leave without the permission of the Indian agent.

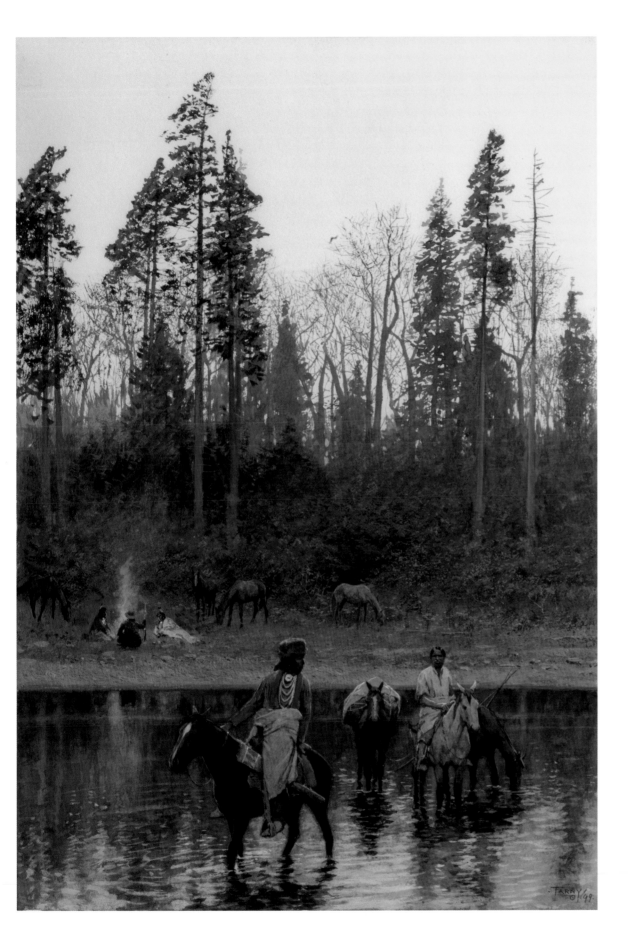

19

The Ford

1899
gouache and watercolor over graphite pencil
15 15/16 x 11 in. (40.5 x 27.9 cm)
signed and dated in the lower right:
FARNY / ☉ / 99
Gift of the Farny R. and
Grace K. Wurlitzer Foundation
1970.183

This painting epitomizes Farny's brilliance as a landscapist. The trees silhouetted against his trademark "lemon sky" add dimension to the scene and give a sense of the expansiveness of the vanishing frontier. The shimmering water brings man and nature together.

No doubt Henry Farny heard many tales about the vanished traditional lifestyle of Plains Indians. Packing possessions and moving from place to place had been part of Plains life. Cold weather required large groups to break apart in order to survive; warm weather brought the group together again to enjoy one another's company and participate in important ceremonies. Farny, through his art, told the story of Plains Indian lives prior to the reservation era.

A careful examination of the group around the fire reveals that the figure with his back to the viewer is a white man sitting between the two Indians.[1] One cannot help but wonder whether this is Farny himself, playfully included in his own painting. When the gregarious Farny traveled west, he enjoyed talking with Indians about their lives; local interpreters enabled him to speak with Indians in some depth. Later, when he returned from each of his western excursions, Farny entertained Cincinnati reporters with tales of his experiences. The reporters were eager to recount Farny's adventures in print, thus contributing to the Farny persona, and very likely bringing new clients to his studio.

1. Personal communication, Peter Strong and Mary Bordeaux, Pine Ridge Indian Reservation, June 12, 2007.

20

Apache Water Carrier

1899
gouache on blue-gray paper
9 1/8 x 5 15/16 in. (23.2 x 15.1 cm)
signed and dated in the lower right:
FARNY / ☉ / 99
Lent by Mr. and Mrs. Stephen G. Vollmer

Single female figures are relatively uncommon in Farny's work. He depicts this Apache woman carrying a traditional pitched basket, called a *tus*, supported by a tumpline across the top of her head. A *tus*, or water jug, was twined and sealed with pine pitch melted in a pot and applied with a brush made of plant fiber. This clever technology allowed women to perform the daily chore of carrying water while leaving their hands free to tend children or carry other burdens. Women of several other southwest Indian cultures, for example the Zuñi and the Acoma, resolved the challenge of transporting water by making large pottery jars with concave bottoms, which they could carry atop their heads.

Apache women, especially the Western Apache, are noted for their superior basketry skills. This Apache woman clearly belongs to one of the Apache groups that was semi-nomadic and so did not make pottery, but wove these special water baskets instead. She holds cut plants, possibly a species used to weave the *tus*, which was usually made of scrub sumac. Her turquoise necklace and blanket with broad stripes are not of Apache manufacture, and may have been obtained through trade with Pueblo people.

Farny painted this image after he visited Fort Sill, where Geronimo and other Apache were imprisoned.

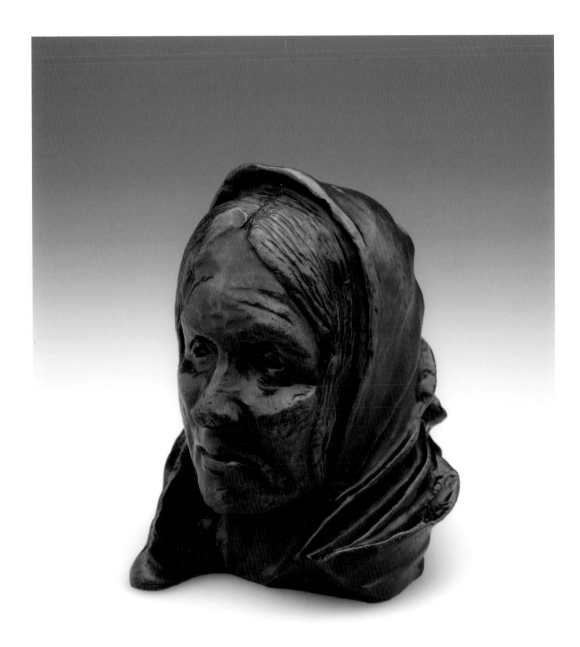

21
Pueblo of Zuñi, Bernice Sal Ql Saye

1899
bronze
4 15/16 x 4 1/8 x 4 7/16 in.
(12.6 x 10.5 x 11.2 cm)
inscribed on the lower back:
PUEBLO OF ZUNI /
BERNICE SAL QL SAYE /
FARNY / ⊙ / 99 6/10
Lent by Charles and Patricia Weiner

During his career Farny made several bronzes with Indian subjects. It is difficult to know where, or even whether, Farny met this woman because there is no documentation indicating that Farny ever traveled to Zuñi Pueblo, or even to the Southwest. When he drew southwestern illustrations for *Century Magazine* (fig. 31, p. 50), for example, Farny used John K. Hillers's famous photographs of the Zuñi (figs. 32 and 33, p. 51), taken for the Smithsonian Bureau of Ethnology, as source images. Farny did meet members of a Zuñi delegation who traveled to Washington, D.C. in 1882, but the published records of that journey do not include the names of any women.

Even though he did not visit Zuñi Pueblo, we know that Farny's interest in the Zuñi people continued throughout his life because he continued to depict them, probably using Hillers's photos. Farny's body of work includes a number of pueblo images, generic views that include the architecture of Zuñi Pueblo or one of the Hopi pueblos. Often the images show women wearing their traditional dress and performing a variety of daily tasks.

22
Indian Scout

1899
gouache over graphite pencil
14 1/2 x 9 9/16 in. (36.8 x 24.3 cm)
signed and dated in the lower right:
•H•F• FARNY• / ⊙ / 99
Gift of The Procter & Gamble Company
2003.64

This Northern Plains man, wearing a typical bone hairpipe breastplate and red trade-cloth-wrapped braids, sits alert astride his horse, waiting for some person, animal, or event outside the painted scene. A woman watches from a distance. The buttes and outcrops in the background of Farny's barren landscape strongly resemble the Badlands. The line of trees in the middle distance is a sure indicator of a small creek in this arid land.

The scout's guns are impressive, and are painted by Farny with care and in sufficient detail as to be readily identifiable. The Colt single action cartridge revolver was manufactured after 1872; it was so superbly designed for its tasks that it was made until 1940. Across the saddle, the scout holds a second model Henry repeating rifle, which holds twenty-two .44-caliber rimfire cartridges. This gun was so prized that, though not officially issued during the Civil War, Union soldiers purchased it out of their own pockets; its admirers said of the Henry that "you could load the gun on Sunday and shoot it all week."[1]

In 1899, the date of this painting, Indians were destitute and living under the strict surveillance of an Indian agent, hence they would be unlikely to openly possess firearms unless they were members of the Indian Police, a group supposedly loyal to the Indian agent, and thus permitted to carry guns.

1. Personal communication, Jack Lewis, July 17, 2007.

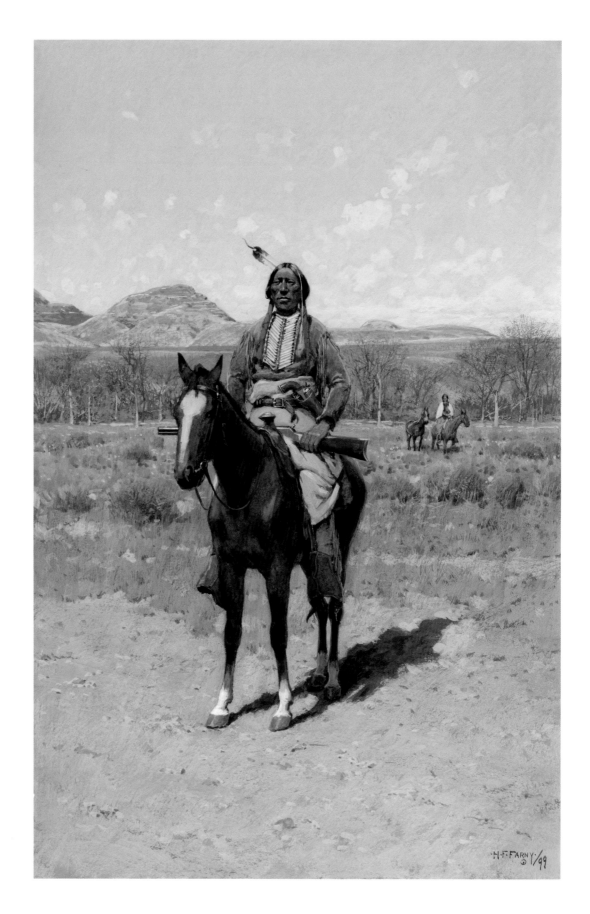

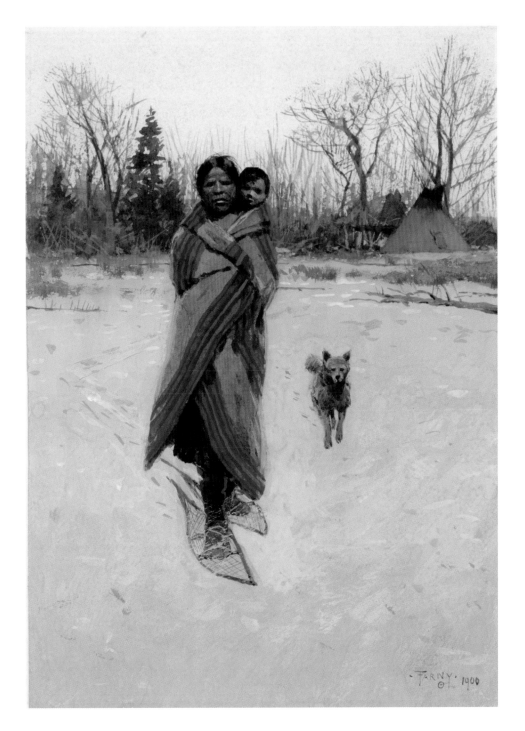

23
Winter Squaw

1900
gouache over graphite pencil
7 3/16 x 5 in. (18.2 x 12.7 cm) on sheet
10 3/16 x 7 13/16 in. (27.4 x 19.8 cm)
signed and dated in the lower right:
• FARNY • / ⊙ / 1900
Gift of the estate of Elizabeth Woods Osborne
1945.9

This mother trudging over the snow appears to be a Plains woman, based on the red-painted part in her hair and the tipis in the background. Her snowshoes with their pointed tips are not typically Great Plains style. Plains snowshoes are generally squared, whereas pointed tips are a design more likely to be found among woodland people. Perhaps she lives in a border area where Plains and woodland cultures have the opportunity to see or use different styles of material goods.

She carries her infant in a traditional manner in her blanket, which may or may not be of Navajo or Pueblo origin. Plains people, who traditionally were nomads, did not weave, but traded with outsiders. The vague stripe pattern of her blanket is culturally non-specific, which makes it difficult to determine whether it is native-made or a manufactured textile. During the summer of 1896, when Lakota Sioux camped at the Cincinnati zoo, the visiting women brought their finest garments with them, including prestigious Navajo blankets. Two women were photographed wearing these beautiful Navajo textiles. Newspaper articles and a surviving letter indicate that Farny visited the zoo many times. He probably saw the women wearing their blankets, which may have inspired the blanket in this painting.

As was the practice of his day, and surely without realizing it, Farny used a degrading term to describe this woman. Today we know the word "squaw" is a particularly vulgar word connoting prostitution or purchase.

24
Evening Campfire

1900
gouache
12 15/16 x 9 1/8 in. (31.2 x 23.1 cm)
on mount 12 3/8 x 9 3/16 in. (31.4 x 23.4 cm)
signed and dated in the lower right:
FARNY / ⊙ / •1900•
Promised bequest of Suzanne B. Loeffler
2005.688

This tranquil scene illustrates what Farny aficionados liked most about his art—a beautiful western landscape inhabited by Indians at one with their environment. In truth, by 1900, Plains Indians were confined to some of the harshest and most barren regions of the Great Plains. Farny understood this, but also knew that whites longed to see representations of Indian life set in breathtaking frontier landscapes.

Although there is not enough detail in this painting to determine which group of Plains people is camping here, tipi design is specific to each people, and a knowledgeable person could often discern at a glance who was at home by the number and length of the poles, the designs on the covering, and subtler details such as the shape of the smoke hole flaps.

Tipis are a triumph of design, adapted to an extreme climate and a nomadic lifestyle. Contrary to general understanding, tipis are not a cone with a circular footprint, but a tilted cone with an egg-shaped base, usually situated so the steeper, broader side of the cone faces the relentless prevailing westerly wind. The doorway generally faces the rising sun. Tipi liners control air flow in winter, keeping drafts off the family inside, and channeling the bitter winds up along the tipi wall and out the smoke hole.

Traditionally, tipis are owned by women, and thus it is women who are responsible for putting them up and breaking them down. All but the largest tipis can be erected by one person if necessary. After horses were introduced to Plains culture tipis did become larger, in part because it was then easier to hunt buffalo and obtain more hides, and also because the larger, heavier covers and poles could be transported by horse travois, or skids, rather than by dog. With the near extinction of the buffalo, the Indians turned to awning canvas to make tipi covers.

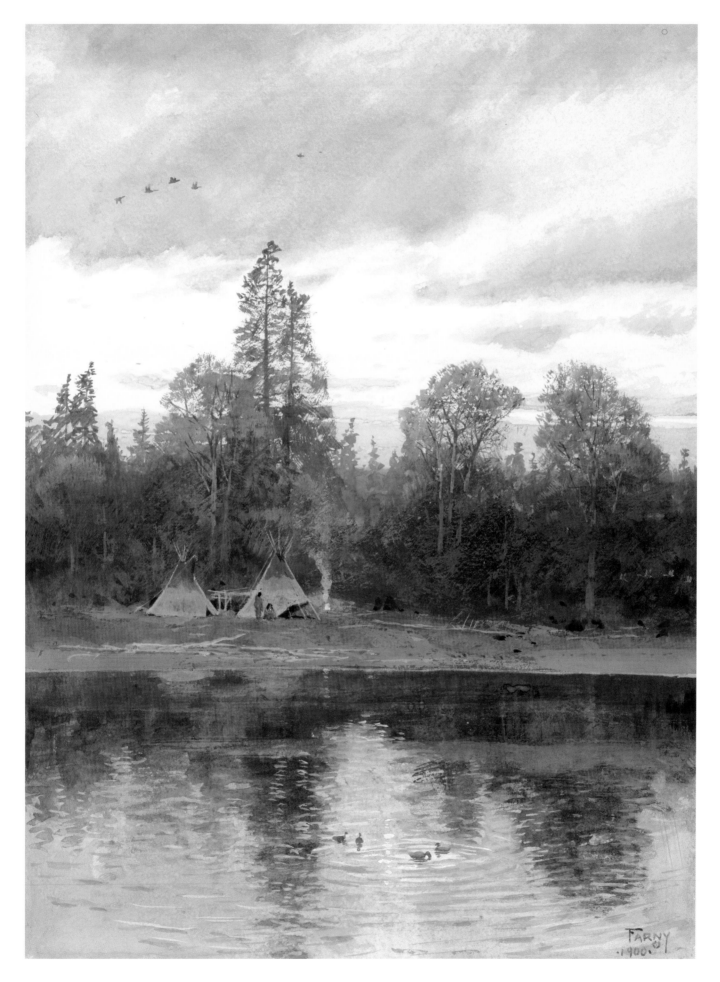

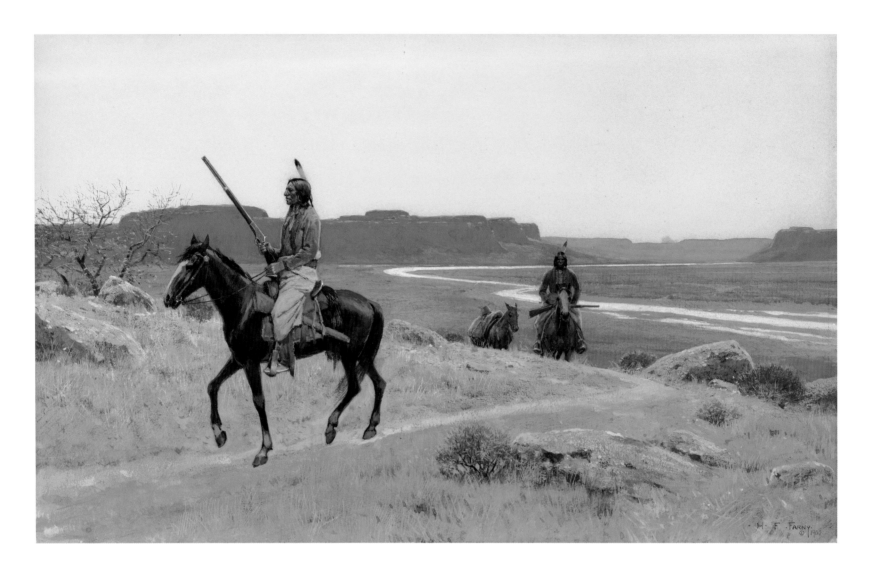

25

In Enemy's Country

1900
gouache
10 5/8 x 16 1/2 in. (27 x 42.6 cm)
signed and dated in the lower right:
•H•F• FARNY• / ⊙ / 1900
Lent by the Williams Family Collection

Plains Indian men aspired to be brave warriors. Traditionally, through daring deeds they earned honor and status in the constant struggle with other Indian nations for horses and hunting grounds—for, like any other group of diverse peoples, Indians competed, quarreled, and warred against each other. The Crow and the Sioux, for example, were bitter enemies.

Recognition as a warrior was gained by being singularly valiant or skillful in battle, or by capturing or stealing horses from enemies. Horse-stealing allowed warriors to exercise skills of stealth, strategy, and horsemanship, and to acquire wealth and status at the enemy's expense. A man kept track of his war exploits by illustrating them on a buffalo hide. When a man excelled as a warrior his tribespeople recognized him as a leader who embodied honorable character traits, such as generosity, respectfulness, truthfulness, and courage.

By the time Plains warriors confronted white settlers and the U.S. military, they were fighting literally for survival. This warrior moves through enemy territory with his finger on the trigger, ready for instant action; Farny has painted enough detail to identify the firearm, with its brass frame and brass nose cap, as an 1866 Winchester rifle.[1]

Once the herds of buffalo had disappeared, and the Indians had been confined to reservations, their world changed, almost overnight. Indians were now fighting for cultural as well as physical survival, but they had been deprived of their traditional methods and means of existence.

1. Personal communication, Jack Lewis, July 17, 2007.

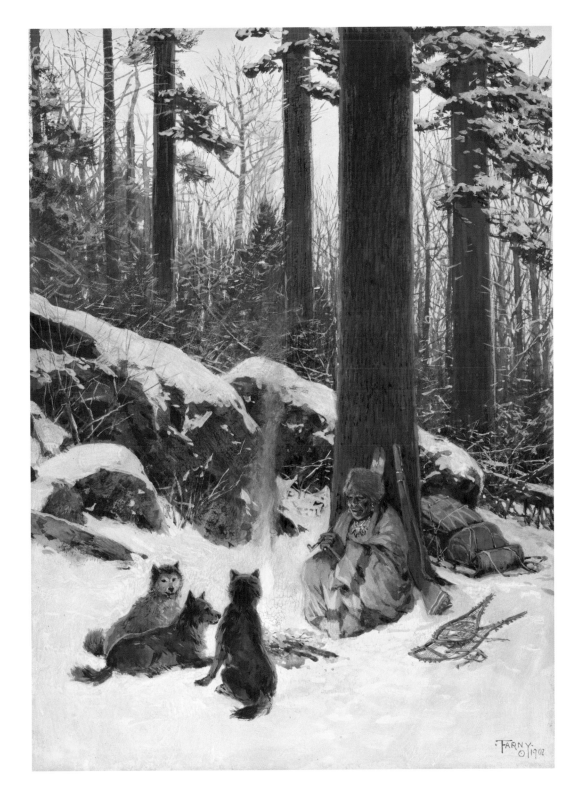

26
After the Evening Meal

1902
gouache
11 3/16 x 8 1/8 in. (28.4 x 20.7 cm)
signed and dated in the lower right:
• FARNY • / ⊙ / 1902
Private Collection

This man, most likely a Northern Plains Cree Indian, relaxes with his dogs at the end of a winter day. Here Farny once again takes artistic license and mixes material culture from different regions. The Great Plains parfleche with its painted geometric motifs is shown with a Cree beaded hide gun case. The toboggan, and the Eastern Woodland-style snowshoes with their pointed tips, show that either the ideas have been imported, or the goods themselves have been traded from another people, a common practice, especially among neighboring groups.

An outdoorsman, though, might wonder about this hunter's expertise. The fire appears to be built directly on the snow and the dogs, rather than sitting so close to the flames, would more likely have dug themselves into the snow for warmth. The snowshoes should be standing up, so that the rawhide webbing can dry. Toboggans were usually pulled by a person, not by dogs; in any case there is no evidence of a dog harness, leading one to wonder why the dogs are with the hunter.[1]

1. Personal communication, Dr. Ted J. Brasser, April 30, 2007.

27
Ute Scout

1902
gouache with touches of gum
10 3/16 x 7 1/4 in. (25.8 x 18.4 cm)
signed and dated in the lower right:
• FARNY • / ⊙ / • 1902 •
Lent by Mr. and Mrs. Lawrence H. Kyte, Jr.

The Ute are not a Plains people; they are
classified today as a Great Basin people.
Around 1880 the Ute were assigned to three
reservations in Utah and Colorado, making it
difficult to determine if Farny ever really saw
any Ute or if he painted from a photograph. In
this gouache the man holds a brightly colored
trade blanket, possibly made by Pendleton
Woolen Mills, a textile highly prized by Indians.
Anglo hats were another manufactured item
popular with Indians, who transformed the
original object by embellishing it with feathers,
medals, beads, ribbons, and found objects that
held personal appeal. Many whites thought
these hats ridiculous, when in fact they were
objects of status that expressed individuality
and a certain worldliness—not like the
collections of Victorian souvenir spoons,
cabinet cards, or postcards sought by whites
at that time.

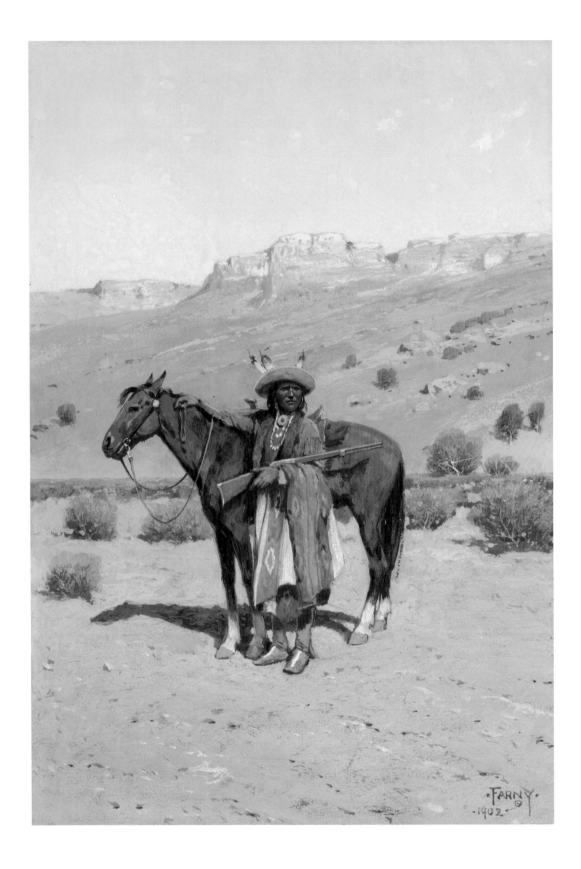

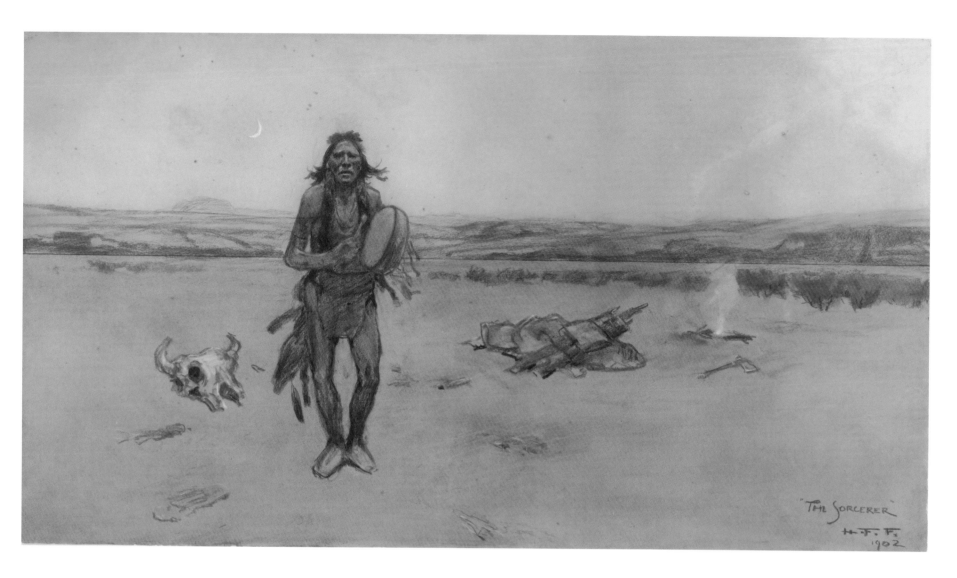

28

The Sorcerer

1902
black and white chalk
21 5/8 x 40 1/2 in. (55.0 x 100.4 cm)
inscribed in the lower right:
"THE SORCERER" / H. F. F. / 1902
Private Collection

The Sorcerer embodies all the energy and tragedy of Plains lives in transition. Ritual activity is combined with singing, drumming, and dancing in an effort to ensure the return of the buffalo and the removal of whites from Indian land and lives.

A close look at the drawing reveals what appear to be traditional Indian objects, such as a buffalo skull, an eagle feather, and pouches that may contain personal medicine, placed in a circle around the sorcerer. By the time Farny drew this scene, the federal government had decided that the best way to "civilize" Indians was to Christianize them. This may be why Farny set the scene at dusk, indicating and perhaps lamenting the futility of the sorcerer's ritual against overwhelming odds.

In this drawing, Farny is blocking out the dimensions and placement of the ritual items for a more finished work, and indeed, the Gilcrease Museum in Tulsa, Oklahoma, owns an oil after this sketch, dated 1903.[1] In the oil, more of the ritual objects can be clearly identified: in addition to the buffalo skull and feathers we see the feet and talons of a large raptor, very likely an eagle, and a small parfleche container that may contain personal medicine. The pile of objects to the left of the fire can also be seen to contain a tomahawk pipe, a quiver of arrows, and a woolen British trade blanket with its white selvage edge exposed.

1. Illustrated in Denny Carter, *Henry Farny* (New York: Watson-Guptill Publications), 184.

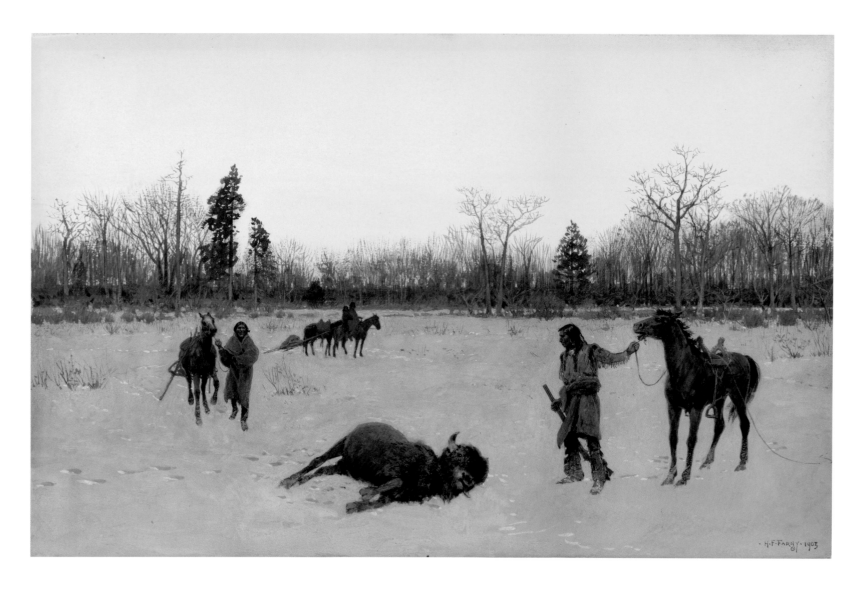

29

A Lucky Shot

1903
gouache and watercolor with touches of gum
11 1/8 x 17 1/2 in. (28.2 x 44.4 cm)
signed and dated in the lower right:
•H• F• FARNY• / ⊙ / 1903
Lent by the Williams Family Collection

Farny captures this scene at the prime moment, just after the kill has taken place but before the animal is butchered—a laborious and less than picturesque process well outside Farny's usual romantic realism. Hunting was a serious business that necessitated a keen understanding of animals and required prayer and ritual. Offering thanks to the kill was an essential component of a successful hunt. Every scrap of the animal was used, and had a particular function.

By the time Farny painted this scene, both buffalo and travois had long been anachronisms— the travois because Indians were confined to reservations and no longer needed to move camp, and the buffalo because whites had slaughtered the animals by the thousands, bringing the vast herds to the brink of extinction. The tongue protruding in death from the buffalo's mouth may be an allusion to the practice of the professional hunters who, using either a .50–.70-caliber military rifle or later, a big-bore Sharps buffalo rifle, mowed down as many buffalo as they could. They took the hides and the tongues, widely considered a delicacy, and thought by some to be an aphrodisiac, and left the rest to rot. This flagrant waste particularly horrified Indians, especially because most were starving.

Farny had seen firsthand in 1884 on his trip for *Century Magazine* how rare buffalo had become in the West. In 1887, the Cincinnati Zoological Gardens constructed an outdoor exhibit for America's endangered buffalo and was successful in breeding them.[1] The zoo is most likely where Farny saw buffalo at close range.

1. David Ehrlinger, *The Cincinnati Zoo and Botanical Garden, From Past to Present* (Cincinnati: Cincinnati Zoo and Botanical Garden, 1993), 32.

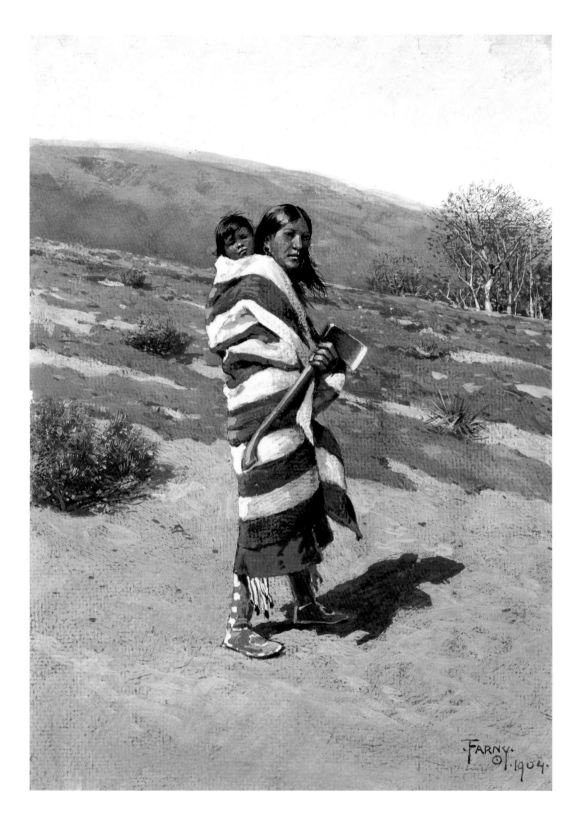

30

Indian and Child

1904
gouache with touches of gum over
graphite pencil on blue-gray paper
10 3/4 x 7 3/4 in. (27.3 x 19.7 cm)
signed and dated in the lower right:
FARNY / ☉ / •1904•
Bequest of Farny R. Wurlitzer
1972.362

The young woman carries her infant on her back by snuggling the baby in a beautiful Navajo blanket, a highly prized possession among Plains Indian women. Early traditional Navajo blankets such as this are very soft, warm, waterproof, and long-wearing, owing to the superior quality of the weaving and the special wool of the Navajo *churro* sheep.

Like horses, domestic sheep are not native to North America but were introduced into Mexico by Spanish colonists, and later were obtained by the Navajo. *Churro* wool is long-fibered and low in lanolin, so it accepts dye without having to be washed in large quantities of water, a quality well-suited to a desert climate.

Even though this lovely young mother is carrying an axe and is presumably on her way to perform some chore, she is dressed to the nines. Her blanket is impressive, but her leggings, generously tasseled with white ermine tails, are just as spectacular.

Many Farny paintings depict Plains Indian women wrapped in a similar Navajo blankets. He may have seen women wearing these blankets on his trips west, and almost certainly saw Lakota Sioux women wearing fine Navajo blankets at the Cincinnati Zoo in 1896.

31
In the Heart of the Rockies

1904
gouache with touches of gum
28 15/16 x 20 7/8 in. (73.5 x 53 cm)
signed and dated in the lower right:
•H•F• FARNY• / ⊙ / •1904•
Bequest of Farny R. Wurlitzer
1972.359

Quintessentially Farny, this painting demonstrates his mastery of northern Plains scenery. Contemporary art historians have engaged in a lively debate about whether Farny painted actual landscapes that he had visited, or simply "compiled" landscapes from a variety of visual resources. Farny did see powerful vistas like this when, in 1884, he traveled to Montana as an artist for *Century Magazine*, for which he illustrated a similar mountain scene of a "little stretch of grassy bottom" with "sunlight on the pea-green river below."[1]

Here, the Indian subjects nonchalantly carry on their everyday activities amid the spectacular mountain landscape. A careful look at the faces of the people in the foreground shows that they look relaxed, indicating that the group is going about its daily pursuits without fear of attack. Traditionally, Indians enjoyed coming together to spend time with their friends and relations after a long winter. Once confined to reservations, Plains Indians were not permitted to leave, even to visit relatives on a nearby reservation, without securing a pass from the Indian agent.

Farny witnessed Indians enjoying themselves with one another when he visited various reservations, and commented upon their sociability. He used artistic license, however, when he painted the woman wearing her valuable Navajo blanket for daily activities. He must have liked painting women in these boldly striped textiles, for several female figures wrapped in these distinctive garments appear in his paintings.

1. Eugene V. Smalley, "The Upper Missouri and the Great Falls," *Century Magazine* 35, no. 3 (January 1888): 409, 410.

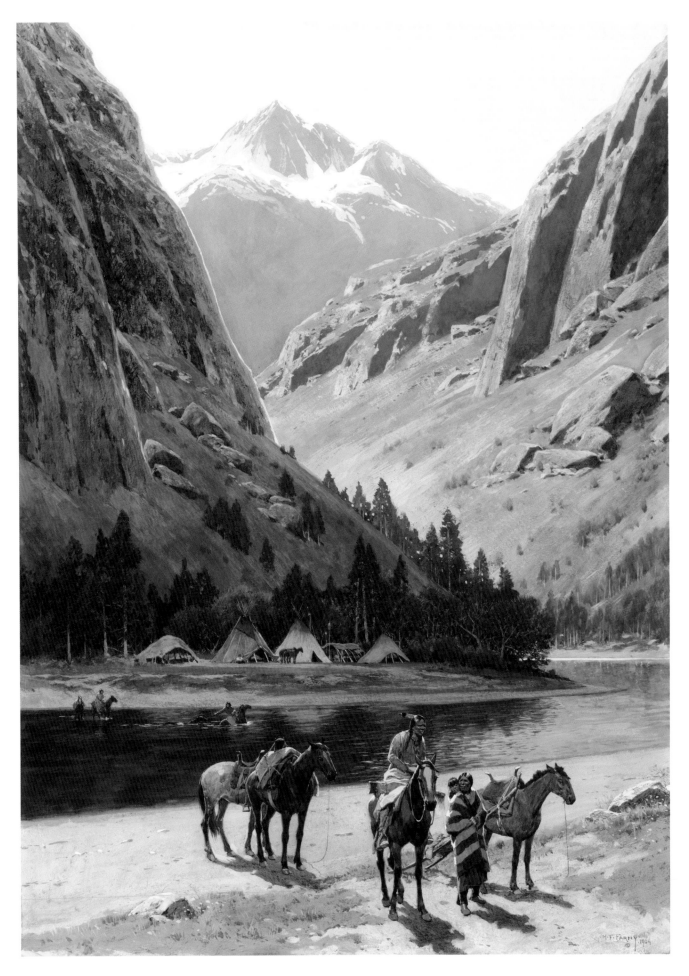

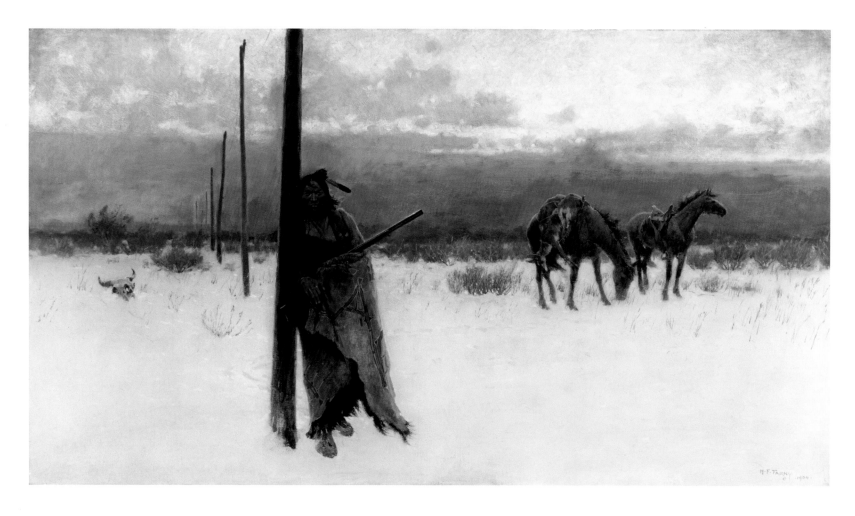

32

The Song of the Talking Wire

1904
oil on canvas
20 1/8 x 40 in. (51.1 x 106.6 cm)
Signed and dated in the lower right:
H. F. FARNY / ⊙ • 1904•
Bequest of Charles Phelps and
Anna Sinton Taft, Taft Museum of Art,
Cincinnati, Ohio

This iconic painting expresses a view held at the time by many whites, who wrongly assumed that Indians were incapable of adjusting to the technological changes thrust into their lives, and believed that telegraph poles and iron horses would eventually doom the country's indigenous people to extinction.

In this painting, as well as in a few others such as *Morning of a New Day*, Farny opted not to paint proud warriors, instead depicting the radical intrusion of hitherto unknown machines into Indian lives.[1] Farny himself, in a fictional sketch, "Sorrel Horse's Medicine," that he published in the *Cincinnati Commercial Gazette*, noted that Indians made their own observations about white technology, calling the train a "firey horse" that "dragged whole tepees full of people."[2] "Sorrel Horse" is a tale of how a Sioux Indian medicine man appropriates the symbolic power of the telegraph pole, "that awful and mysterious contrivance of the wicked palefaces," to his own advantage. Sorrel Horse "used to dance, howl and beat his drum for hours around a telegraph pole, and, applying his ear to it, deliver oracular commands and prophecies, which created consternation amongst his painted tribesmen." Farny's humor expresses another aspect of Indians' relationship to unknown mechanical devices.

Certainly the scene here can be interpreted in no other way than that the doomed Indian is destined to follow the path of the buffalo. A jarring note for an ethnologist is that the Indian is wearing an Arapaho robe with a painted border representing a buffalo. This artistic style was most frequently worn by and identified with women, though on occasion, as here, it was worn by men. Usually, a man's robe would have depicted his brave warrior exploits.

1. William H. Truettner, "For Museum Audiences: The Morning of a New Day?" in Amy Henderson and Adrienne L. Kaeppler, eds., *Exhibiting Dilemmas: Issues of Representation at the Smithsonian* (Washington, D.C.: Smithsonian Institution Press, 1997), 40–43.

2. Henry Farny, "Sorrel Horse's Medicine," *Cincinnati Commercial Gazette*, March 12, 1893, 19.

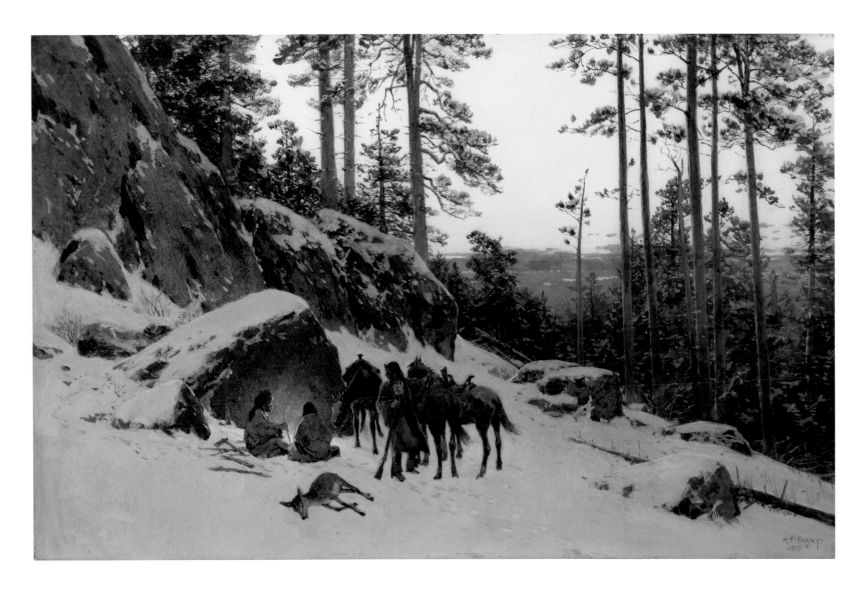

33

The Campfire

1907
gouache and watercolor with traces of gum
11 1/8 x 17 1/2 in. (28.2 x 44.4 cm)
signed and dated in the lower right:
H•F• FARNY• / •1907• ⊙
Lent by the Williams Family Collection

Scenes such as this probably did occur when Indian hunting parties found a sheltered place to rest. The Indian on the left seems to be slowly building the evening fire, one that he most likely started using a piece of flint to strike sparks off a fire steel, a useful item that Indians acquired through trade. Traditionally, these important objects were stored in a beautifully decorated leather strike-a-lite pouch. Later, Indians stored their reservation ration cards in these pouches.

Before the introduction of fire steels, a European technology, Plains Indians made fire by rapidly hand-twirling a hard wooden drill to create heat through friction. The drill was set in a small "hearth," or hole, in a soft wood such as cottonwood, spread with a tinder such as pulverized dried buffalo dung or rotten bark. Fires were carefully tended so as to avoid continually having to re-make them, and sometimes were carried to a new village or campsite by igniting a substance, such as buffalo dung, that would smolder a long time.

Even though this party has killed a young deer, and may eat part of it, unless they intend to carry it to their home camp, they are certainly carrying a supply of pemmican—a ubiquitous Plains Indian food made from jerked meat, dried chokecherries or berries, and fat. Frontier whites and Indians alike relied on pemmican, because it was easy to carry, calorie-dense, and resistant to spoilage.

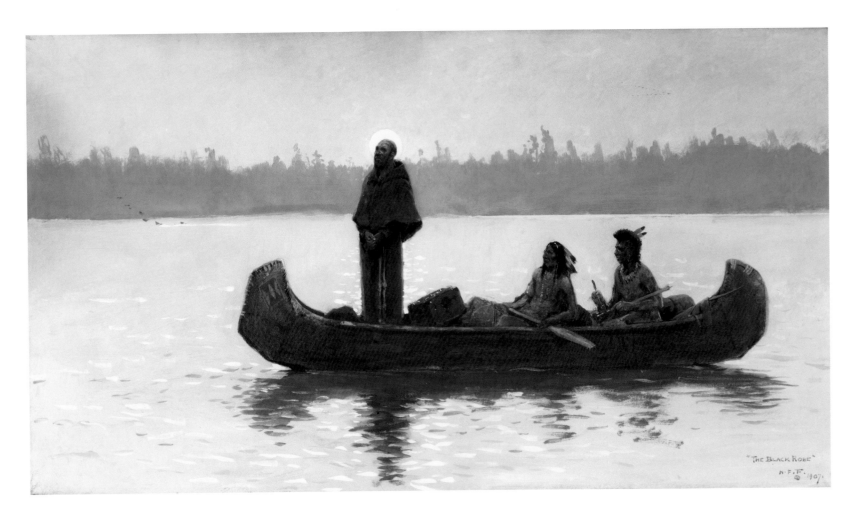

34

The Black Robe

1907
gouache
22 x 40 in. (55.9 x 101.6 cm)
inscribed in the lower right:
"THE BLACK ROBE" / H. F. F. / ☉ 1907
Gift of Mr. and Mrs. Charles M. Williams
1978.431

In 1907, toward the end of his career, Farny began a series of historical paintings. *The Black Robe* is one of four that he is known to have completed. It depicts Father Joseph Le Caron, a Roman Catholic missionary and member of the Recollect order. In 1615, Le Caron journeyed into New France, as the Canadian wilderness was then called, into what is now the province of Ontario. He was the first European to visit the Huron Indians' remote agricultural settlements.

Farny committed several historical and ethnological faux pas in this gouache, mixing Plains elements with Eastern Woodland in a highly unlikely way. The drab brown birch or elm bark canoe is acceptable, but the idea for painting a colorful Plains Indian parfleche design on the bow would not have diffused so great a distance. In 1615 the Great Plains were still unknown, not only to whites, but very likely to eastern Indian peoples.

The position of the men in the canoe is also an issue Farny did not choose to portray realistically. He must have known enough about canoemanship to realize that one of the two paddlers should sit in the front; that Le Caron, as passenger, should sit in the middle, not stand, so as not to upset the watercraft; and that the man in the rear should control the steering paddle. Thus the steerer would have neither time nor hands available to prepare his pipe for smoking—especially not a long Plains-style pipe rather than a Huron pipe. The man's Mohawk hairstyle, though, is correct.[1]

Farny's clever artistic device of placing Le Caron's head directly in front of the moon, which looms behind him like a halo, symbolizes his religious status and suggests he is worthy of sainthood. Le Caron's devotion to the well-being of the Huron remains legendary even today.

1. Personal communication, Dr. Ted J. Brasser, April 30, 2007.

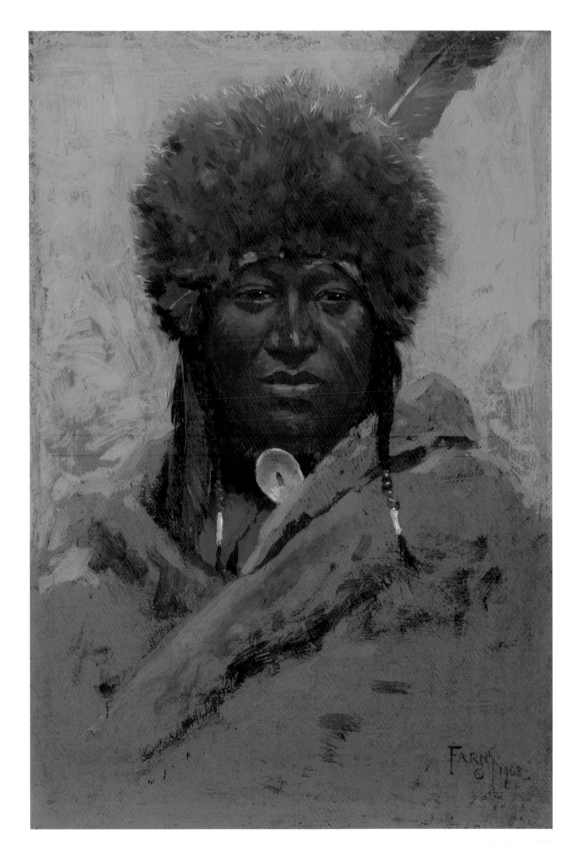

35

Indian Head

1908
oil on academy board
9 1/2 x 6 7/16 in. (24.1 x 16.4 cm)
signed and dated in the lower right:
FARNY / ☉ / 1908
Lent by Mr. and Mrs. Stephen G. Vollmer

The sitter for this portrait closely resembles the man in Farny's 1892 *Sioux Brave* (cat. 11). The two images—clothing, colors, ornaments, and composition—are nearly identical, despite the sixteen-year interval between the two. Both studies may be of the same individual, who is almost certainly one of Farny's "secretaries," or models.

This subject's face paint, because it is non-specific to a people, probably has no particular meaning. Farny's frequent addition of face paint to his images is not merely decorative, however. It is a means of adding drama to his portraits by playing on the popular stereotype of Indians, just as he paints eagle feather warbonnets on Indians in unlikely contexts.

In this portrait Farny has painted ornaments that Indians enjoyed wearing—objects that were foreign to the Great Plains region. Indians conducted a lively exchange with distant groups, as well as their neighbors, for raw materials, traditional products, and food. When Lewis and Clark crossed the Great Plains, they discovered that an extensive trade network had long been in existence. Sometimes the Indians already had goods similar to those the expedition had brought, not only for purposes of trade, but with the intention of fostering friendly relations.

The shell disc at the subject's throat is probably marine in origin, and thus would have arrived on the Plains from one of the two ocean coasts via trade. These discs, which are sometimes quite large, were frequently worn at a man's throat in this way. Similar ornaments can be seen in many of Farny's paintings and illustrations.

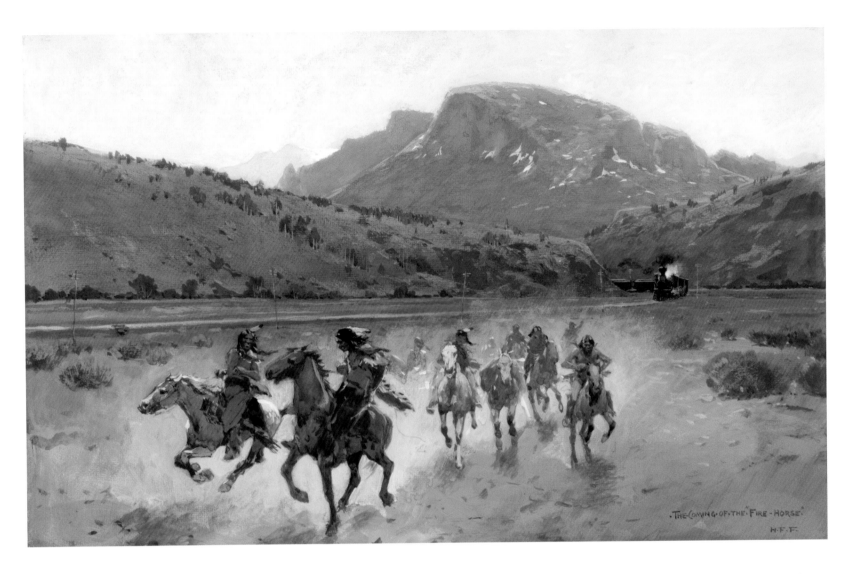

36

The Coming of the "Fire Horse"

ca. 1910
gouache over graphite pencil on blue-gray paper
13 9/16 x 21 9/16 in. (34.5 x 54.7 cm)
inscribed in the lower right:
•THE•COMING•OF•THE•"FIRE-HORSE•" /
H. F. F.
Gift of Farny R. and Grace K. Wurlitzer
1968.316

Here Farny chooses to juxtapose white technology—an approaching train proceeding down a track lined with telegraph poles—and Plains Indian men, a subject he repeatedly revisited. Modern viewers understand the symbolism, but most do not understand how massive an effort was required to construct railroads across the roadless West, and how Indians must have felt when first confronted not only with the "fire horse," but by construction crews numbering in the thousands, in whose wake frontier towns sprang up, followed by steady waves of emigrants.

While Indians initially may have been afraid of the railroad, they soon realized that their land was being taken away to make way for whites. Treaties establishing tribal lands were frequently rewritten by the federal government to permit right-of-way to railroads, to commercial interests who discovered profitable resources on Indian lands, and to settlers who wanted the land itself. The railroads sliced reservations into fragments, and then the fragments shrank under white encroachment until federal legislation in 1934 stopped the process.

The painting's narrative is ambiguous; it has often been interpreted as representing terrified Indians fleeing the roaring monster. Another viewer, however, might think the Indians are simply racing the train. Regardless of the interpretation, Farny has created an ambitious composition with many running horses; he uses the dust they kick up to capture their speed and charge the landscape with energy.

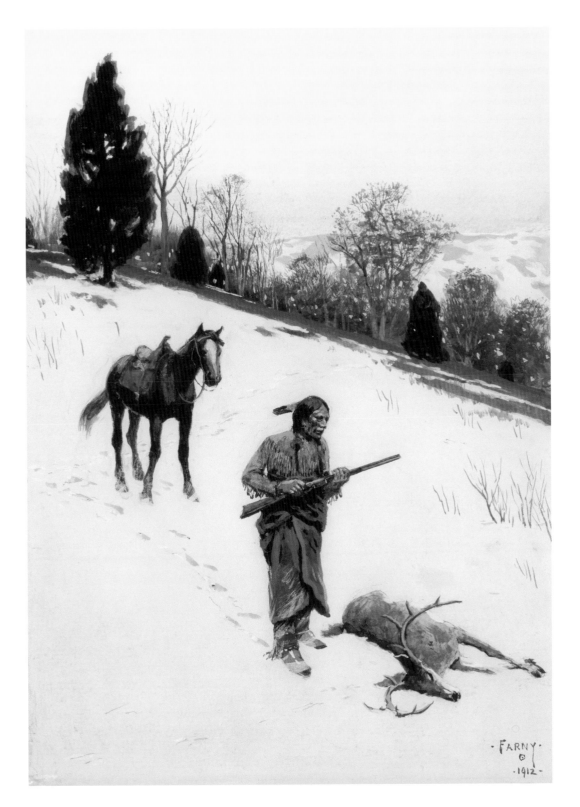

37

Indian Hunting Scene

1912
gouache and watercolor with touches
of gum over graphite pencil
28 11/16 x 6 1/4 in. (22.1 x 15.9 cm)
signed and dated in the lower right:
•FARNY• / ⊙ / •1912•
Bequest of Farny R. Wurlitzer
1972.361

By the time Farny painted this gouache, early filmmakers were producing "flickers"—a series of static shots projected rapidly one after another to tell a simple story. The first Western hit, in 1908, was *Bronco Billy and the Baby*, whose crude plot was packed full of action and sentiment. *Bronco Billy* was quickly followed by other flickers, some produced by William F. "Buffalo Bill" Cody.[1] Like these early filmmakers, Farny understood that western themes were highly marketable. In many ways this hunting scene possesses all the storytelling power of a frontier flicker.

Early in his career, Farny noted that he had been criticized as "hatching out pictures as a hen does chickens." Yet, even though he continually recycled and even reused images and themes, Farny contended that "When I have something to say, I put it on canvas, and you can't run me by machinery."[2]

1. L. G. Moses, *Wild West Shows and the Images of American Indians, 1883–1933* (Albuquerque: University of New Mexico Press, 1996), 223–27.

2. "Some Notable Pictures by Cincinnati Artists," *Cincinnati Commercial Gazette*, June 19, 1892, 17.

38

Sketch for "The Return of the Raiders"

n.d.
gouache with touches of gum over graphite pencil
20 7/16 x 29 5/8 in. (51.9 x 75.3 cm)
inscribed in the lower right:
Sketch for "The Return of the Raiders" / • FARNY • / ☉
Gift of Fanny Bryce Lehmer
1936.853

This sensational sketch depicts the return to camp of Plains Indian raiders who have taken a white baby captive. In the right foreground, a warrior gently hands the infant, swaddled in voluminous baby dress to emphasize its innocence and whiteness, to an Indian woman poised tenderly to mother the tiny creature. In chilling counterpoint, several warriors at the center of the scene brandish lances or poles hung with scalp locks. Viewers at that time might have inferred that the scalps could be those of the child's parents.

The stereotype of cruel or ignoble savages seizing white children to raise as Indians became fashionable in white imagination and resulted in a genre of books known as captive narratives, the first published in New England in 1682.[1] The commercial success of captive narratives may have inspired Farny to explore the theme. The sketch makes visual the worst fears of white frontierspeople: beyond the risk of their own violent death lurks the possibility that their children might be taken and made into Indians.

The Indian counterpart of these captive narratives are the stories Indian children told of their experiences at government boarding schools, such as the infamous Carlisle Indian Industrial School in Pennsylvania, where Indian children were taught to mirror white behavior and punished harshly when they practiced any of their native ways or spoke their Indian language. More insulting yet, Carlisle stressed vocational rather than academic training, so that the sons and daughters of chiefs were trained as tradespeople and domestic servants.

There is no evidence that Farny actually executed the painting for which this sketch was intended.

1. Robert F. Berkhofer, Jr., "White Conceptions of Indians," in William C. Sturtevant, ed., *Handbook of North American Indians*, vol. 4 (Washington, D.C.: Smithsonian Institution, 1988), 535.

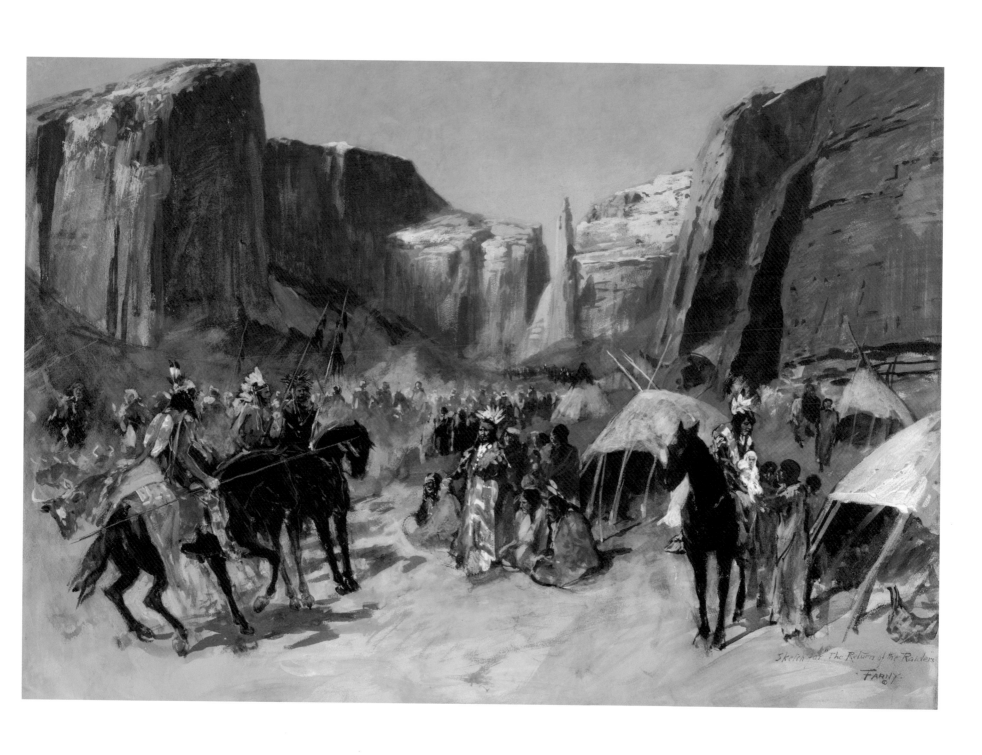

39

Indians Fishing–Northwest Coast

n.d.
gouache and watercolor
9 5/8 x 17 1/4 in. (24.5 x 43.8 cm)
signed in the lower right: •FARNY• / ☉
Gift of C. R. Smith
1965.9

This distinctive style of watercraft, called a "Chinook" canoe, was made, with slight variations, by both the Nootkan people of Vancouver Island and the Makah people of Puget Sound. No doubt Farny was taken with the canoe's artistic projecting prow, which gives the appearance of an animal's head. The Indian term for this type of prow translates as "tongue sticking out," but in fact the people say that the ornamentation does not "mean anything." The carving of the body of the canoe however is dictated by tribal custom.[1]

Denny Carter, in her book *Henry Farny*, notes that this superb gouache was based on a photograph accompanied by an undated newspaper clipping headlined "Moving Day for Siwash Family-Siwash Dugout Canoe on Puget Sound."[2] During the nineteenth century whites used the term "Siwash" to mean "Indian" and its use, which Indians found offensive, continued into the twentieth century. The term originated with "Chinook Jargon," a language used by missionaries, fur traders, and early white settlers in the northwest coast region.[3]

Perhaps it is significant that Farny did not use the term "Siwash" in titling the painting; somehow, he knew that "Siwash" was derogatory. Ever interested in the lifeways of America's numerous indigenous peoples, Farny learned that these particular basketry hats were worn by the Nootkan people and paid tribute to them with this painting. Perhaps he learned about the Nootkan by visiting the Northwest Coast exhibit in the Anthropology Building when he attended the World's Columbian Exposition in Chicago.

1. T. T. Waterman, "The Whaling Equipment of the Makah Indians," in *University of Washington Publications in Anthropology*, vol. 1 (Seattle: University of Washington Press, 1920–1927), 18, 22.

2. Denny Carter, *Henry Farny* (New York: Watson-Guptill Publications, 1978), 32–33.

3. Laurence C. Thompson and M. Dale Kinkade, "Languages," in William C. Sturtevant, ed., *Handbook of North American Indians*, vol. 7 (Washington, D.C.: Smithsonian Institution, 1990), 50–51.

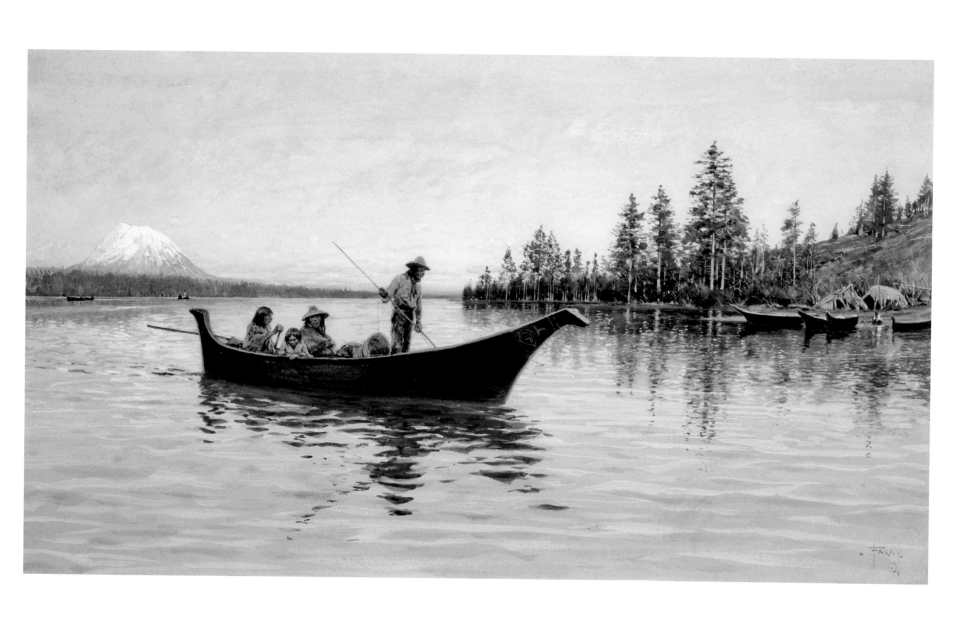

CHRONOLOGY

1830
Indian Removal Act forces most eastern Indian tribes to relocate west of the Mississippi, opening fertile Indian lands for white occupation and causing further breakdown of traditional cultures.

1847
François Henri Farny born July 15, Ribeauvillé, Alsace

1853
Farny family enters U.S., October 19

1854
Farny family settles in Warren, Pennsylvania

1859
Farny family moves to Cincinnati

1861
Farny makes his first known drawing of an Indian, in his school songbook

1862
Homestead Act entitles any citizen or would-be citizen to claim 160 acres of public land—often Indian land—and purchase it after living on it for five years.

1863
Death of Farny's father

1865
Farny draws a scene of old Fort Washington, peopled with frontiersmen and Indians

Harper's Weekly publishes its first Farny illustration, *The Turner Festival at Cincinnati, Ohio*, September 30

1866
Farny moves to New York to work for publishers of *Harper's Weekly*

1867
Travels to Europe; studies with Thomas Read Buchanan in Rome

1870
Exhibits artwork in first Cincinnati Industrial Exposition

1872
Elected member of The Literary Club

1873
Travels in Europe and studies art

Begins teaching at Ohio Mechanics Institute

1874
Publishes *Ye Giglampz* with Lafcadio Hearn

1875
Collaborates with Frank Duveneck on heroic oil painting for Cincinnati ladies' "Centennial Fair"

Travels in Europe and studies art

1876
Battle of Little Bighorn; Lt. Col. George Armstrong Custer and entire unit of the Seventh Cavalry killed

1879
Smithsonian's Bureau of (American) Ethnology established

Farny is primary illustrator for a major revised edition of McGuffey's Readers, providing 76 of the 300 illustrations

1881
Sitting Bull, Lakota war chief and spiritual leader, surrenders July 20 at Fort Buford, Dakota Territory

A Century of Dishonor, Helen Hunt Jackson's indictment of U.S. government mistreatment of Indians, published

Farny illustrates Cincinnati Industrial Exposition catalogue by Clara De Vere

Farny Indian illustrations published in *The Eclectic History of the United States*

Farny makes his first trip west, departing sometime after August 1 for Fort Yates, Standing Rock Agency, Dakota Territory; returns November 5

Makes his first fine art paintings featuring Indians as subjects

Hired by Maria Longworth Storer to decorate Rookwood pottery with Indian images

1882
Meets Zuñi Indians in Washington, D.C. July 29; illustrates three articles for *Century Magazine*

Signature circle and dot motif first appears on Zuñi illustrations

Completes *Toilers of the Plains* and *Sioux Women of the Burnt Plains*

Exhibits *Blackfoot Indian*, inscribed "Fort Yates, Dakota" in Cincinnati Industrial Exposition

Buffalo Bill produces his first outdoor Wild West show

1883
Ration Day at Standing Rock Agency published in *Harper's Weekly*, July 28

Farny joins Villard excursion on the Northern Pacific Railroad: meets Sitting Bull; illustrates driving of last spike for *Leslie's Illustrated Weekly*, September 22

A Dance of Crow Indians published in *Harper's Weekly*, December 15

1884
Toilers of the Plains published in *Harper's Weekly*, June 21

Farny travels down Missouri River with Eugene Smalley for *Century Magazine*; visits Fort Benton and Piegan Indian lodges

1885
The Prisoner wins cash award at American Art Association exhibit, New York

1886
The Prisoner published in *Harper's Weekly*, February 13

A Cheyenne Courtship published in *Harper's Weekly*, July 24

The Killing of Abraham Lincoln, the Pioneer, 1786, published in *Century Magazine* serialized biography of Lincoln, November

1887
General Allotment Act (Dawes Act) breaks up communal tribal holdings on some reservations by allotting reservation land in severalty to individual Indians.

Suspicious Guests published in *Harper's Weekly*, February 5

1888
Century Magazine publishes Smalley article and Farny illustrations of trip down Missouri River

Farny helps organize Cincinnati Art Club

1889
Farny moves his studio to Covington

The Great Salt Lake of Dakota, illustrating article by friend D. W. Huntington, published in *Harper's Weekly*, March 9

A Snake Dance of the Moqui Indians published in *Harper's Weekly*, November 2

1890
Sketches on a Journey to California in the Overland Train published in *Harper's Weekly*, March 22

Indian "Tablet Dance" at Santo Domingo, New Mexico published in *Harper's Weekly*, June 7

Death of Sitting Bull, December 15

Massacre at Wounded Knee Creek on Pine Ridge Reservation, December 29

1891
The Last Scene of the Last Act of the Sioux War published in *Harper's Weekly*, February 14

1892
Farny elected president of Cincinnati Art Club

1893
Serves on national jury choosing art for exhibition at World's Columbian Exposition, Chicago

Publishes fictional sketch "Sorrel Horse's Medicine" in *Cincinnati Commercial Gazette*, March 12

Exhibits paintings at Lincoln Club to benefit Cincinnati Women's Columbian Association, March 14

Farny watercolors exhibited at World's Columbian Exposition, May 1–October 31

1894
Travels to Fort Sill Reservation, Indian Territory; meets Geronimo

1895
Cree Indians from Havre, Montana camp at the Cincinnati Zoological Gardens

1896
Lakota Sioux, Sicangu band of people from Rosebud Reservation, South Dakota, camp at the Cincinnati Zoological Gardens

1897
Elected to U.S. Commission on Fine Arts for Paris Exposition

1902
Theodore Roosevelt admires Farny's artwork

1906
Farny marries ward, Ann Ray

1907
Completes *The Black Robe*, first in series of historical paintings

1908
Birth of son, Daniel

1915
Cincinnati Art Museum holds loan exhibition of Farny paintings

1916
Farny dies, Cincinnati, December 23

1924
Indian Citizenship Act grants U.S. citizenship to all Indians who are not already citizens.

1934
Indian Reorganization Act (Wheeler-Howard Act) reverses Dawes Act and encourages tribal organization.

Farny one-person exhibitions:

1943
Henry F. Farny and the American Indian, Cincinnati Art Museum

1965
Henry F. Farny, 1847-1916, Cincinnati Art Museum

1975
Henry F. Farny, Indian Hill Historical Museum Association, Cincinnati, Ohio

1981
The Realistic Expressions of Henry Farny: A Retrospective, The Snite Museum of Art, University of Notre Dame, Indiana

1983–84
Henry Farny 1847-1916, Archer M. Huntington Art Gallery, The University of Texas, Austin

1997
Henry Farny: The Lure of the West, Cincinnati Art Museum

The Vanishing Frontier, Henry F. Farny 1847-1916, Taft Museum, Cincinnati, Ohio

INDEX

"About Some Indians," 57
Abraham Lincoln: A History, 58
Acoma, water-carrying technology, 114
Adena Indian mound, 44
After the Evening Meal, 121, *121*
Alsace, 15, 16, 17, 39
American Art Association, 59, 94
American Art Review, 16
American military and treatment of Indians, 63–64, 109
American Water Color Society exhibition, and Farny gouache, 82
Apache, 65
Apache, 30, 94, 100; different groups of, 114; western expansion and, 109; "hostiles," 59; and Mexican influence, 102; water-carrying technology, 114
Apache Ambush, An, 109, *109*; Farny hears Indian tales about, 109
Apache Water Carrier, 114, *114*
Appletons' Illustrated Almanac for 1869, 41
Arapaho robe, 128
Art Academy of Cincinnati (earlier, School of Design of the University of Cincinnati), 77
Arthur, Chester Alan, 49
artists' suppliers, 80; in Cincinnati, 74, 85
assimilation/Americanization, in boarding schools, 26, 34, 132; and religion, 107; on reservations, 26, 34, 37, 48, 134. *See also* federal Indian policy
Attack on the Emigrant Train, The, 20
Badlands, the, 116
Barbizon style, 76, 77
Battle of Little Bighorn, 45, 64
Belt, Arthur (Blokaciqa), 66
Bierstadt, Albert, 17, 32, 76; and photography, 80
Bingham, George Caleb, 21, 32. *See also The Concealed Enemy*
Bismarck, Dakota Territory, 19, 46, 52, 79
Black Dog, 49
Blackfeet (formerly Blackfoot), 38, 41; and

starvation on the reservation, 56
Blackfoot Indian, 41, *41*
Black Robe, The, 82, 130, *130*
Blanton Museum of Art at the University of Texas at Austin, 79
Bodmer, Karl, 11
Bonaparte, 16
Bow Priesthood Society, 49
Boy in Native Dress with Ornaments Near Eagle and Eagle Cage Made of Adobe and Sticks, 50, *51*
Bronco Billy and the Baby, 133
Browne, Henry Kirke, 34
Bryant, William Cullen, 22–23, 24
buffalo and other wild game, disappearance of, 45–46, *46*, 47, 60, 124; importance to Indian (Plains) life, 46; white professional hunters and, 55, 60, 124
Buffalo Bill, and frontier stage shows, 43, 45; and Indian stereotype, 98; producer of "flickers," 133; Wild West Show, 30, 43–44, 66
Burbank, Elbridge Ayer, and ethnology, 32; portraits of Indians, 12
Bureau of (American) Ethnology, 49; first anthropological expedition to Zuñi Pueblo, 49, 50, 115. *See also* Cushing, Frank Hamilton; Hillers, John K.
Cable, George W., 57
Calder, Alexander Stirling, 34
Camera Club of Cincinnati, 56–57; and Farny, 57
Campfire, The, 129, *129*
Camp of the Uncupapas [*sic*], 41
Canon Hopi trading post, 50
Captive, The (gouache, formerly *The Prisoner*), 59, 82, 94, *95*; popularity of, 94; process of making, 82; reverse side, *82*; versions, 94. *See also The Prisoner*
captive narratives, 134. *See also Sketch for "The Return of the Raiders"*
Carlisle Indian Industrial School, 134
Carter, Denny, 78, 136
Catlin, George, 112; and catlinite, 105; as

first-hand observer, 12; as Indian artist, 11, 43; Indian as natural man, 12; portraits of individual Indians, 12–13; possible influence on Farny, 44; and Western American art traditions, 12, 98
Cayenne, French Guiana, 16
Central Pacific Railroad, 30
Century Magazine, Cushing articles about Zuñi, 49–50; expedition of Farny and Smalley, 19, 55–56, 111, 124, 126; Farny illustrations, 38, 49–50, 51, 58, 74, 115
Century of Dishonor, A, 45
Cherokee, 98
Cheyenne, 40, 59; and Farny, 106
Cheyenne Camp, 106, *106*
Cheyenne Courtship, A, 59, *59*
"Chicago Fire, The," 17, *17*
Chief Ogallala Fire, 32, *32. See also* "Ogallala Fire"
Chinook Burial Grounds, 26, *26*
"Chinook Jargon," 136
Chiricahua Apache, 66, 109. *See also* Geronimo
Cincinnati, and art supplies, 74; and Farny's career as an artist, 41; and the Düsseldorf style, 76; and Indians, 40, 66; interest in the frontier, 43; and Wild West shows, 43, 66
Cincinnati Academy of Fine Arts, 76
Cincinnati Art Club, 32, 77, 86; and Farny, 34, 66; and gouache, 81; and Ogallala Fire/Joe, 64
Cincinnati art collectors and Farny, 86
Cincinnati Art Museum, 85, 92
Cincinnati Camera Club. *See* Camera Club of Cincinnati
Cincinnati Columbian Association, 65. *See also* Women's Columbian Exposition Association of Cincinnati and Suburbs
Cincinnati Commercial Gazette, 17, 67, 110, 133; and Farny statements about Indians and Indian policy, 57, 63, 66, 128
Cincinnati Daily Gazette, 45, 46, 47, 92, 106; and Farny statements about Indians and Indian policy, 49, 106

Cincinnati Enquirer 73, 79, 92; and Farny discussion of government Indian policy, 19

Cincinnati Etching Club, 79

Cincinnati Industrial Expositions, 77; and Farny, 41, 42, 46, 77; and Herzog, 77

Cincinnati Turner Festival, 41, 74, 75

Cincinnati Zoological Gardens, and buffalo, 124; Farny visits, 117; and Indians, 79, 111, 117, 125; Wild West Show at, 66

Clarke, Robert, 44; bookstore, 44, 46, 65, 92

Clubbe, John, 76

Cochise, 109

Cody, William F., 43, 98, 133. *See also* Buffalo Bill

"Cohak–Wah, White Medicine Bead," 49, 51

Cole, Thomas, 22, 23

Comanche, 30, 66

Coming of the Fire Horse, The, 29, 132, *132*

Commerce of the Prairies, 20

Commercial Gazette. See Cincinnati Commercial Gazette

Completion of the Northern Pacific Railway, 52. *See also* Villard excursion

Concealed Enemy, The, 21, *21*

Corot, Jean Baptiste Camille, 77

Courbet, Gustave, 77

Couse, Eanger I., 32

cowboys, and Farny photographs of, 57; and Plains Indian life, 19

Cree Indians, 79, 121

Crook, George, 48

Crossing the Continent, 19

Crow, Crow Agency/Reservation, 28–29; entertain Villard excursion, 53–54, 90; and Farny, 53–54; and grass dances, 54; and war and scalp dances, 54. *See also Sioux Brave*

Cushing, Frank Hamilton, and Zuñi Pueblo Indians, 49–50

Custer, George Armstrong, 45. *See also* Massacre at Wounded Knee

Cuthead [Yanktonai] Sioux, 60

Dakota Territory, 51–52

"Dakotah Indians," 57

Dance of Crow Indians, A, 28, 53–54, *54*, 84, 90, *91*; variant versions, 23–29, 54, 75, 90

Daniel Boone at Age Fourteen 18, *18*

Davis, Jefferson, and Farny political cartoon, 16

Dawes Act (General Allotment Act), 30, 48

Dengler, Frank, 77

Department of the Interior, 53

De Vere, Clara (Clara Anna Rich Devereux), 42

"Do Unto Others As Thou Woulds Have Then [sic]," 39, *40*

Dramas and Dramatic Scenes, 43

Düsseldorf, as a center of art education, 17, 21; and Indian paintings, 31–32; popularity of its "style," 76. *See also* Bierstadt, Albert; Elder, John Adams; Farny, Henry

Düsseldorf Art Academy and American students, 17

Duveneck, Frank, 77; etchings compared to Farny's, 79

Dying Indian, The, 34

Dying Tecumseh, The, 34

Eastern Woodland Indians, 98; and Farny, 39; and Farny's mixing of Great Plains culture with, 58, 121, 130

Eclectic History of the United States, The, 44

Elder, John Adams, 23

Emery B. Barton canvas, 85

End of the Race, 25, 26, 64. *See also The Last Scene of the Last Act of the Sioux War*

End of the Trail, The, 32, 34

ethnology and Indians, and art, 38, 54; and Farny, 37, 38, 40, 44; popular confusion about Indian culture, 47. *See also* Cushing, Frank Hamilton; Ewers, John

Evening Campfire, 118, *119*

Ewers, John, 38

Fallen Warrior, The, 34

Farny, Charles, commitment to social justice, 16; emigration, 16; move to Cincinnati, 16, 39; political views of, 16

Farny, Henry, and Cincinnati, 16, 34, 38, 39, 41–42; collector of Indian artifacts and photographs, 32, 65; early life, 15, 39, 40; Indian "expert," 38; and Indian impoverishment, 19, 37, 55; and Lafcadio Hearn, 17, 42, 79; love of the West, 106; and the mythic West, 38, 67; political background and sympathies, 16, 17; predicts Wounded Knee, 63; sympathy for the downtrodden, 17, 34, 37, 48, 64; trips to the West, 12, 19, 38, 43, 46, 51–52, 53, 54; view of federal Indian policy, 19, 34, 38, 46, 48, 59, 64; works as icons of Indian and Western art, 67, 128. *See also* Villard excursion; *Ye Giglampz*

Farny as artist, 67; admirers of, 66–67; appeal to popularity, 99; apprenticeship, 16; canvas use by, 85; caricaturist/cartoonist, 16, 41; Cincinnati studio, 74; and color theory, 84; early work, 39, 73, 74; etcher, 79; European studies, 17, 41, 76–77; at *Harper's*, 16, 74; illustrator, 16, 37–38, 43; and innovation, 86; as landscape painter, 111, 112, 126; lithographer, 74, 79; media employed (gouache, graphite, ink, lithography, oil, photography, watercolor), 73, 74–75, 77, 79; models, 41, 64, 105, 131; and other artists and sculptors, 50, 86–87; papers used, 84–85; pictures of, *6*, *82*; and photography, 12, 38, 56–57, 76, 81, 101; and Plains Indians, 9 (*see also* Plains Indians); popularity and success of, 41, 49, 58, 59, 64, 67, 86; signature, 51; students of, 86; as teacher, 77; technical and artistic skills, 86, 130; working methods, 80, 81, 82–83.

Farny as Indian artist, absence of individual Indians, 12, 34; appeal of mythic West, 38, 111; and archaeological evidence, 44; artistic license taken by, 102, 121, 126; bronze by, 115; and Catlin, 44; compared to other artists, 12–13, 31–32, 34, 53; early Indian works, 39, 40, *40*, 41, 73–74; encounters with Indians in childhood, 18, 39, 73–74; encounters with Indians in later life, 46, 109; ethnological inaccuracy or questionability of, 40, 45, 46, 50, 51, 54, 58, 59, 121, 128; ethnological interest of, 37, 98; historical accuracy of, 37, 38, 39–40, 44, 46, 48–49, 53, 54, 55, 59, 61, 63–64, 106; historical inaccuracy of, 59, 96, 101, 130; historical paintings, 130; and Great Plains reservations, 46, 49, 112; hunting scenes, 14, 79, 83–84, 133; and Indian communities and culture, 12, 106, 126; and Indian hardship, 59, 64, 67, 92; Indian names of, 39, 49; and Indian women painted/sculpted, 114, 115; Indians as doomed, vanishing, 12, 25, *30*, 31, 34, 46, 64, 90, 100, 123, 128; Indians as savages, 94, 134; Indians in winter, 10, 14, 27, 30, 31, 46, 92, 108, 121; Missouri River travels, 55; and models, 64, 81, 102, 105; narratives, 100, 112, 124, 129, 132; and Navajo blankets, 117, 125, 126; ornaments, 131; portraits, 79, 80, 104, 105, 110; and railroads, 28–29, *29*, *30*, 52, *53*, 128, 132; romanticism of, 46, 59, 67, 108; and Seneca Indians, 39; sensationalism of, 58, 94, 134; and Sioux village, 46; and Sitting Bull, 52; sketch in situ, 110; and sketches, 46; static narratives, 13, 14, 27, 106; stereotypes of Indians, 58, 94, 95, 101, 131; sympathy for Indians, 18, 39, 55, 64, 66; themes, 11, 28–29, 67, 132; understanding of Indian culture, 47; use of photographs, 32, 37, 46, 50, 51, 79, 115, 136; western landscapes with Indians, 118, *119*, 126

Farny, personality of, 34, 42; playfulness of, 38, 42, 64, 67, 76, 113, 128; as speaker/storyteller, interviewee, entertainer, 38, 42, 46, 66, 67, 113, 128; visits to forts, 60; as writer on art topics, 42; writer on Indians, 41, 57. *See also* Fort Sill

Farny in his studio, 82, 83

Farny's "secretaries," as models, 64, 131

federal Indian agencies. *See* Standing Rock Agency

federal Indian policy, consequences of, 19, 34, 37, 64; criticisms of, 45; war and scalp dances forbidden, 54; goals, 37; forced assimilation, 26, 34, 37, 48, 134; permits needed to leave reservation, 53, 90, 112, 126; rations, 19, 48–49, 56 (*see also Ration Day at Standing Rock Agency*); reservations, 25, 112, 116, 123, 124, 126. *See also* Dawes Act

Field Mice, 41
Fliegende Blätter, 77
Flynn, Edwin (Ed), 17, 59. *See also Suspicious Guests*
Force, Manning Ferguson, 77
Ford, The, cover, 113, *113*
Fort Benton, 19, 55
Fort Moultrie, South Carolina, 13
Fort Randall, 46
Fort Sill Reservation, Farny and inspection of, 30, 109, 110, 114. *See also* Geronimo; Miles, Nelson
Fort Totten Reservation, 60
Fort Yates, Dakota Territory, 19, 26, 27, 46; and Farny watercolors/photographs, 80, 81; and Sitting Bull, 44–45
Fort Washington, 40
Fort Washington, Cincinnati, 40
France, political and social history of, 15
Frank Leslie's Illustrated Newspaper, 53; and Sitting Bull, 52
Fraser, James Earle, 34
Gaff, Thomas T., 67
Galley Slave, The, 79
"Game Birds and Their Haunts," 41
General Allotment Act (Dawes Act), 30, 48
Geronimo, 30, 109, 110, 114; and Farny, 30, 66, 109. *See also Signor Pacer, Chief of Scouts who Captured Geronimo*
Geronimo, Apache, 30, *30*
Ghost Dance Religion, 107
Gibson & Company, 74
Gilbert, General, 46
Gilcrease Museum (Tulsa, Oklahoma), and *The Sorcerer*, 123
Got Him, 65, 100, *100*
gouache, conservation problems of, 85; effects of light on, 84; and Farny, 74, 75–76, 81, 82; other artists of the West and, 81
Graham, Charles, 53
Grant, Ulysses S., 51, 66; and "peace policy," 26; and Sitting Bull, 52
Green, James Albert, 42
Greenough, Horatio, 34
Greeley, Horace, 22
Groseclose, Barbara, 21
Guadalupe Hidalgo, Treaty of, and Indian life, 109
Hahn, William, 32
Happy Days of Long Ago, 33, 34
Harper Brothers, 74; Farny as engraver and cartoonist for, 74
Harper's New Monthly Magazine, 50
Harper's Weekly, and *A Dance of Crow Indians*, 53–54, 55, 76, 90; employer of young artists, 76; and Farny, 16, 28, 38, 41, 46, 47–48, 58, 60, 61, 63, 74, 75, 76; and federal Indian policy, 48; and Hillers and Metcalf, 50; hostility to Indians, 59; inaccuracies, 94; and *The Prisoner*,

58, 59, 94; quality valued, 74; and *Toilers of the Plains*, 46–47, 92
Hauser, John, 81
Hearn, Lafcadio, and Farny, 17, 42, 79. *See also Ye Giglampz*
Henry Farny, 136
"Henry Farny's Book," 39–40
Herzog, Hermann (Herman), 17, 76, 77; and Düsseldorf style, 76, 77; influence on Farny, 77
Hillers, John K., photographs by, 49, 50, *50*, 51, *51*; use by artists, 51, 115
Hopi Indians, 51; and Farny, 58, 60, 115. *See also Snake Dance of the Moqui Indians*
horses in Indian life, 112, 120
Hudson River School, 77
Hunkpapa Sioux, 44. *See also* Sitting Bull
hunting, 124, 129, 133
Huntington, Dwight W., 56; and sympathy for Indians, 60; visits forts, 60–61
"An Indian at the Burial–place of his Fathers," 22–23
Huron Indians, 130
In Brush, Sedge, and Stubble: A Picture Book of the Shooting–Fields and Feathered Game of North America, 57
Indians, captive narratives and, 134; "classic" Plains lifestyle, 112 (*see also* Plains Indians); confined to reservations, 112, 116, 124, 126; cultural survival, 120; dances of, 36, 54, 61, *62*, *62*, 90, *91*, 107 (*see also A Dance of Crow Indians*); degradation of, 66, 117; "doomed," 12, 22–24, 30, 34, 46, 128; entertainments by (*see* Cincinnati Zoological Gardens; *A Dance of Crow Indians*; Wild West shows); forced assimilation, 26, 48, 134; and government-issued items, 49, 129; hardships/starvation, 13, 124; hunting, 124, 129, 133; and Indian Police, 116; intertribal hostility, 120; in literature, 22–23; and modern technology, 128, 132 (*see also The Coming of the Fire Horse*; *Morning of a New Day*; *The Song of the Talking Wire*; "Sorrel Horse's Medicine"); moved to reservations, 12; painted by Farny (*see* Farny, Indian artist); painted by other artists, 32–33; patronizing/racist treatment and views of, 22, 47, 48, 55; permits to leave reservations, 90, 112, 126; popular confusion about Indian culture, 47; and railroads, 132; religion, 107, 123; reservation life, 26, 120, 123, 129; relocated, 28; ritual items, 123; as savages, 45, 47, 81, 94, 95, 123, 134; sociability, 126; stereotypical dress, 98, 101; trade networks of, 131; treaties broken, 109; transition from traditional life, 57, 60, 124; wars, battles, hostility, 20, 40, 45, 58, 60, 65, 66, 100, 101, 109. *See also* federal Indian policy; individual tribes

Indian and Child, frontispiece, 125, *125*
Indian Dancing, 45
Indian Encampment, 96, 97. *See also* Plains Indians
Indians Fishing–Northwest Coast, 136, *137*
Indian Head, 131, *131*. *See also Sioux Brave*
Indian Hunting Scene, *133*; work described, 83–84, 86, 133
Indian on Horseback, 99, *99*; and peace medal, 99
Indian Scout, 116, *116*
Indian "Tablet Dance" at Santo Domingo, New Mexico, 62, *62*
Indian Territory, 26, 28, 66, 109. *See also* Fort Sill
Indian Removal Act, 26
"Indian Warrior," 24
In Enemy's Country, 120, *120*
In Luck, 13, *14*
In Pursuit, 101, *101*
In the Heart of the Rockies, 126, *127*
In the Valley of the Shadow, 10, 30, *30*
Iron Shell, photographed by Farny, 110. *See* Lakota Sioux
Iroquois Confederacy, 19; and the State of New York, 19
Issue Day at Standing Rock, 76. *See also Ration Day at Standing Rock Agency*
Jackson, Andrew, and Indians, 26
Jackson, Helen Hunt, 45
Joe, model for Farny and other artists, 32, 64
Jones, Colonel, 66, 110
Keam, Thomas, 50
Keam's Canon Hopi trading post, 50
Kemper, H. W., 40
Killing of Abraham Lincoln, the Pioneer, 1786, The, 58
Kiowa, 30, 66. *See also* Pacer
Kodak, 80
Kohl and Middleton Dime Museum, 64
"Lacotah Yappi," 57
"Ladies of the Columbian Association, The," 81
Lakota Sioux, 40, 46, 48, 59, 64, 105, 106; at Cincinnati Zoo, 111, 125; give Farny an Indian name, 46; medicine man, 107; and Navajo blankets, 117, 125; and *Toilers of the Plains*, 92; and Wild West show, 66; and Wounded Knee Massacre, 101. *See also The Last Scene of the Last Act of the Sioux War*
land developers, 19, 30
Last Arrow, The, 34
Last of His Tribe, The, 23, 24, 64
Last of the Herd, The, 85–86, *86*
Last of Their Race, 24, *24*
Last Scene of the Last Act of the Sioux War, The, 63, *63*. *See also End of the Race*
Last Vigil, The, 41, 66
Lawrence, Frederick Sturgis, and Pacer, 102

League of the Ho–dé–no–sau–nee or Iroquois, 29
Le Caron, Joseph, 130
Leutze, Emanuel, 32
Leslie's Newspaper. See Frank Leslie's Illustrated Newspaper
Lewis, Henry, 32
Lewis and Clark, 20, 131
Lincoln Club/Hall, 64, 65; Farny exhibit and pleasure at, 64, 65. *See also* Women's Columbian Exposition Association of Cincinnati and Suburbs
Literary Club (Cincinnati), Farny's involvement with, 41, 57
Louis (Indian guide, Fort Yates), 46
Louis–Napoléon, 16
Louis–Philippe, 16
Lucky Shot, A, 124, *124*
Lummis, Charles F., 62
Makah people, 136
Man Weaving Blanket on Vertical Loom Suspended from Adobe Wall, 50, *51*
Massacre at Wounded Knee, 63, 101
Mayer, Frank, 23
McDonald, Alexander, 65
McGuffey readers, and Farny illustrations, 43, 67
Meakin, Lewis Henry, 86–87
Medicine Man, The, 107, *107*
Metcalf, Willard, 49, 50, 51
Meyer, Enno, 66
Miles, Nelson, Farny and Fort Sill Reservation (Indian Territory, now Oklahoma) inspection/tour, 30–31, 66, 109, 114; portraits of the Comanche Tashkoniy, Geronimo, 110
Miller, Alfred Jacob, 11, 13, 23
Mindeleff, Cosmos, photographs of Moqui/Hopi Indians, 61
Minnewaukau, North Dakota, 60
missionaries, agencies and Indians, 26, 130; and boarding schools, 26, 34; and religion, 107
Missouri River, Farny travels down, 55
Mobile, Alabama, 66
models, use of by Indian painters, 32; Farny's, 105. *See also* Farny, models
Mohawk hairstyle, 130
Moment of Suspense, A, 102, *103;* source photograph for, *102. See also* Geronimo
Mondragon (Tudl–Tur, "Sunshine on the Mountains"), 32
Moran, Thomas, 81
Morgan, Lewis Henry, 39
Morning of a New Day, 29–30, *30,* 128
Mountain and Meadow, 111, *111*
Mountain Ranch, A, 56
Mountain Trail, The, 65
Mountain Trail, A—Crow Indians, 82
"Moving Day for Siwash Family–Siwash Dugout Canoe on Puget Sound," 136

Munich, 17; as art center for American artists, 77; Farny in, 77, 79; influence of Barbizon school on, 77; Munich style, 78; and photography, 81
Music Hall, Cincinnati, 66
Muybridge, Eadweard, photographic studies, 101, and Farny's awareness of, 101
"My Adventures at Zuñi," 49
"Nana" (Naiche), 66
Navajo, 117; blankets, 117, 125, 126; and *churro* sheep, 125
New Territory, 27–28, *28*
New York Tribune, 22
Nootkan people, 136; and basketry hats, 136
Northern Pacific Jubilee–Driving the Golden Spike, The, 53
Northern Pacific Railroad, 28, 52, 54, 79
Northmen in Rhode Island, 44
Northern Plains Indians. *See* Plains Indians
"Ogallala Fire" (also called Joe), 64, 105
Ohio Mechanics Institute, 77
Ohio Valley archaeology, 45–46
oil paints, availability of for Farny, 74; use of, 85
Old Jacob, 18–19, 39, *39,* 73
On the Alert, 13, *13,* 112, *112*
Osage, 21
Osceola, and Catlin, 12–13
Osceola, Black Drink, Seminole, 13, *13*
Pacer, also known as Peso, as model, 102, *102, 103. See also* Geronimo
Paiute Indians, 62
Papoose and Squaw, and versions, 78, 79
Paris Salon exhibition, 47
Parsons, Charles, 76
Pat Rogers tragedy, 42
peace medals, 99
pemmican, 129
Phillips, Bert, 32
photographs, difficulties of, 80; equipment for, 80; Indian subjects and, 32; and Sitting Bull, 52
pictographs, 51
Piegan Camp on Teton River, 55, *55*
Piegan Indians, degradation and poverty of, 19, 55; Farny's picture of, 55, *55;* relatives of Blackfeet, 56
Pine Ridge Indian Reservation, South Dakota, 63, 101
Piper of Hamlin, 41, 77
Plains Indian, 98, *98;* and headdress, 98; and leggings, 98
Plains Indians, 46, 66, 90, 94, 96, 112, 116, 118; extinction of buffalo and, 55, 92; and Farny's misplacement of, 58; and Farny's mixing of cultural elements of, 40, 44, 130; and federal policy, 37, 48; and fire, 129; importance of horses and guns to, 112, 120; and importance of hunting, 108; intrusion of cowboys on, 19; life in transition, 48, 57, 123; and Navajo

blankets, 117, 125, 126; pipes, 105, 107; and railroads, 132; religion, 107; sun dance, 107; sweat lodge, 96; tipis, 118; traditional customs and lifestyle, 59, 104, 113; warbonnets, 44, 101; warriors, 120; and white settlers, 120, 132; in winter, 10, 31, *31,* 108 (see also Farny as Indian artist: Indians in winter); and women's education, 104. *See also* Ewers, John; *Tashkoniy / Comanche; A Young Squaw*
Polk, James K., 20
Portrait of a Boy in a Blue Jacket and Red Cap in a Landscape, 74
Powell, John Wesley, 49
Prairie Waif, The, 43
printing techniques, 74–75; and Farny, 74–75
Prisoner, The (gouache, retitled *The Captive*), 59, 82, *82,* 94, 95 *See also The Captive*
Prisoner, The (wood engraving), 58, 59, 94. *See also The Captive*
Pueblo Indians, and Farny's ethnological inaccuracy, 50; and Taos Society of Artists, 32; and trade with other Indian groups, 114, 117; weaving of, 51
racist view of Indians, 22
Pueblo of Zuñi, Bernice Sal QL Saye, 115, *115*
railroads, 52; advertisement, 102; and Indians, 132; as networks, 132. *See also* individual railroads
Ration Day at Standing Rock Agency, 48, *48,* 49, 76, 94; accuracy of, 48–49. *See also Issue Day at Standing Rock*
Read, Thomas Buchanan, Farny studies with, 76
Reid, Buchanan, 17. *See* Read, Thomas Buchanan
Relics from the Mounds, 44, *44*
Remington, Charles, 32
Remington, Frederic, 32
reservations, 19, 25; forced assimilation on, 26, 34, 37, 48, 107, 134; hardships of, 59, 64, 67, 92; origins of, 25; relocation for many Indians, 28; permits to leave, 53; encroachments on by settlers, hunters, railroads, 56. *See also* individual reservations
reservation system. *See* federal Indian policy
Rettig, Martin, 73, 81
Return from the Hunt, 108, *108;* importance of hunting, 108
Rindisbacher, Peter, 31
Rip Van Winkle, 77
Rogers, Randolph, 34
Rookwood and the American Indian, 102
Rookwood Pottery, 51, 57
Roosevelt, Theodore, 57; views Farny paintings, 66
Rosebud Reservation, South Dakota, 66, 110. *See also* Lakota Sioux
Sage, Lieutenant, 46
"Sage–Cock Shooting in Montana," 57. *See also Theodore Roosevelt "Sage Grouse Shooting"*

Saint-Gaudens, Augustus, 34
Santo Domingo Pueblo, Farny and, 62
Scene from "The Last of the Mohicans," 22, 23
Schreyvogel, Charles, 32
Schurz, Carl, 45
Scouts of the Prairie, The, 43
Seminole, 20
Seminole War, Second, 20
Seneca, 40, 73; artifacts in New York State collection, 39; as assimilated, 18, 39; and the degradation of Indians, 18. *See also* Old Jacob
Sentinel, The, 66
Sharp, Joseph Henry, and ethnology, 32; as Indian portrait painter, 12; and models, 32
Shawnee, 58
Shoshone, 62
Shoulder Length Portrait of a Warrior, 79, 80
Signor Pacer, Chief of Scouts who Captured Geronimo, 102, 102. *See also A Moment of Suspense*; Geronimo
Silence, 85
Silent Guest, The, 77–78, 79
Singing School Companion, The, 39
Sioux, 46, 47, 57, 79; and Farny's signature, 51; and Sioux village, 106; *Ration Day at Standing Rock Agency,* 48–49. *See also* "Sorrel Horse's Medicine"
Sioux Brave, 84, 105, 105; Crow hairstyle on, 105
Sioux Camp, The, 65
"Sioux Indian Chief Threatens a Massacre," 64
Sioux Women of the Burnt Plains, The, 47
Sitting Bull, 30, 44–45, 46, 52, 63; comments about Battle of Little Bighorn, 45; Farny portrait of, 79; white misunderstanding of, 44–45
Siwash (a pejorative), 136
Sketches on a Journey to California in an Overland Train, 62
Sketch for "The Return of the Raiders," 72, 86, 134, 135; process of producing, 82
Smalley, Eugene V., 19; and Missouri River travels with Farny, 55, 57
Smithsonian Institution, 38, 49. *See also* Bureau of (American) Ethnology
Snake Dance of the Moqui [Hopi] Indians, 36, 61, 61
Society for Suppression of Music, 42
Solitude, 77
Song of the Talking Wire, The, 31, 128, 128
Sorcerer, The, 123, 123
Sorrel Horse, 57
"Sorrel Horse and the Thunder God, The," 57
"Sorrel Horse's Medicine: A Yarn of the Buffalo Range," 57; and Indians and white technology, 57, 128. *See also* Indians, railroads; *The Song of the Talking Wire*
squaw (a pejorative), 105, 117

Standing Rock Agency/reservation, 19, 46, 48–49, 57, 59, 63; and Farny, 92, 94
Stanley, John Mix, 11, 26
Stephen, Alexander, 50, 51
Stevenson, John, 49
"Story of Wounded Knee, The," 64
Strobridge Lithographing Company, 79
Suspicious Guests, 59, 60; and variant versions, 59
"Tablet Dance," properly Corn or Tablita Dance, 62, 62
Taos, New Mexico, art colony, as collectors of artifacts, 32; and Pueblo Indians, 32
Tashkoniy / Comanche, 84, 110, 110; Farny sketch in situ, 110
Teller, Henry M., 53
Territory of New Mexico, 49
Thalheimer, Mary Elsie, 44
Theodore Roosevelt "Sage Grouse Shooting," 57, 66
tipis, 118
Toilers of the Plains, 27, 27, 47, 47, 51, 64, 92; ethnological details of, 46; versions of, 27, 47, 57, 92, 93
Tombola, 84
trade beads, 105
Traxel & Mass canvas, 85
treaties with Indians, breaking of, 109; and railroads, 132
Truce, The, 59. *See also Suspicious Guests*
Truettner, William H., 30
Turner Festival at Cincinnati, Ohio, The, 75
Twachtman, John, 77
Twain, Mark, 57
Ukchekehaskan, Minneconjue Sioux, 80
Union Pacific Railroad, 30
United States Cavalry, 63, 65, 101. *See also* Battle of Little Bighorn
United States Indian Department (USID), 19, 49
"Unke–Unkee–ah / Siah Tappah / Blackfoot," as Farny model, 41, 41
Unwelcome Guests, 59, 65. *See also Suspicious Guests*
Ute Indians, 122
Ute Scout, 122, 122; and his clothing, 122; Farny and, 122
Van Antwerp, Bragg & Company, 43
Van Briggle, Artus, 51
Venable, W. H., 43
Villard, Henry, 28, 54, 90
Villard excursion, 51–53, 90; and Crow dances, 53–54; and driving of the last spike, 28, 29; and Farny, 51, 79
von Diez, Wilhelm, 77; as teacher of Farny, 77
Wadsworth, Daniel, 23
watercolor, 78, 80; and Farny, 79–80, 81; problems of, 84
Weinmann, Adolph, 34
West, the, artistic and popular interest in, 43;

changes in, 19, 59
western American art, and George Catlin, 43; and monumental landscapes, 25, 110
western expansion, 20; and white/Indian conflict, 20, 45; and mistreatment of Indians, 109
Wetmore, P. M., 24
Whatman papers, 84
White Man's Trail, The, 28–29, 28
"White Medicine Bead," 49, 51
Whittredge, Worthington, 32
"Whizhays" (Long Boots), 39. *See also* Farny as Indian artist: Indian names
Wild West Shows, educational, 66. *See also* Buffalo Bill's Wild West Show
Wilde, Oscar, 47
Wimar, Carl, 32. *See also The Attack on the Emigrant Train*
Winter, 79
Winter Encampment of the Crow Indians, 26–27, 27
Winter Squaw, 82–83, 117, 117; mix of material culture in, 117
"Women Grinding Corn," 50
Women's Columbian Exposition Association of Cincinnati and Suburbs, 64, 65
wood engraving, and Farny, 75–76
Woodward College (now High School), 39, 74
World's Columbian Exposition (Chicago), Farny as exhibitor, 100; Farny as judge and exhibitor, 65; Northwest Coast exhibit, 136; and Rookwood pottery, 51
World's Columbian Exposition (Chicago), Women's Building, Cincinnati Room, attendance at fundraising exhibit for, 65; fundraising for, 64, 65
Ye Giglampz, 17, 42–43; title page, 17
Yell of Triumph, The, 13, 15
Young Squaw, A, 84, 104, 104
Zuñi Pueblo Indians, ethnographic description of, 49–50; Farny and Metcalf drawings of, 49–50, 51; and Farny's signature, 51; trip to Washington, D.C. and Boston, 49–50, 51; and water-carrying technology, 114
Zuñi Weavers (painting), 51; Farny's mistakes in, 51
Zuñi Weaving (illustration), 50; Farny's mistakes in, 51